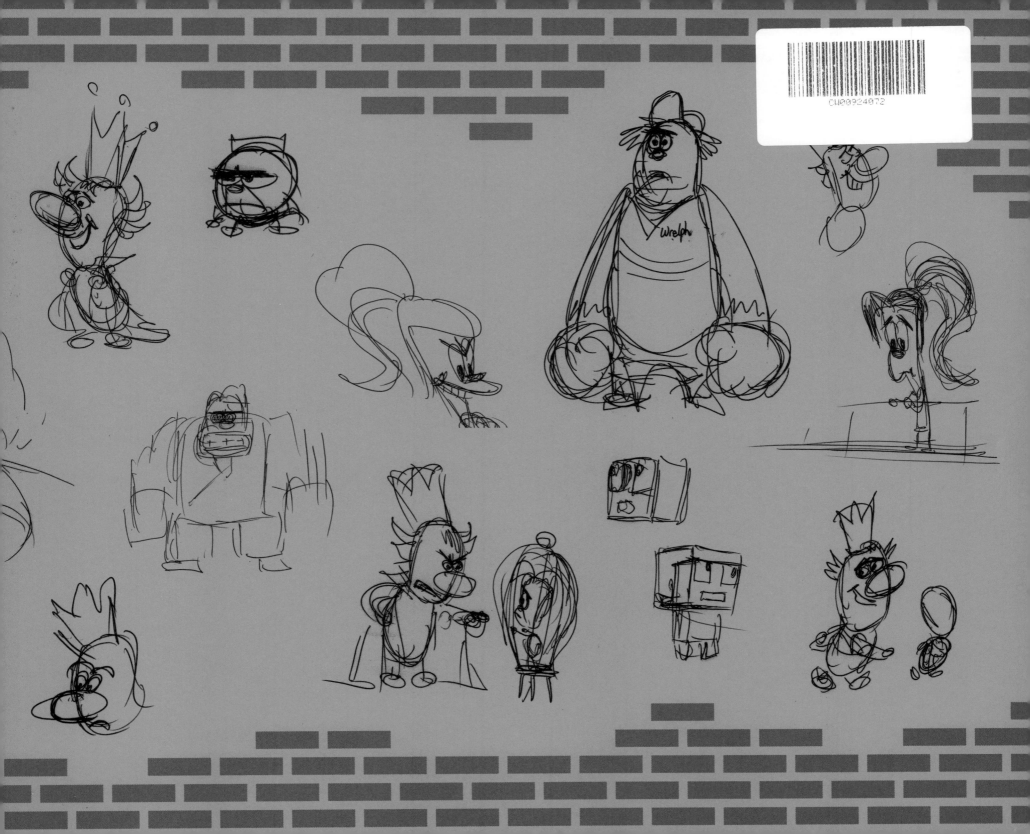

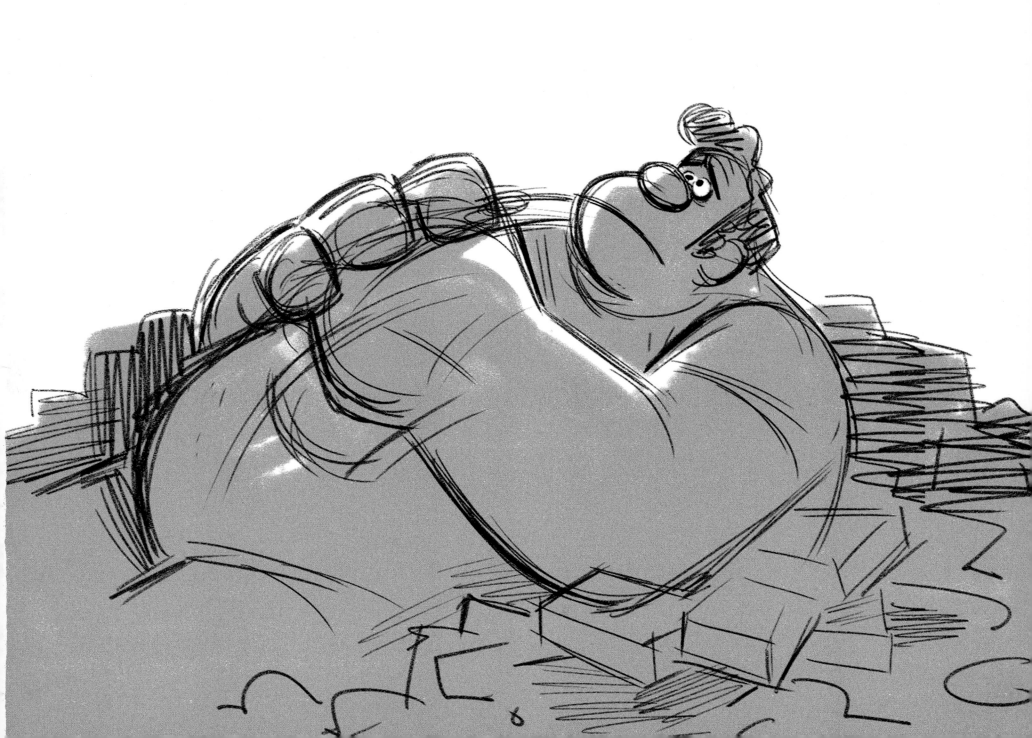

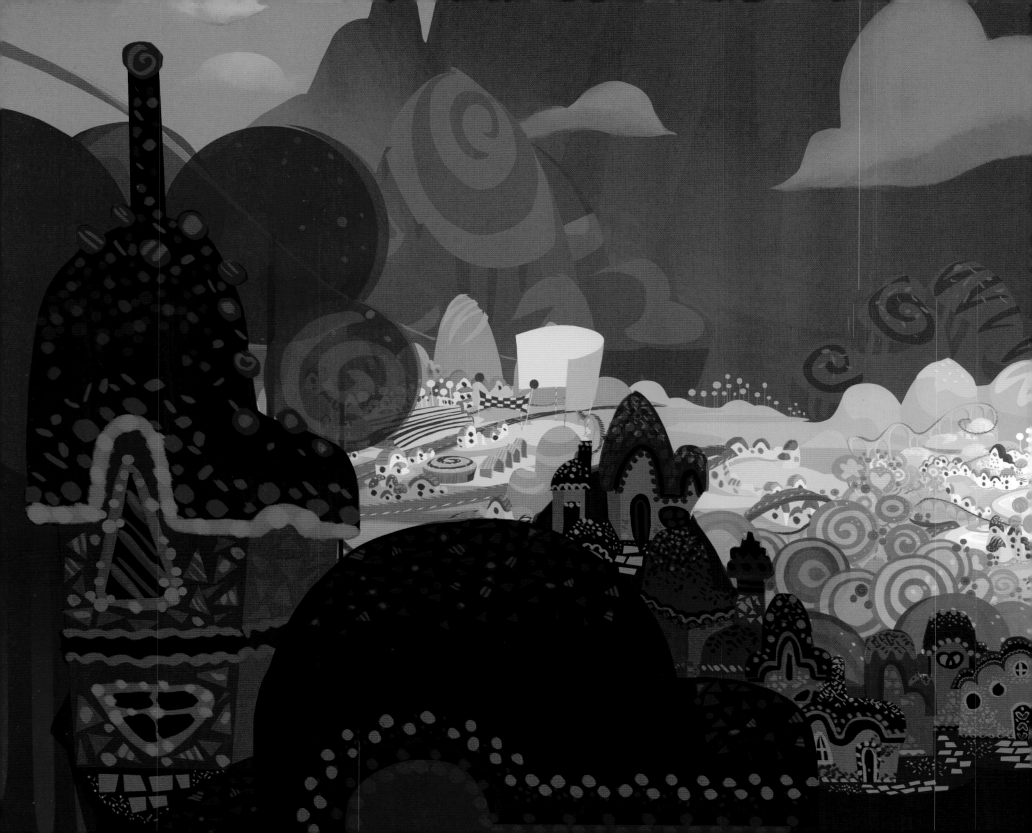

THE ART OF Disney

WRECK-IT RALPH

BY JENNIFER LEE AND MAGGIE MALONE

PREFACE BY JOHN LASSETER

FOREWORD BY RICH MOORE

CHRONICLE BOOKS
SAN FRANCISCO

Library of Congress Cataloging-in-Publication Data:
Monn, Jennifer Lee.
The Art of Wreck-It Ralph / Jennifer Lee and Maggie Malone ; Preface by John Lasseter ; Foreword by Rich Moore
pages cm
ISBN: 978-1-4521-1101-8
1. Wreck-It Ralph (Motion picture)—Illustrations. 2. Animated films—United States. I. Title

NC1765.U53W745 2012
791.43'72—dc23

Manufactured in China

Designed by Glen Nakasako, Smog Design, Inc.

10 9 8 7 6 5 4 3

Chronicle Books LLC
680 Second Street
San Francisco, California 94107
www.chroniclebooks.com

Front Cover: **Lorelay Bove** / Digital • Back Cover: **Lorelay Bove** / Digital • Front Flap: **Cory Loftis** / Digital • Back Flap: **Cory Loftis** / Digital • Front and Back Endpapers: **Rich Moore** / Pen
Page 1: **Bill Schwab** / Digital • Pages 2-3: **Lorelay Bove** / Digital • This and Next Page: **Justin Cram** / Digital • Pages 6-7: **Wayne Unten** / Digital

CONTENTS

PREFACE

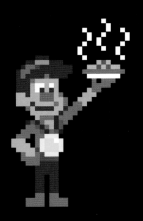

When Rich Moore first pitched us his idea for *Wreck-It Ralph*, I got so excited because it was unlike any of our other films. Rich took us through the arcade screen to meet Ralph, an '80s-era videogame bad guy who so desperately wants to be a hero that he goes on an adventure, wrecking havoc through two new modern-day games. Ralph causes the lives of all these different game characters he meets to collide in a way we've never seen before. And this mash-up of worlds is what makes this film so hilarious and unique.

Rich and his artistic team invented three game worlds for the film that are completely original but are based upon concepts that are familiar to the audience. The eight-bit world of Fix-It Felix, Jr. celebrates the sights, sounds and physics of those classic arcade games everyone loves, like Donkey Kong, Dig Dug, and Pac-Man. Ralph, Felix, and the Nicelanders walk in right angles and move their arms in unison and symmetrically—or in twinned poses, as we call it in animation. This simple style is so charming but also makes the game instantly recognizable as one from the '80s.

For Hero's Duty, the first-person shooter game where Ralph gets his Medal of Heroes, the artists designed a world that is off-the-charts realistic. That's the hallmark of those action games for Xbox and PlayStation that I watch my sons play. So our artists had to create an equally gritty and immersive world and a mythology to go with it. Finally, Sugar Rush, the game in which Ralph meets loveable Vanellope Von Schweetz, celebrates the kart racing conventions of a Nintendo 64–era game. And the cartoony all-dessert world is just spectacular. You see Mike Gabriel and Lorelay Bove's delicious-looking development art for Sugar Rush and say, "oh yeah, I'm there."

Creating all these distinct worlds has been so much fun but bringing them together into one story has been an unusual design challenge. We needed an appealing and believable way to connect the worlds into one arcade universe, but at the same time keep the worlds with their own sets of rules separate. That's when Rich and writer Phil Johnston came up with what is really the fourth world of the movie: Game Central Station. Game Central is a transportation hub that exists inside a simple power strip. For it, the visual development artists figured out how to marry the architectural language of the electrical outlet with the beautiful arches and details of New York's Grand Central Station.

We've been so lucky bringing Rich into the studio from *The Simpsons* and *Futurama*. He's only been with Disney Animation on *Wreck-It Ralph* for a few years, but already his directing expertise and smart sense of humor have benefited the studio as a whole. Rich's talent really shines through in his development of original characters like Ralph, Vanellope, Felix, and Sargeant Calhoun, who are so funny and so fresh, yet full of emotion. We're also tremendously fortunate that Mike Gabriel, an amazing animator and director who I've known since I first worked at Disney, was so intrigued by Rich's story and characters that he volunteered to join the project as an art director. It's Mike's first time doing the job and he, along with Ian Gooding, have done it brilliantly.

As all of the incredibly bold and diverse art in this book shows—from the initial character sketches, to the original eight-bit designs, to the set models made out of real candy—*Wreck-It Ralph* brings together four unique yet recognizable worlds that, when combined together, create a universe we've truly never seen before.

—John Lasseter

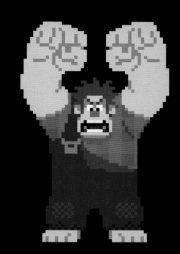

FOREWORD

When I was a sophomore at Cal Arts in 1985, I met a visiting alumnus named John Lasseter. He had recently started working for a new computer animation studio and wanted to share with our class a project they had just completed. Up until that day, computer animation had just been about flying logos to me. It was great for motion graphics, but it could never tell a story like character animation could. Or so I thought. What John showed us that day blew me away. It was Pixar's first short film, *The Adventures of André and Wally B*. John had taken all of his training at Cal Arts in hand-drawn storytelling and infused it into this new art form. The result was an engaging comic story set in a believable world about characters I cared about. An honest to God computer animated cartoon! I had no idea how he achieved it in a practical sense, I only knew that someday I wanted to work with this guy in this medium.

After I graduated, my career took me deep into the world of 2-D animation. I had the great fortune of joining *The Simpsons* as a director at the show's inception, and found myself at the epicenter of a television phenomenon. It was a big moment that lasted more than two decades. During that time, I worked with the most talented storyboard artists, writers and designers that the 2-D television genre has ever known, first on the *The Simpsons*, and then on *The Critic* and *Futurama*. All the while, I continued to follow the extraordinary work that John and crew were doing at Pixar. And like the rest of the world, I added each of their successes to my list of all-time favorite movies.

When John became the creative head of Walt Disney Animation Studios, he got in touch with me and asked if I was interested in developing and directing a CG movie. My initial reaction was, "Me? How does a guy go from *The Simpsons* to Disney?" At first it seemed like there was a big difference between my sensibility and what I thought was right for the Disney canon and the studio's legacy. But John assured me that, from the beginning, Disney Animation has always been about invention and reinvention. I also wondered about making the transition from 2-D to computer animation. Then I thought back on the jump John had made, when I first met him at Cal Arts, and realized the change in medium didn't matter. At our core, we are all striving to do the same thing—create memorable characters and worlds, and tell stories with heart. To that end, *The Simpsons* and Disney aren't that different.

Getting to make *Wreck-It Ralph* at Disney Animation Studios has been a dream come true. There is such tremendous support for the creative process at the studio under John and Ed Catmull's leadership. Our charge is to create characters that we care about, worlds that we love, and bring our stories to life with the best animation possible. We get there by exploring different ideas, finding the right ones and allowing them to grow. It's an organic process with a mind of its own. There's no map to chart it, but if you navigate its currents with faith and respect, it will take you right where you need to go.

This amazing process is only possible with the most talented people in the industry driving it. I have been so lucky to have Mike Gabriel and Ian Gooding art directing *Wreck-It Ralph*, along with a whole team of artists whose work on the film has been truly exceptional. The art in this book is a testament to their boundless imagination and passion. I hope you enjoy it.
-Rich Moore

I'M GONNA WRECK IT!

I CAN FIX IT!

Justin Cram, Wayne Unten / Digital

INTRODUCTION

WRECK-IT RALPH: A DIFFERENT KIND OF MOVIE

"*Wreck-It Ralph* is different." Those words have echoed through the halls of Walt Disney Animation since the film's inception in 2008. But what makes it different? Most obvious to many is the simple idea that although Disney Animation is best known for its traditional fairy tales, *Wreck-It Ralph* is anything but traditional. It stars a bad guy named Ralph, with big hands and a tendency to wreck everything. Ralph's partner in crime is a nine-year-old impish moppet with dirty hair named Vanellope Von Schweetz, who is more interested in being a go-kart racer than a princess. The only romance in the movie is between a naive handyman named Felix and a tough-as-nails female, Sergeant Calhoun, whose greatest strength is in hunting down giant robot bugs. The villain is the effervescent King Candy, who wears festive pantaloons. Instead of one fantasy world, it's got seven disjointed worlds, ranging from the square and simple to the sharp and hostile to the swirly and delicious. All this is plenty to label *Wreck-It Ralph* "different" in terms of a Disney animated film, but how did such a different film come to be? Answering that question isn't easy and involves everyone and everything—from the director to the story to the crew.

A DIFFERENT KIND OF DIRECTOR

Walt Disney once said, "Our field of entertainment still has many new and exciting and wonderful things to bring to the restless public wanting variety and novelty in the movie theater. The only thing we should fear and be on constant guard against is getting bogged down—getting into the ruts of monotony and timeworn repetitions which the business of entertainment cannot long stand."

Emmy® Award–winning director Rich Moore came to Disney in 2008, bringing with him an edgy animation aesthetic and a bold, risky

sense of humor. But he also had a clear goal that was right in line with Walt's philosophy. Rich explains, "I wanted to add to the Disney Animation canon a film for everyone . . . but for everyone *today*. I wanted it to be fresh and modern and speak to today's sensibilities."

But joining a company deeply rooted in its traditions isn't easy. Producer Clark Spencer explains, "There's a lot of history here at Disney Animation. Many people have been here for a while. There are ways that we do things, so when a new person comes in, you always wonder, 'Will there be moments in time when they're butting heads

because of different approaches?'" So, needless to say, there was a lot of buzz around the building, wondering what "the new guy" was going to do.

And Rich's approach quickly proved to be different. Disney has a reputation for making some of the most appealing characters in animation. But Rich brought something more to the designs that Art Director Mike Gabriel found exciting: "His designs were very funny. So I told the Visual Development group, 'Every design you bring in now, make it funny,' just to see what it would stir up. Everybody was trying new things and getting laughs on everything they were doing. It was really freeing."

But what many of the artists appreciated most about Rich was how he quickly created a comfortable and collaborative environment. He always welcomed new ideas, constructive criticism, and exploration. There was no hierarchy. He only asked that the artists stretch their imaginations as far as they could. Story Artist Josie Trinidad describes the experience: "He encouraged us to really push ourselves. I'd only worked on more-classic fairy tale adventures, which I loved, but they had a singular style. Rich was inviting me to explore and truly be myself in my work."

So the "new guy" not only became known as funny but also a great collaborator and, as Clark Spencer put it when describing Rich as a director, "His different sensibility and approach is opening people's eyes to what Disney Animation ultimately can be."

A DIFFERENT KIND OF STORY

When it came to finding the right screenwriter with whom to develop the story, Rich read a lot of great scripts from some very talented people, but none of them caught him. "Then Director of Development Maggie Malone brought me a script by Phil Johnston," he says, "and I fell in love with the writing and the characters. It was so funny. The story just fired, and propelled me forward." Phil had never worked in animation, but upon meeting him, Rich knew immediately that Phil had the talent he was looking for to develop and write *Wreck-It Ralph*: "He knows people better than anyone I know. His ability to put himself

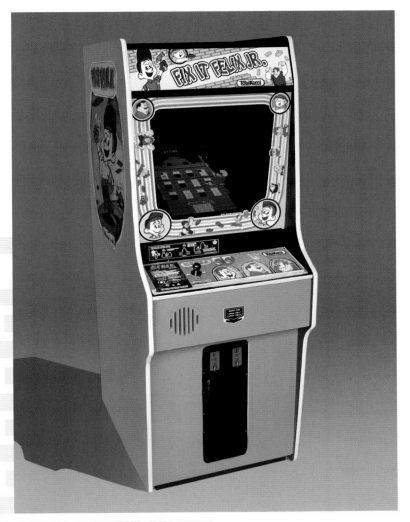

Scott Watanabe / Digital

into the character's mind is amazing. The best comedy happens when something is not just funny but also genuine in a way that everyone relates to. Phil is really great at that."

Phil wasn't sure if he was a fit for Disney, but as he says, "The thing that probably attracted me most to the project was something Rich said to me early on. He said that in twenty years, he wanted people to look back and say, 'How the heck did you ever convince Disney to take a risk on a crazy movie like this?' The idea of pushing Disney's storytelling limits got me very excited."

So Rich and Phil spent several months developing the characters and trying to make a truly modern and original fairy tale. Phil wrote the first draft, and the response was incredible. Story Artist Nancy Kruse remembers her initial reaction: "I thought, 'What a great, crazy story. The characters were appealing but flawed. I like flawed characters that have problems. Cinderella is too nice. I love her, but I'll never be like her. I'm more like Vanellope, so I related to that."

Head of Story Jim Reardon adds, "So many animated films are a little on the snarky side these days. It's best expressed with the character standing there, arms folded and smirking at you. I can't stand that too-cool-for-school idea. There are no characters in this film like that. They all say what they mean and mean what they say no matter how terribly flawed it is. I really like that, and I responded well to it."

Character Design Supervisor Bill Schwab sums up the reaction to the story from a design perspective: "Typically on movies that I've worked on here at Disney, you're defining rules of design and color for one world. But *Wreck-It Ralph* has seven very distinct worlds, each with its own specific design and art direction. It's the most complicated film we've ever designed, but it's worth it for such a great story."

A DIFFERENT KIND OF CREW

After a successful first table read of the script, Clark Spencer came on board as the producer, and it was time to put together a creative team. Rich reached out to experienced Disney director Mike Gabriel to be his art director. Mike had been with Disney for thirty years and had directed such beloved classics as *Pocahontas* and *The Rescuers Down*

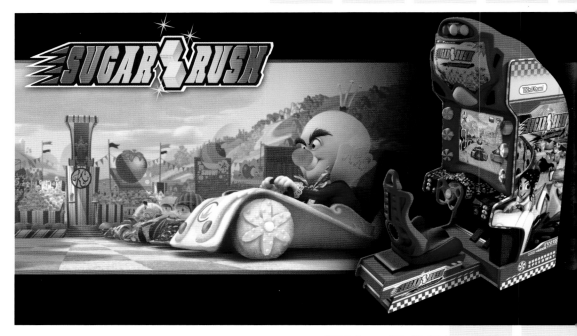

Ryan Lang, Scott Watanabe / Digital

Under. Rich explains, "He had a long tradition here, which I respect. I wanted that eye. He knows what Disney characters should look like and how to get there. He's also steeped in the legacy of the studio. I felt like I needed some of that. I didn't know if he'd be interested, but luckily he said 'yes.'" Rich then mixed it up, bringing in a co–art director whom Rich had known for a long time. "Ian Gooding and I went to school together. He is a guy who knows what things should look like, what makes them look their best, and he gives the look function and appeal like no one I know."

To build his story team, Rich looked to fellow *Simpsons* director Jim Reardon to come on as his head of story. Jim had just co-written Pixar's Academy Award®–nominated script *WALL-E*, but also he had a quirky sense of humor that Rich couldn't wait to bring to Disney. Story Artist Steve Markowski smiles as he says, "To see Jim's humor in a Disney film is a unique treat. Jim can look at everything in life and find ten jokes about it. You'll laugh hysterically at all ten of them. Eight of them you'll throw out because there's no way you could include them in a Disney movie. But you're still left with two pieces of gold."

In the spirit of the film's great mash-up of locations and styles, Jim and Rich added some story artists to the team whom they had worked with on *The Simpsons*, along with some who had worked in videogame development. Jim remembers, "Initially, the worry was, 'Would they mesh well with the story people that have been here at Disney for a long time?' Much to my pleasure the crew has gotten along great, and everybody is contributing, trying to make it funny and touching at the same time."

As the crew grew, Rich and Clark rounded out the Story and Visual Development departments with some of the most diversely experienced talent Disney Animation has ever had—from the best in Layout, Animation, Lighting, and Effects to experts in Modeling, Rigging, and Look. Their work is featured throughout this book and stands as the visual record of all that went into making *Wreck-It Ralph* "so different."

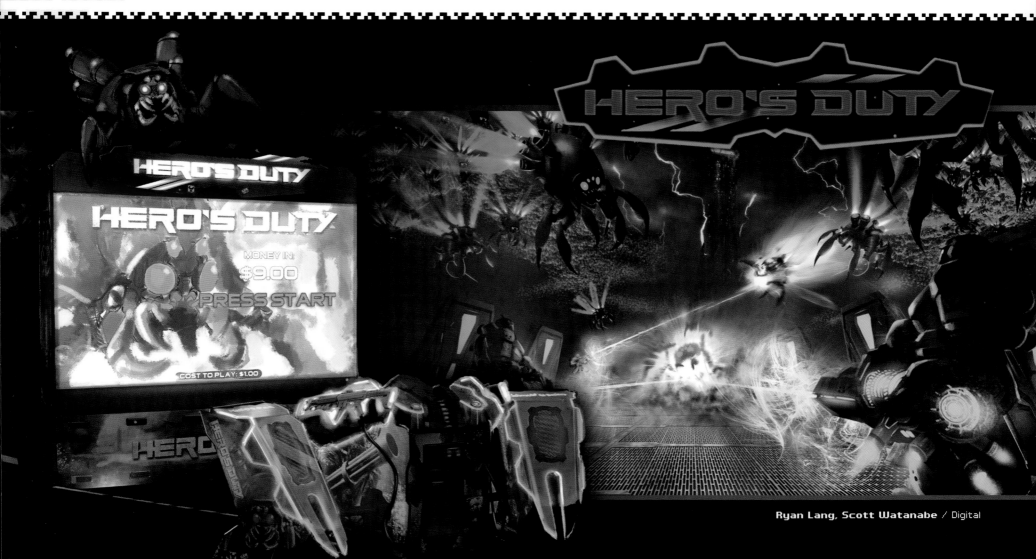

HERO'S DUTY

HERO'S DUTY

HERO'S DUTY

MONEY IN:
$9.00

PRESS START

COST TO PLAY: $1.00

Ryan Lang, Scott Watanabe / Digital

11

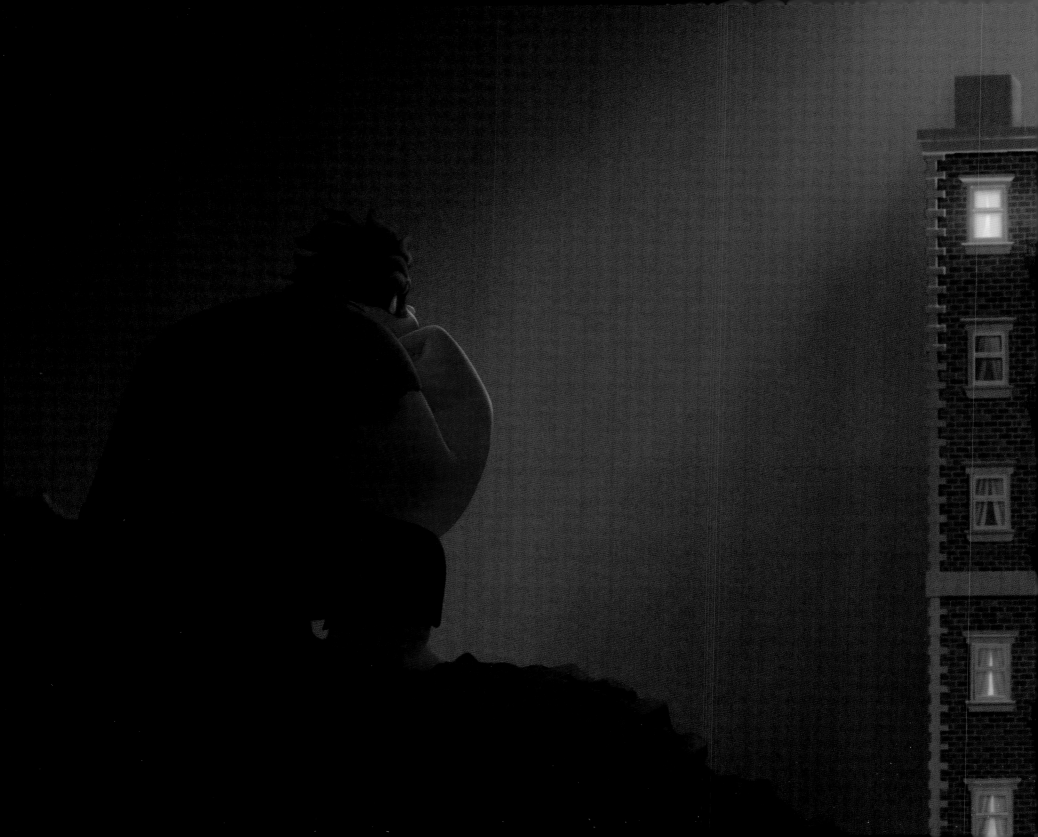

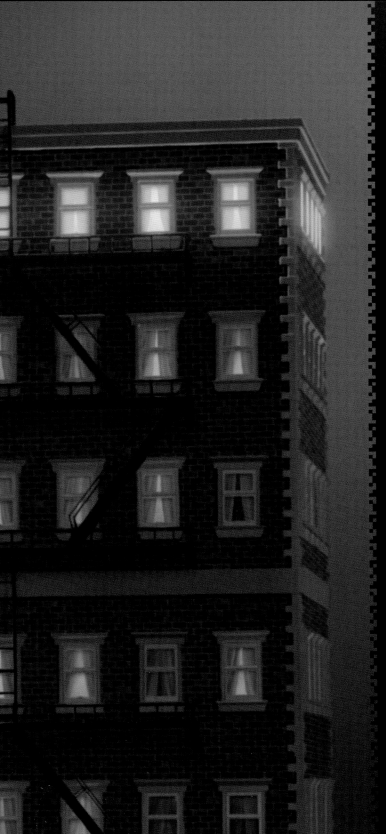

SIMPLE IS NEVER SIMPLE

*W*reck-It Ralph may be one of Disney's most complex animated films to date, but it is in Fix-It Felix, Jr.—the film's most basic '80s arcade game—that we find our protagonist.

From the very beginning, Director Rich Moore knew he wanted the story to center around "the simplest pixelated, 8-bit videogame character, struggling with the complex question: 'Isn't there more to life than the role I've been assigned?'"

Designing the Fix-It Felix arcade console and the look of the game from a player's perspective came together quickly. They went right to a classic platform game with raster graphics and an upright cabinet.

But the real question was: What should the game look like when we pass through the monitor's glass and into Ralph's world? Producer Clark Spencer recalls, "In the beginning we thought, 'Let's keep it simple because that's probably what it would have been if it was 8-bit.'" So the Art department designed a single building on a green lawn with a black sky. Even the lighting fit the game's design. Director of Look & Lighting Adolph Lusinsky describes it as "an inverse of reality. The way you really see things, the dark colors get milky and lighter as they go

Andy Harkness / Digital

Scott Watanabe / Digital

"Yes, we understood what an old classic game looks like in 8-bit, but we've never been able to push through a screen to see what it becomes when it's fully realized. That gave us a lot of latitude in designing it."
—Rich Moore, director

Gooding (Design), Charles Scott (Model), Lance Summers (Look) / Digital

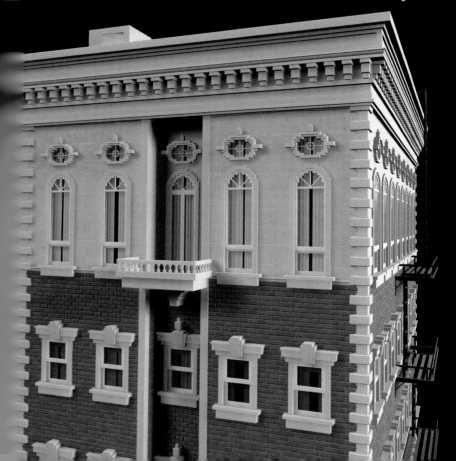

away from you. In Fix-It Felix, we lit it backwards; we put the blackest blacks farthest away and made the closest shadows more luminous."

It was all very true to the 8-bit idea. "Yet we knew it was missing something," says Rich. "It was rather grim and cold. It was not a place we wanted to spend time in or a place we could see Ralph ever being happy to return to in the end."

Then, as Art Director Mike Gabriel remembers, "One of the first images I ever had for the Fix-It Felix world was Central Park at night, with the white lights in the trees and the little bridge over the creek beneath the city skyline. We went back to that." In addition, the team brought in Co–Art Director Ian Gooding. Ian said he noticed right away that "the design was lacking a sense of history. Why is the building there other than just for the videogame?" To him, it was important to treat it like a real world that had a past and not like something that was manufactured. "I gave the building some character. I broke up the facade into different materials, since in real life most brick buildings aren't just all brick. Also, we added lots of variation to the trees, walkways, and street lamps." Finally, that black void of a sky was made more pleasant with the addition of stars.

The creative team then knew they had something special. Mike describes the response: "We all got much more excited about the idea that when you go behind the glass of the game, you're in a fully realized world that has richness and fullness, and tells the audience, 'This is not a videogame. This is a film.'"

Andy Harkness / Digital

Andy Harkness, Lorelay Bove / Digital

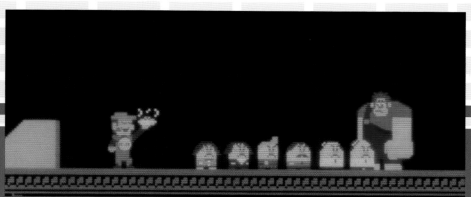

Wayne Unten, Joe Pitt / Digital

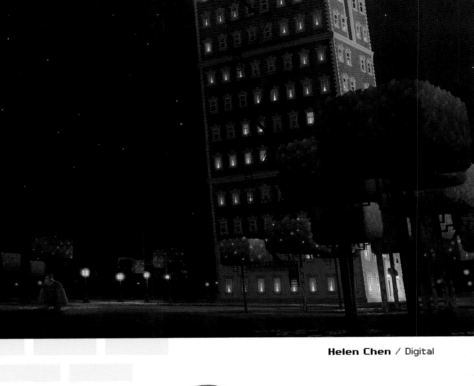

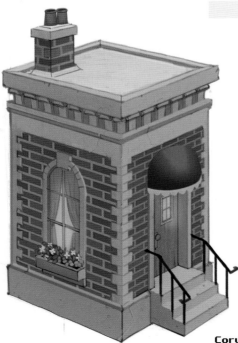

"Fix-It Felix evolved to a more complex world that has a warmth and a charm to it. It was about going in and actually placing some lights and some trees so it feels a little bit more like, 'Oh, there's a park there.' Beyond the building there's a bridge that we sense goes somewhere."
—Clark Spencer, producer

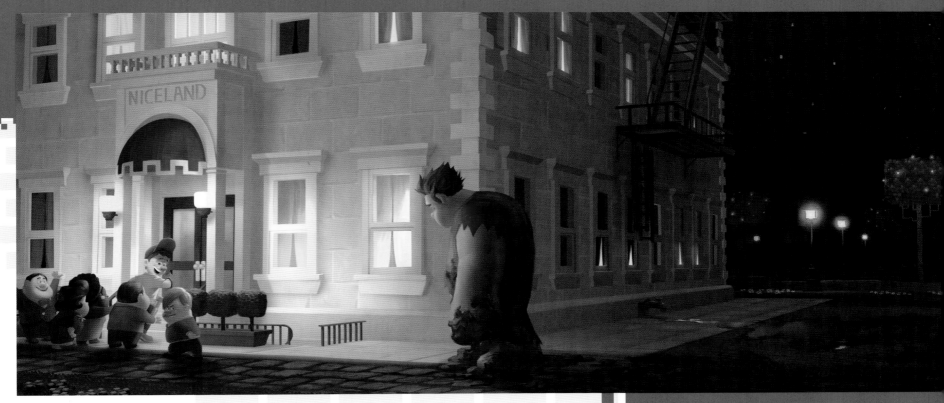

Helen Chen / Digital

Lighting Key / **Jorge Obregon** / Digital

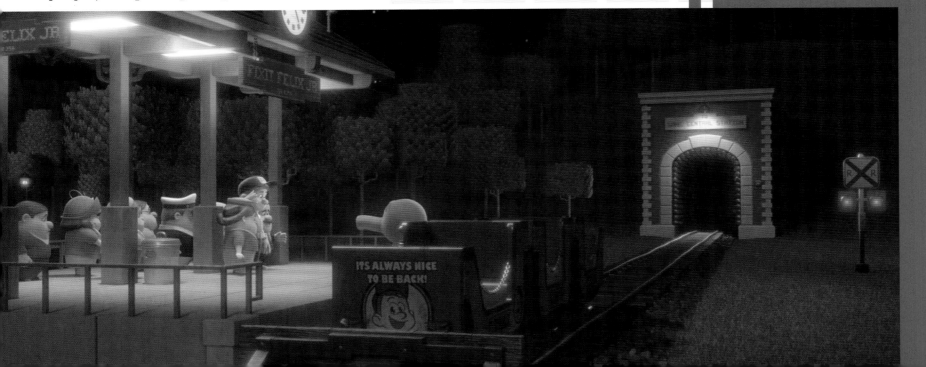

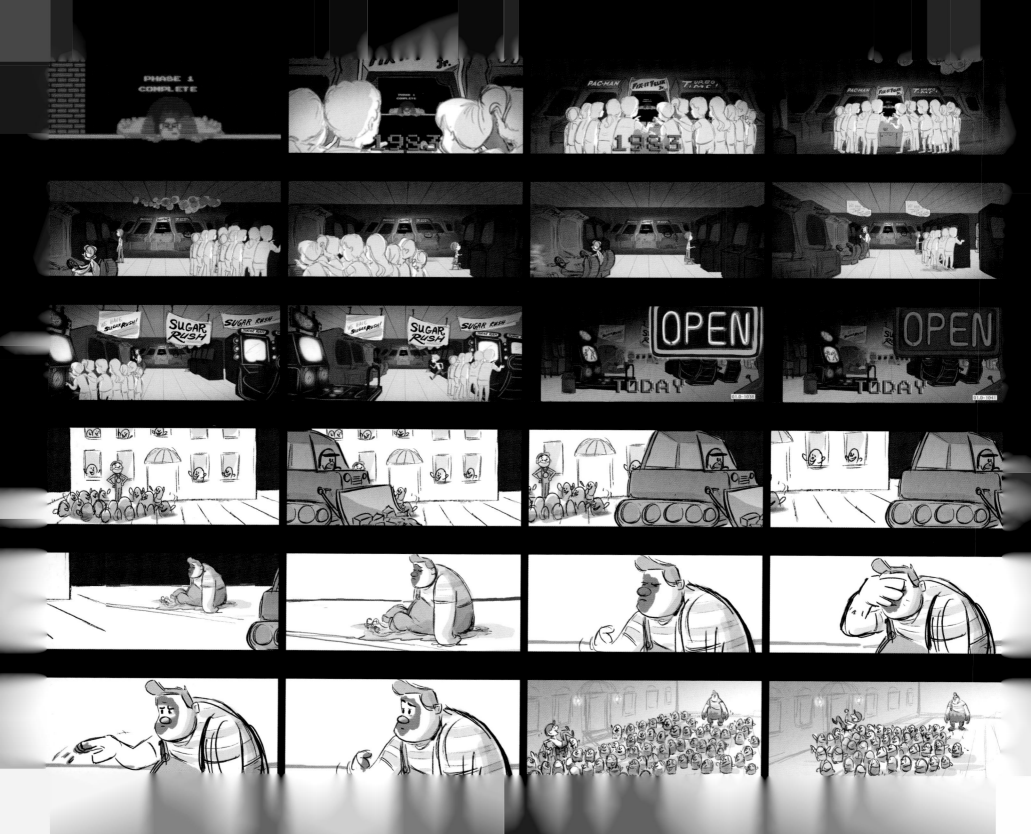

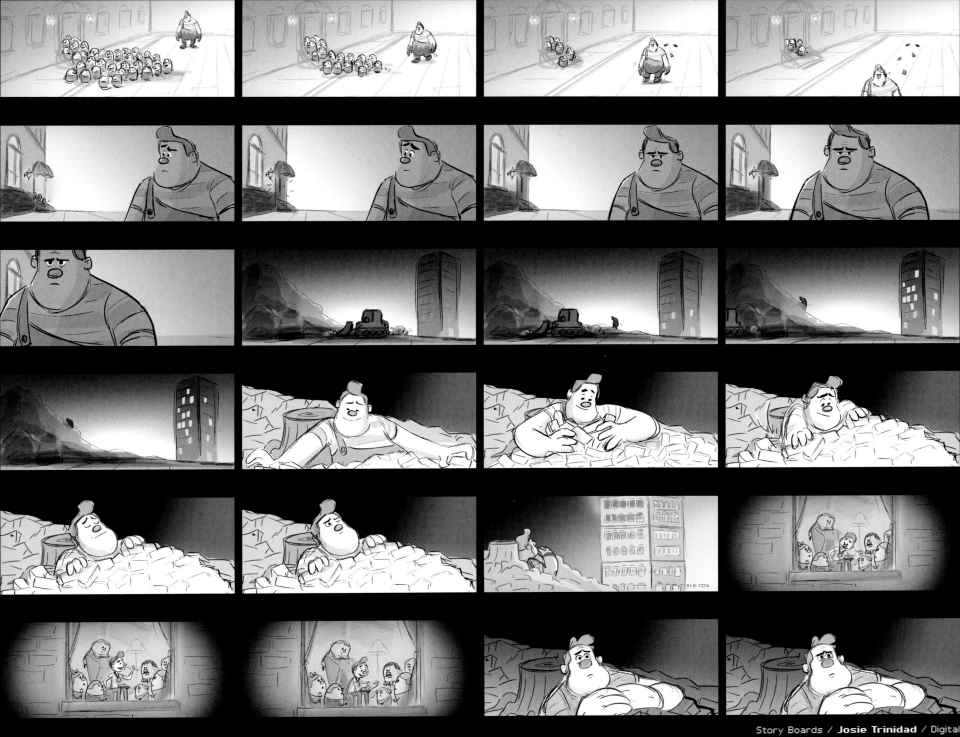

WRECK-IT RALPH

When it came to designing Ralph, Rich explains, "We were always calling Ralph a brutish lout. The challenge was figuring out what a brutish lout looked like."

That proved no easy task. The creative team started with what they knew about him. Until he was uprooted by the development of the Niceland Apartments, Ralph lived a simple mountain life and slept in a tree stump in the woods. There were some early versions where Ralph was a troll. Then he was a monster, then an ogre, then a shambling caveman. He had wrecking balls for hands, then a horn on his head, then bunny ears. He was a Sasquatch, a gorilla, and for about a week he was even a bulldozer. Screenwriter Phil Johnston imagined Ralph as: "part cat, part baboon, part dog, part skunk, part weasel, tapir, pig, wild boar, one-forty-third ape."

Rich met with John Lasseter to discuss which animal would make the most sense for a middle-aged, down-on-his-luck, angst-ridden character such as Ralph. Only one animal really fit: a human. "We then thought, what if you take a human character and put huge fists on him, because that's what would be important to him in terms of wrecking?" recalls Clark. "That's when we really started to gain ground on Ralph's design."

The next challenge was the push-and-pull between what felt appealing but was also true to the pixelated look of a classic 8-bit videogame. Initially they tried to break him into actual squares, but while that worked conceptually and was funny, it was difficult to read Ralph's emotions. As Head of Story Jim Reardon explains, "We discovered that you can't make Ralph so basic in his design that the design itself distracts your eye throughout the movie." So they swung the other way and went for realistic, and Ralph quickly became more relatable.

Daniel Arriaga / Digital

Zach Petroc (Model),
Ryan Duncan and **Sheri Wong** (Look) / Digital

But when the animators began building Ralph in CG, they noticed a problem. As Head of Animation Renato dos Anjos explained, "What CG does really well is round things off and soften them." The design was losing the 8-bit feel entirely. Rich recalls: "Ralph became too soft and his design was no longer saying anything about where he came from." So they added back in some strong planes to his shape. They squared off his hands, feet, shoulders, and jaws. They gave him a more aggressive posture and a more staccato gait, and, as Rich Moore puts it, "That's when we hit the sweet spot. We had our Ralph."

But through the many stages of Ralph's physical development, there was one thing he always was—the bad guy who wrecked things.

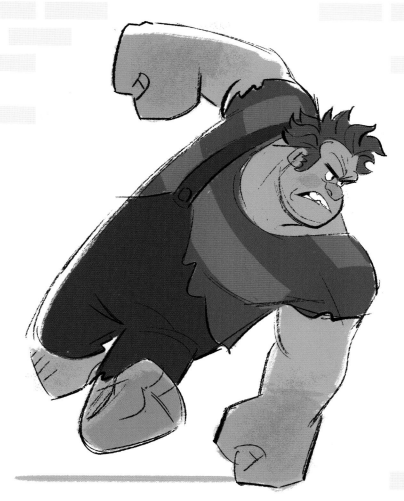

Bill Schwab / Digital

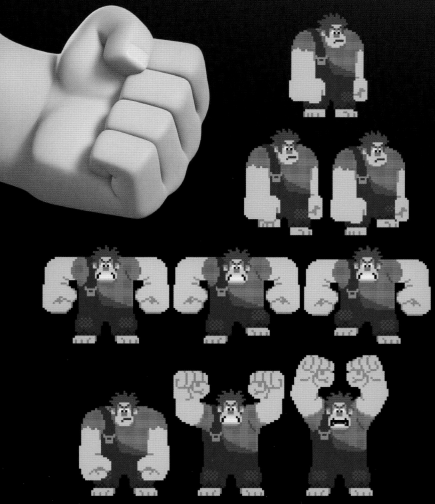

Wayne Unten / Digital

Bill Schwab / Digital

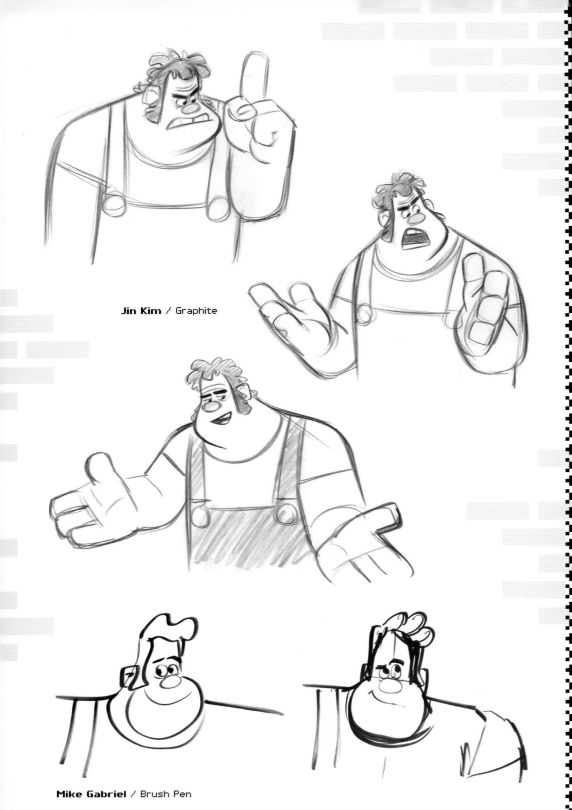

Jin Kim / Graphite

Mike Gabriel / Brush Pen

Bill Schwab / Digital

"He's a big, square, heavy lug. He's naive and innocent in a way. He's sheltered. He has a short temper, and he has a really good heart. He has to just feel like somebody recognizes that in him."
—Mike Gabriel, art director

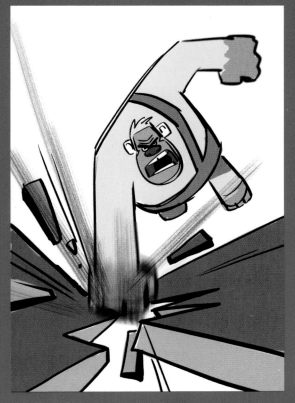

Jin Kim / Digital

Jin Kim / Digital

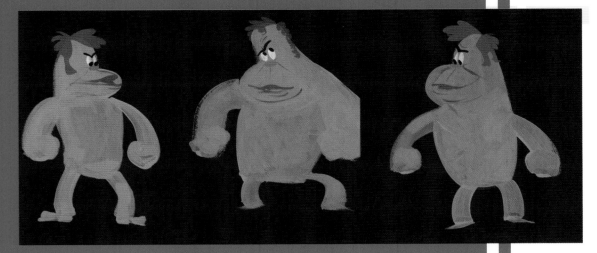

Mike Gabriel / Liquid Acrylic

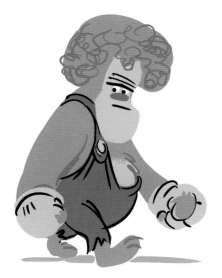

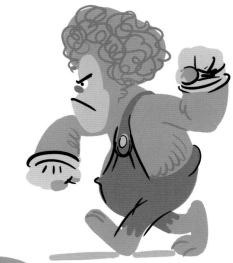

Mike Gabriel / Digital

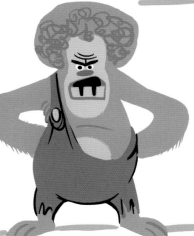

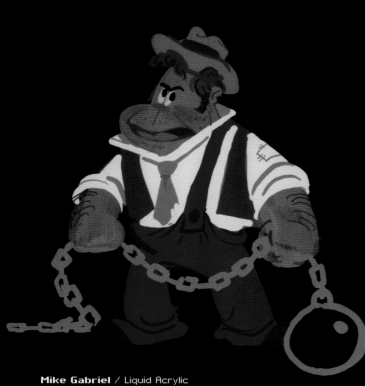

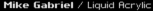

Mike Gabriel / Liquid Acrylic

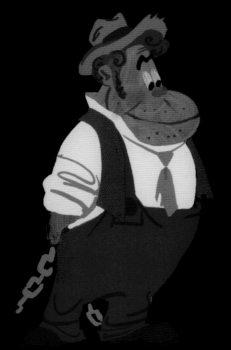

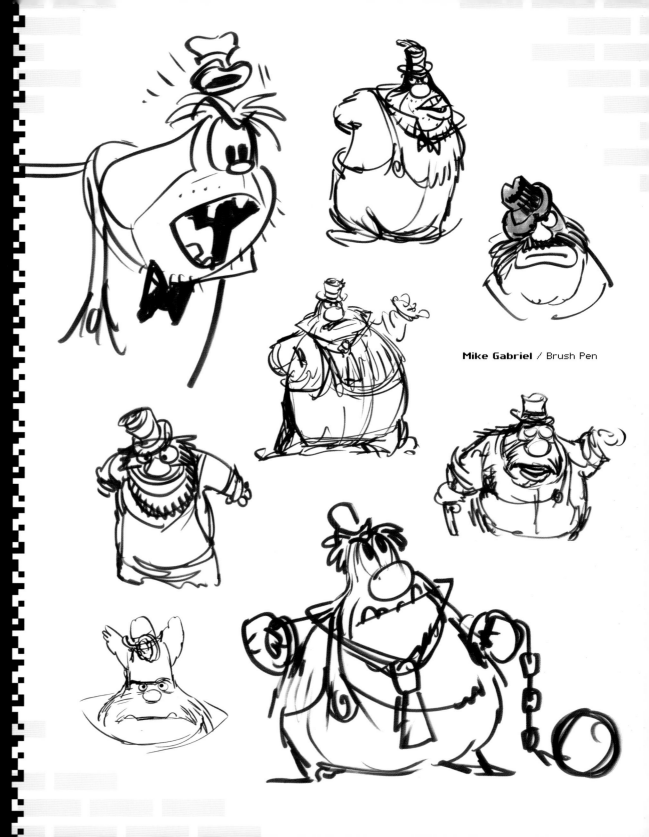

Mike Gabriel / Brush Pen

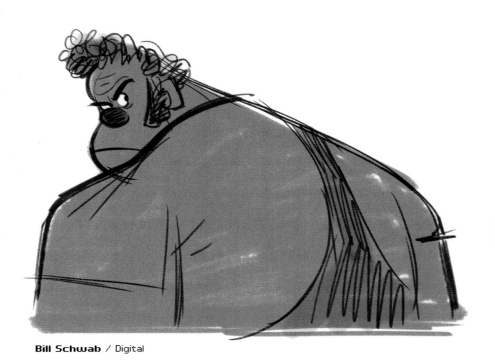

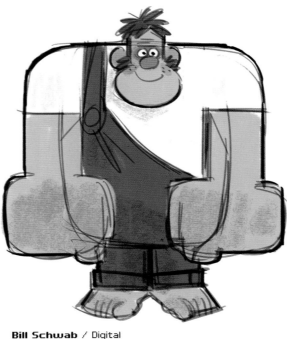

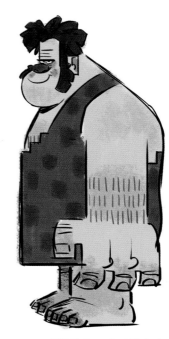

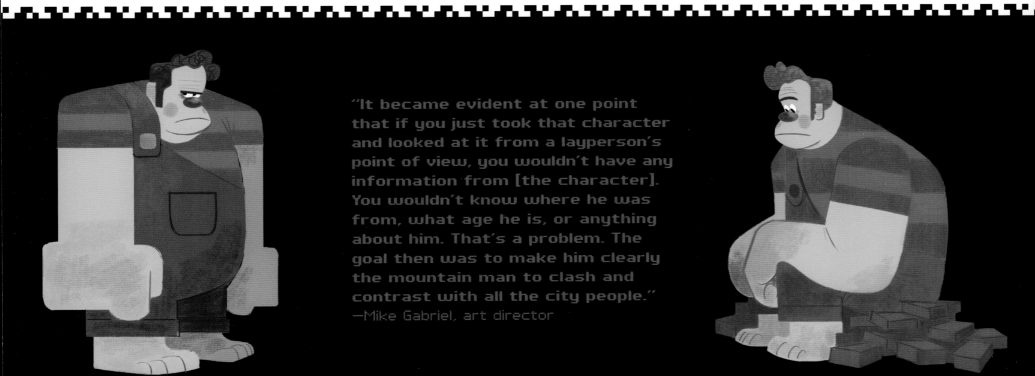

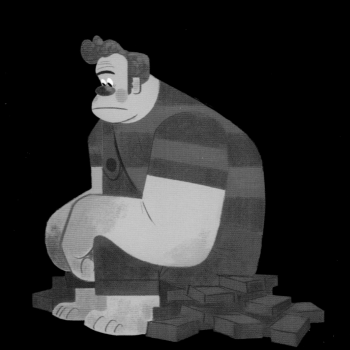

"It became evident at one point that if you just took that character and looked at it from a layperson's point of view, you wouldn't have any information from [the character]. You wouldn't know where he was from, what age he is, or anything about him. That's a problem. The goal then was to make him clearly the mountain man to clash and contrast with all the city people."
—Mike Gabriel, art director

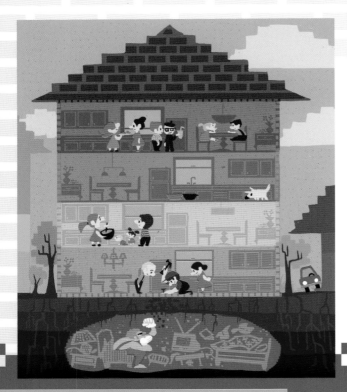

Bill Schwab / Digital

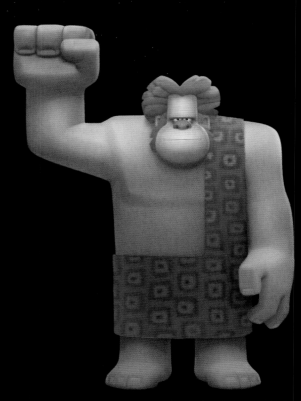

Andy Harkness / Digital

Claire Keane / Digital

Bill Schwab / Digital

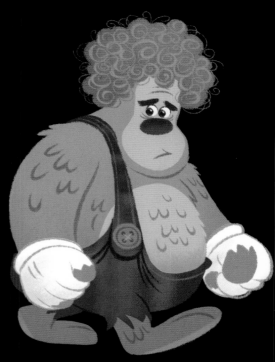

Daniel Arriaga / Digital

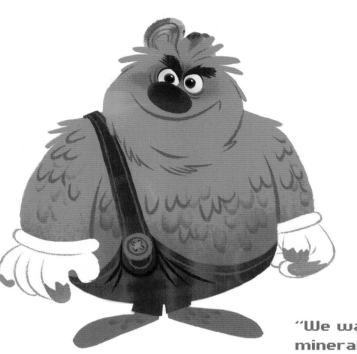

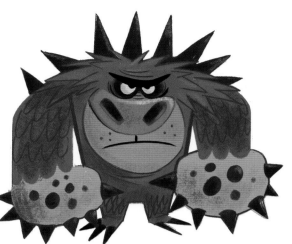

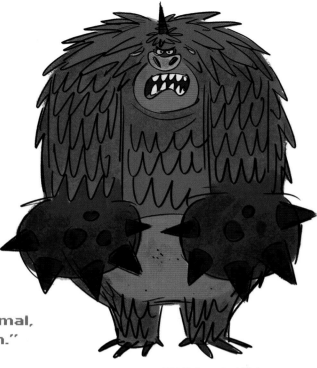

Daniel Arriaga / Digital

Bill Schwab / Digital

"We wandered in different directions: animal, mineral, monster, tractor, yeti, Sasquatch."
—Mike Gabriel, art director

Bill Schwab / Digital

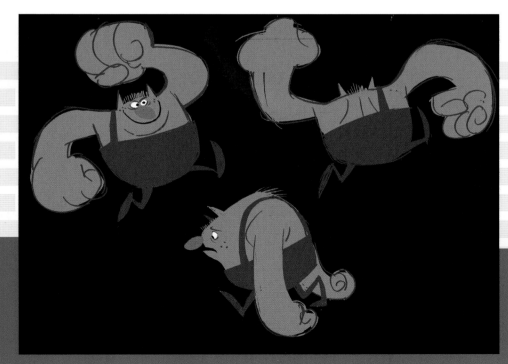

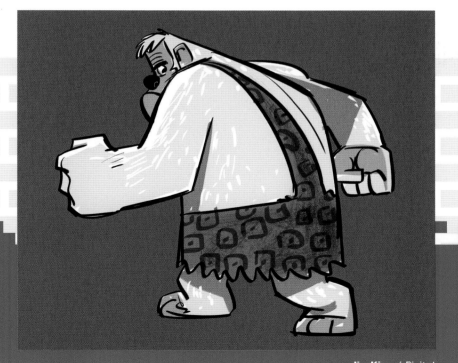

Bill Schwab / Digital

Jin Kim / Digital

FIX-IT FELIX, JR.

Unlike Ralph, the general look of Felix came together quickly. He was always human and, as Mike Gabriel says, "Rich had a clear idea of Felix as a really likable, funny guy, sort of Steve Carell in *The 40-Year-Old Virgin*, Richie Cunningham from *Happy Days*, and Mario from *Donkey Kong*, all rolled into one."

Story Artist Leo Matsuda's funny drawings really helped capture all of that. Leo explains, "I saw this guy from a society that is very basic and elementary. To me, he's naive and pure, like a boy from the farm, and that's the only thing he knows." Nice-guy Felix had a baseball hat, hammer, tool belt, and work boots. He didn't need much more than that and seemed finished.

But when translating Felix's design to CG, Renato says, "We discovered that there was something about Felix's proportions that was off. We had a hard time moving him. His head was way too big. Also, his profile looked awkward and not very appealing. We tried different angles, but nothing felt right."

It was a change in the story that helped Felix "find his legs." Initially, Felix was going to spend the movie tagging along with Ralph like a buddy. But then the blooming love between Calhoun and Felix could not be denied, and "as soon as he was paired with Calhoun," says Character Design Supervisor Bill Schwab, "Felix became much easier to design." He needed to look mature enough to carry a romantic subplot. Animator Mark Henn did some new drawings of Felix, giving him longer legs, stronger arms, and an older look. The visual development artists then pushed Felix's features to be more like the voice talent, Jack McBrayer, and his face found the appealing look it needed.

Daniel Arriaga / Digital

Eryn Katz and **Chad Stubblefield** (Model),
Ryan Duncan and **Michelle Robinson** (Look) / Digital

Wayne Unten / Digital

28

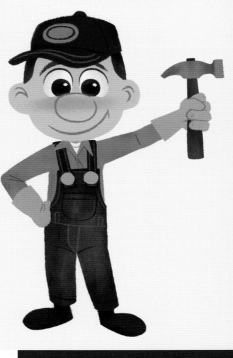

Daniel Arriaga / Digital

Jin Kim / Graphite

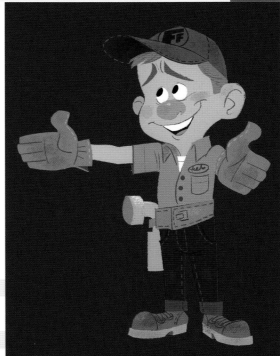

Bill Schwab / Digital

Daniel Arriaga / Digital

"It's a very difficult thing to pull off because you want these characters to move like a Disney character and be very believable in the way they act and move, but also bring you back to that 8-bit world of simple characters and stylization."
—Renato dos Anjos, head of animation

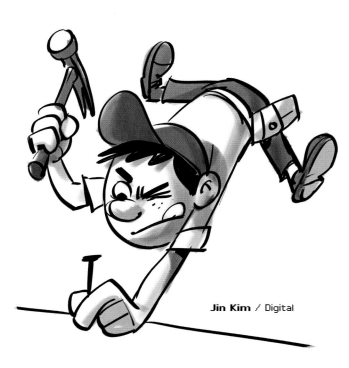

Jin Kim / Digital

Daniel Arriaga / Digital

Bill Schwab / Digital

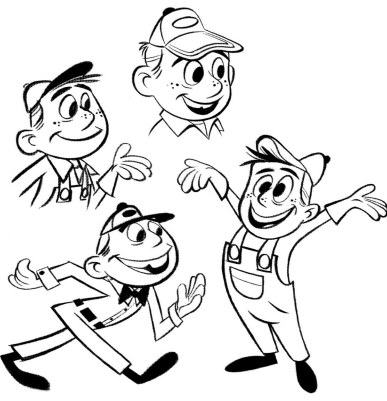

Daniel Arriaga / Digital

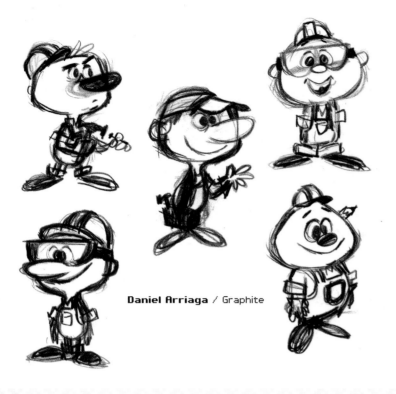

Daniel Arriaga / Graphite

Tom Ellery / Digital

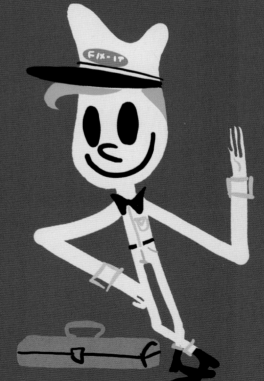

Mike Gabriel / Digital

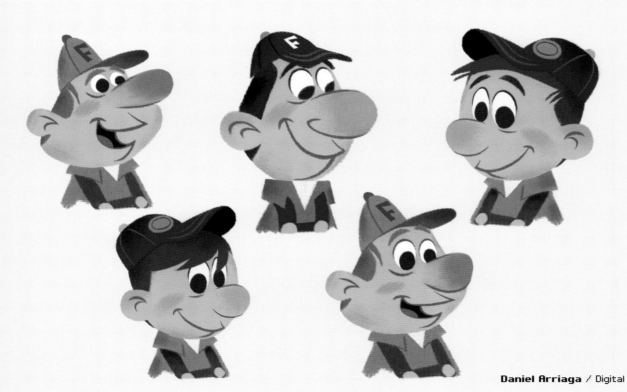

Daniel Arriaga / Digital

THE NICELANDERS

"Weebles and Fisher-Price People Meet Knots Landing." —Rich Moore, director

In the beginning, the Nicelanders were basically just thumbs with eyes. The initial idea was to keep them simple. Jim Reardon describes them: "They looked the same, talked the same, and acted almost as one unit." They got a lot of laughs, but it was hard to imagine how their opinions could matter to Ralph or the audience. John Lasseter and Ed Catmull challenged the story team to treat the Nicelanders more like real people.

Story Artist Leo Matsuda ran with that, as his colleague Lauren MacMullen remembers: "In a scene Leo was boarding, the building started to shake. All of a sudden, we cut inside to see one of the Nicelanders rush to keep a vase from falling, and we thought, 'Oh, they have possessions. They have things they care about.' It was exciting to realize that a character designed to only be seen at a window during gameplay had some kind of interior life."

Backstories for the Nicelanders started popping up, and their designs became more individualized. There was the guy who made ships in a bottle (Don), the guy with a lot of cats (Norwood), the pastry connoisseur (Mary), and the worrier (Roy). Each one became a distinct character, and one of them in particular would not be ignored. . . .

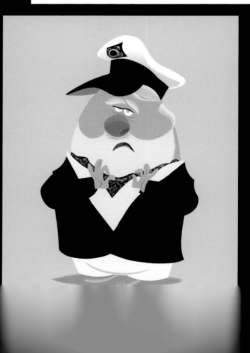

"The Nicelanders are a little challenging because they're really stocky. Any time you move their shoulders they're intersecting something. Sometimes what looks really simple on a design is very tricky on the CG side."

Bruce Smith / Digital

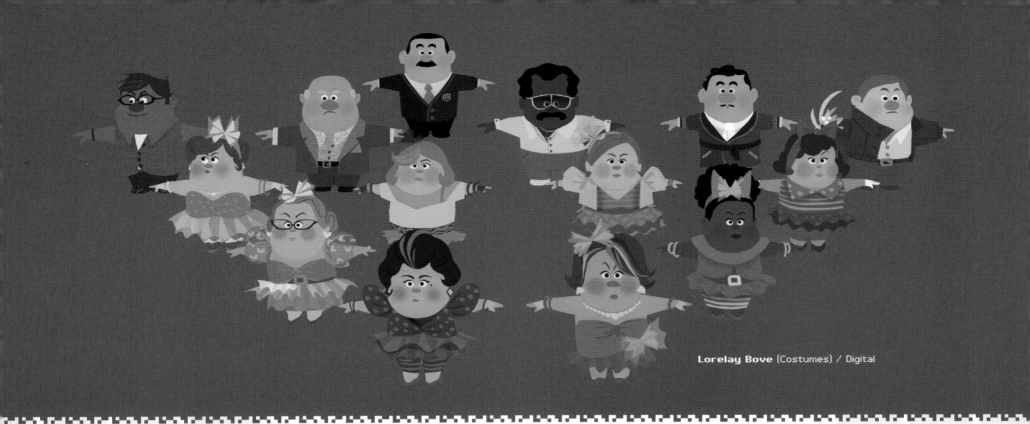

Lorelay Bove (Costumes) / Digital

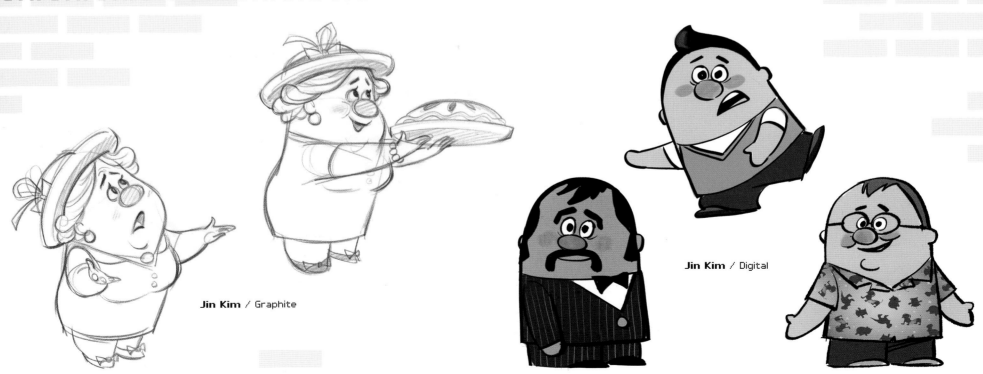

Jin Kim / Graphite

Jin Kim / Digital

GENE

Joe Pitt, Doug Bennett
Digital

Story Artist Raymond Persi remembers the "birth of Gene": "Bill Schwab did a design of one of the Nicelanders with a little mustache. I was really inspired by it because it reminded me of this producer I'd worked with in the past. I drew him as the mayor of Niceland. He became a spokesperson for the Nicelanders, and once he stepped out of the crowd, he never went back." Raymond went on to storyboard all of Gene's and the Nicelanders' main scenes. In addition, Rich says, "since Raymond understood Gene so well, we had him voice Gene in the scratch recordings." Interestingly enough, he gave such a great performance that the filmmakers could think of no better person than Raymond to voice fastidious Gene in the final film.

"It would be nice to imagine after having lived through this movie what Gene would have to say about it. It certainly wouldn't be positive."
—Lauren MacMullen, story artist

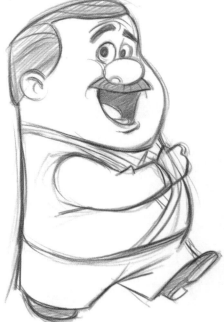

Jin Kim / Graphite

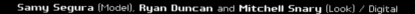

Samy Segura (Model), **Ryan Duncan** and **Mitchell Snary** (Look) / Digital

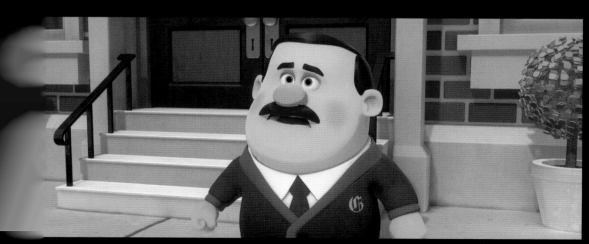

Lighting Test / **Jorge Obregon** / Digital

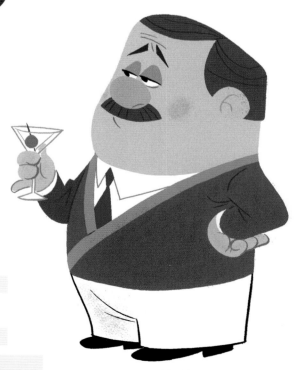

Bill Schwab / Digital

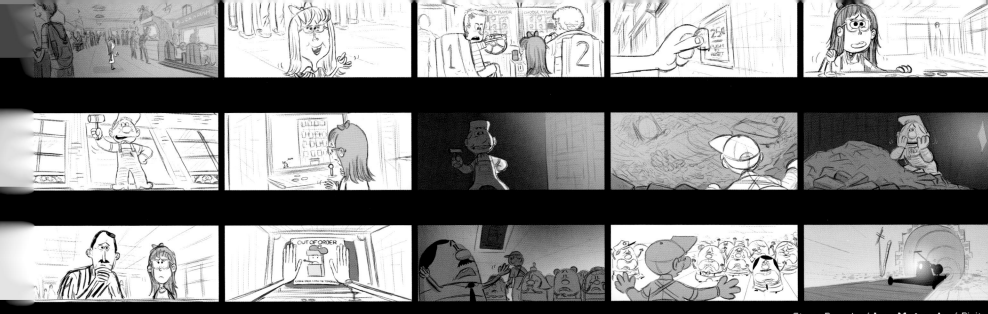

Story Boards / **Leo Matsuda** / Digital

Color Key / **Lorelay Bove** / Digital

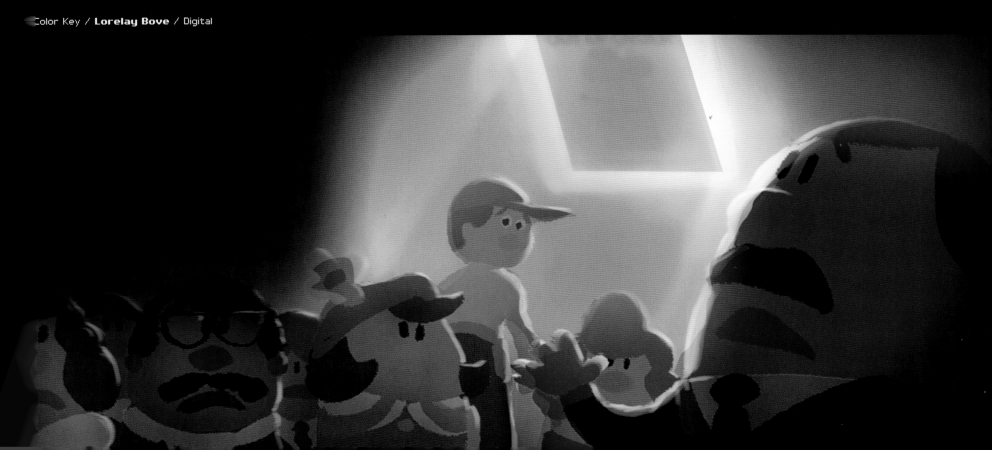

"Ralph, if you win a medal, we'll let you live up here!"
—Nicelander Gene

The creative team knew that the Penthouse had to be an inviting place to contrast with Ralph's lonely brick pile. But they also wanted it to be a space not built for a guy Ralph's size. The original designs had very low ceilings. It supported the physical comedy of Ralph struggling to fit, but it became distracting and took away from the idea of the Penthouse as something special and a place where Ralph could actually live.

So Ian Gooding approached the Penthouse the same way he approached the design of Niceland—to support the story and the 8-bit style but also to feel real and swanky. He explains, "I designed the entranceway with a low ceiling and a raised floor, so when Ralph enters he can't stand up. But then the apartment opens up like a grand loft space with soaring ceilings, which looked very appealing and was true to modern penthouse designs."

To invoke the 8-bit feel, Ian went with a contemporary style which is very angular, but also, he discovered "when you take contemporary furniture by famous designers and squash it to fit the short legs of the Nicelanders, it looks really fun and silly, which is great."

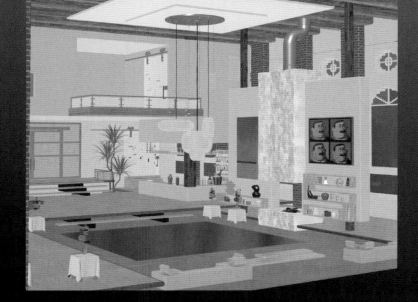

Ian Gooding (Design), **Charles Scott** (Model) / Digital

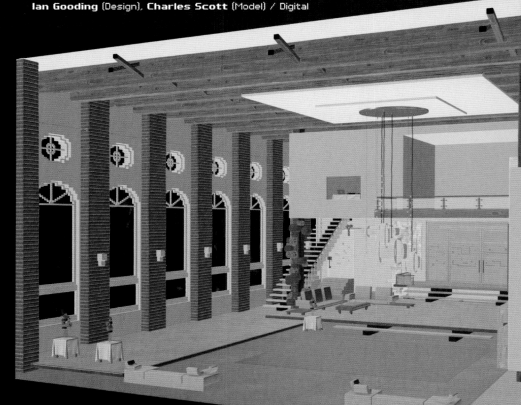

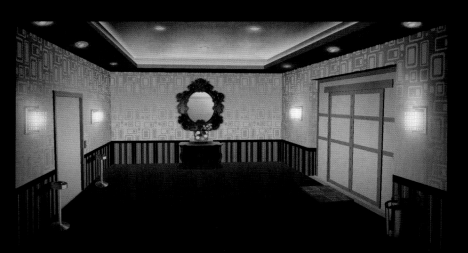

Justin Cram, Ian Gooding / Digital

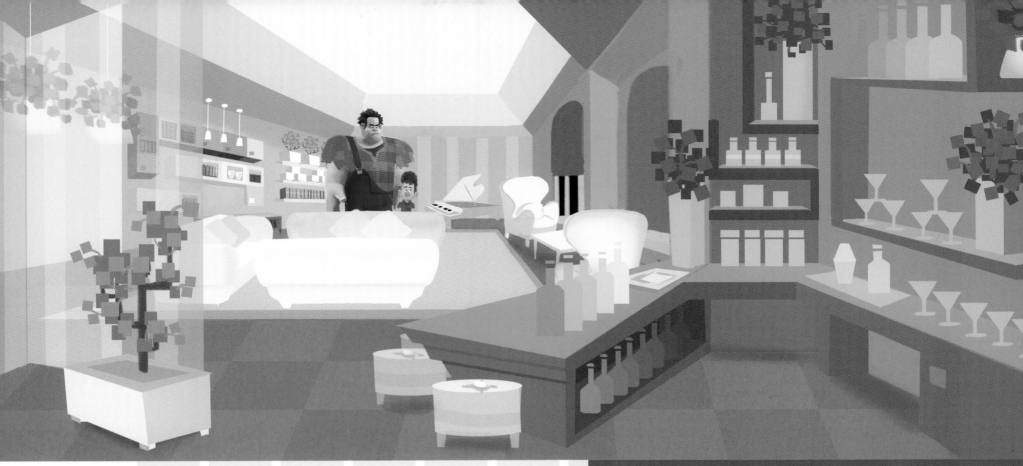

Lorelay Bove / Digital

"If you look at a downtown loft space, you can see the old brick. They don't hide the fact that it used to be an old building on the inside as well. It's nice to see the two things together rather than just unrelated and arbitrary."
—Ian Gooding, co-art director

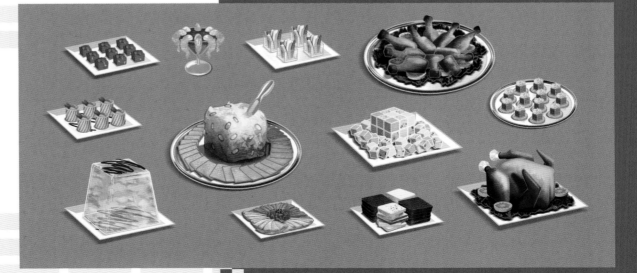

Justin Cram / Digital

Justin Cram / Digital

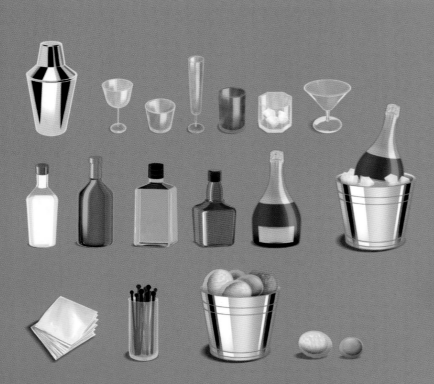

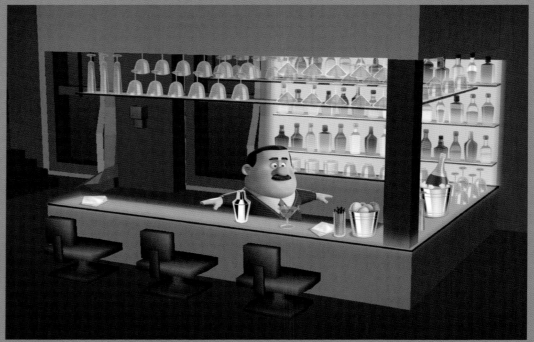

Justin Cram / Digital

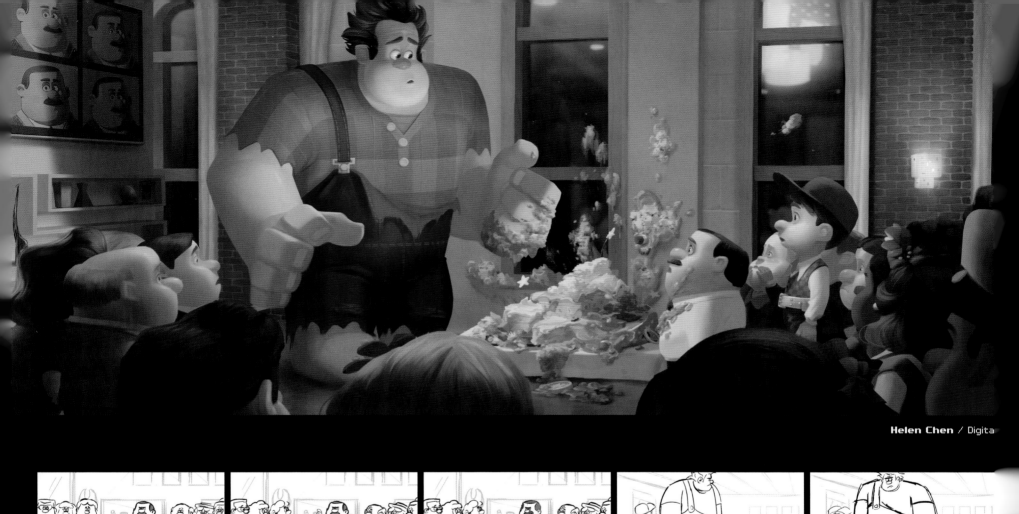

Helen Chen / Digital

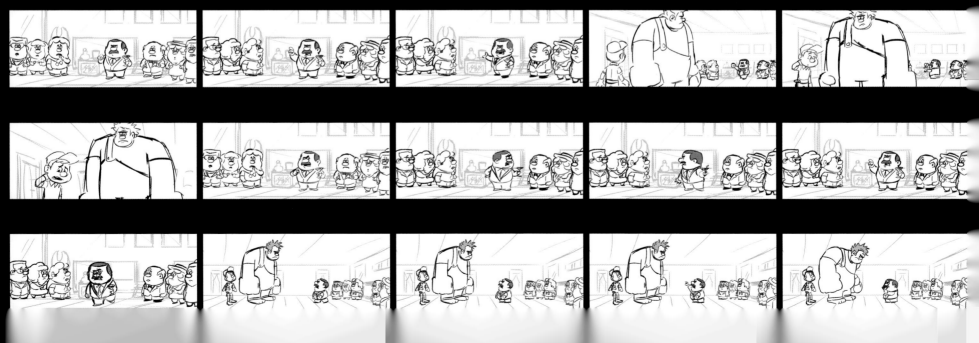

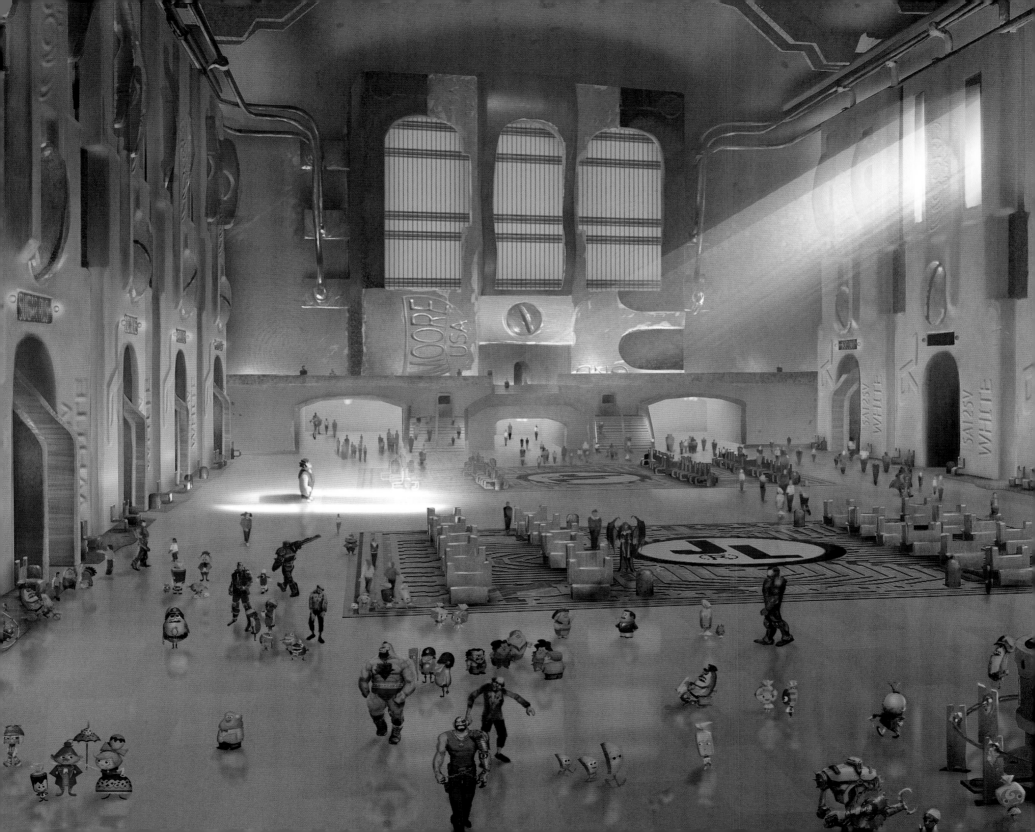

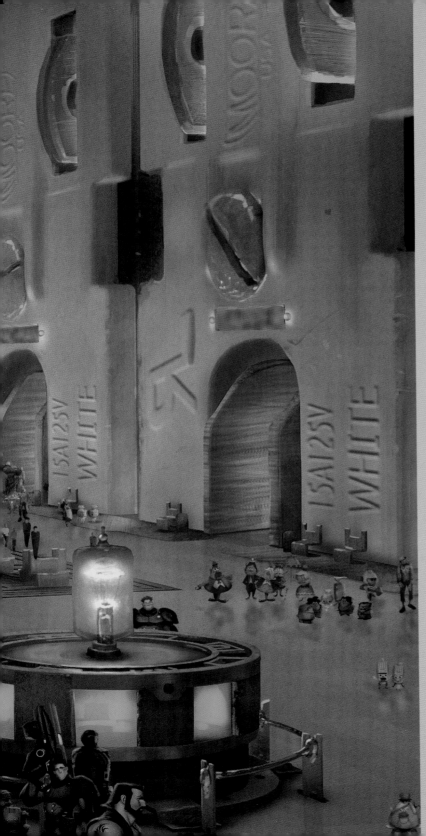

GAME CENTRAL

CREATING AN ARCADE UNIVERSE

While having Ralph and Felix journey from game to game was part of the original concept of Rich Moore's film idea, figuring out how the videogame characters actually got there is another story.

"At one point early on," recalls Phil Johnston, "Ralph and Felix were going to go through the toilet and come out in another game, as if it was a vortex. Finding something that made sense and had game logic was a big deal."

Rich and Phil started playing around with the idea of a power strip as a transportation hub, envisioning their characters physically traveling through the cords and connecting in one central location. This seemed a believable way to yoke together all the game worlds into one arcade universe, but the concept didn't feel completely inspired.

The idea to fuse electrical outlet architecture with a train station came up one day when Rich and Phil were walking down the street in New York City, where Phil lived. "We thought, what if the plugs were like the portals in Grand Central Station?" recalls Phil. "It's bustling and hustling, and it's gorgeous."

Ryan Lang (Design), **Jim Finn** (Crowds / Blocking),
Minh Duong (Model), **Lance Summers** (Look) / Digital

TRAIN STATION MEETS POWER STRIP

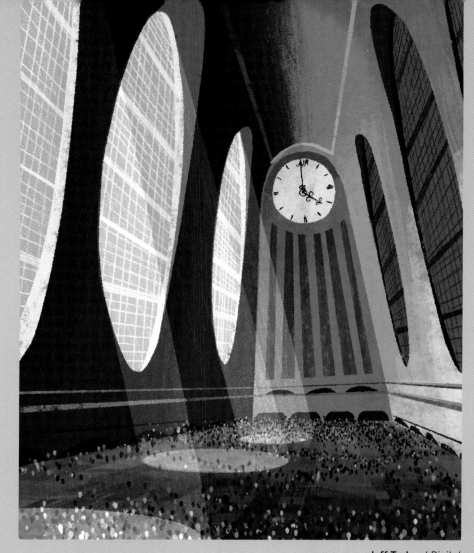

Jeff Turley / Digital

Finding the design balance between power strip and train station was tricky. "In the very beginning we were going too industrial and electrical," Clark Spencer explains. "The characters were going to walk on electricity. Though it makes sense, we were overthinking it. Then, we moved toward the idea of it being much more like Grand Central. We even sent our visual development team on a research trip to Manhattan, to take a hard-hat, behind-the-scenes tour of the station. A ton of great details came out of that trip and informed our designs. At that point we brought John in and he said, 'Well, now it's just a train station and you've lost what's interesting about it being an actual power strip.'"

Ultimately, Visual Development Artist Ryan Lang helped find the design sweet spot by going to the source—literally. He studied the insides of half a dozen cracked-open power strips. "People kept stopping by my cubicle, warning me not to plug them in," he recalls with amusement. And what he discovered was this: "The inside of a power strip is surprisingly bare"—not unlike the cavernous central hall of a train station.

"Ryan did brilliant work," Mike Gabriel says, "finding the language in there that makes it feel authentic." "Now," adds Clark, "it reads as the interior of a power strip, even if you don't know what that looks like."

"Game Central went through various attempts to be logical. If we tried to be logical with it, we always ended up in this weird sci-fi realm. When we got too elegant with it, it didn't feel right. When we got too creepy and gritty, it wasn't a place you wanted to be. It had to be cleaned up a little bit and lit like Grand Central Station."
—Mike Gabriel, art director

Ryan Lang / Digital

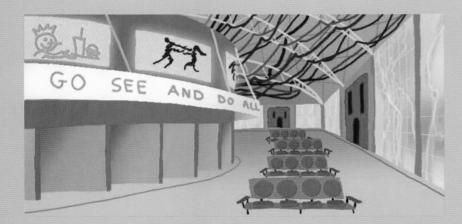

Ryan Lang / Digital

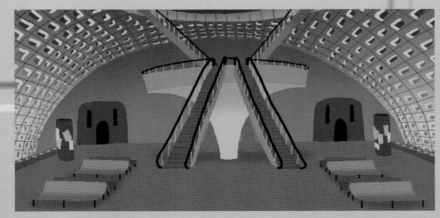

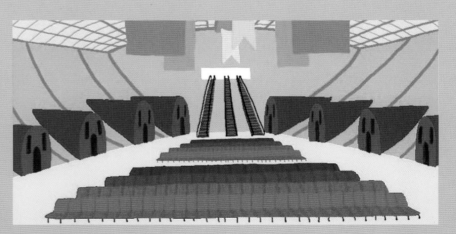

Doug Walker / Digital

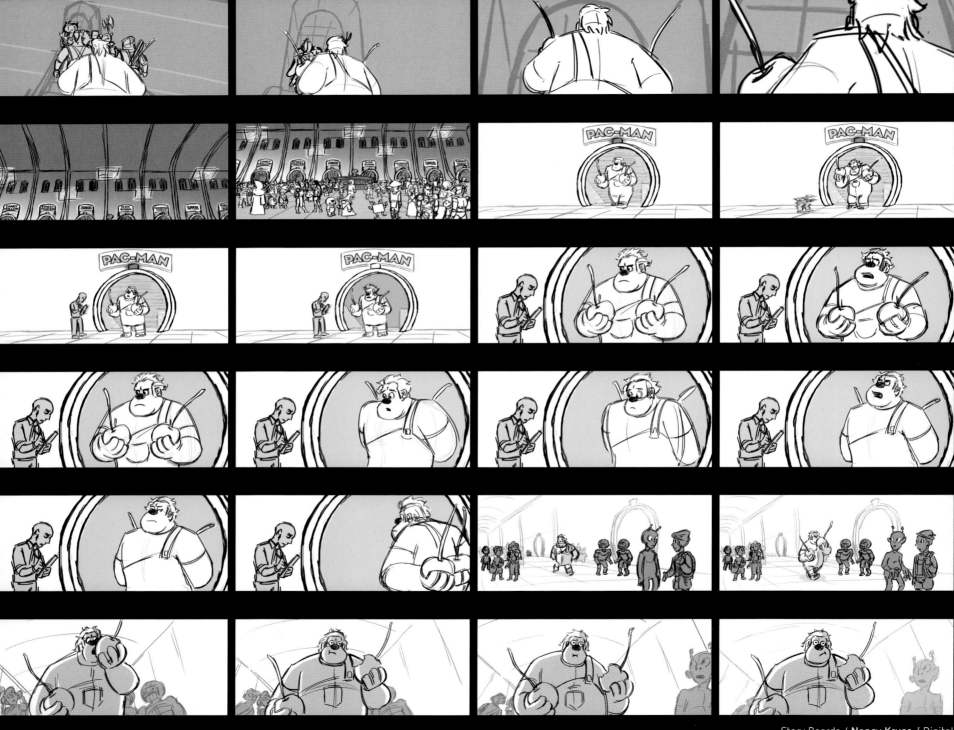

Cory Loftis / Digital

Jeff Turley / Digital

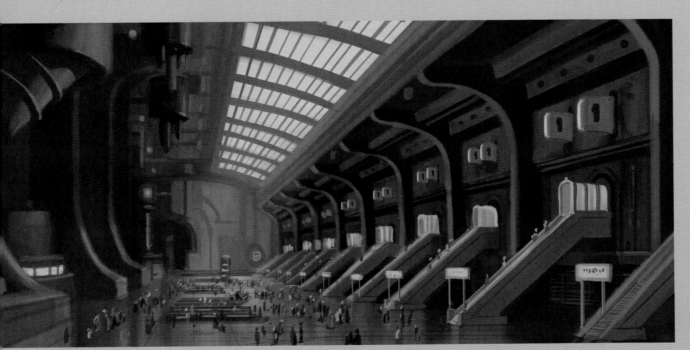

James Finch / Digital

"I've always loved this world because it's such an interesting conceit. What you didn't know was that crummy industrial power strip is really a transportation hub for all characters to go visit all of the games. The moment I heard that being pitched, I was totally invested in this movie."
—Clark Spencer, producer

47

TRANSPORTIVE LIGHTS

Inspired by elegant black and white photos of Grand Central from the 1930s, Ryan then took Game Central and figured out how to light the set to give it the same warmth and lived-in feeling of New York's iconic station. To reinforce the believability of this transportation hub world, Adolph Lusinsky, director of Look & Lighting, then came in to give the space a sense of hustle and bustle. "Our goal for Game Central was to make this world feel really busy, like there's a lot of motion," he explains. The lighting team accomplished this task by using low raking lights that cast flickering shadows on the walls.

Adolph and his team also used volumetric light, informally called "God rays," to imbue the space with a sense of gravitas and elegance. When a game is unplugged in the film story and put "out of order," heavenly rays filter through the empty outlet sockets that translate into windows within Game Central. It's a beautiful effect that reinforces the feeling that these videogame characters are indeed alive.

Comparing the initial conception of the arcade's transportation hub with its execution on screen, Phil concludes, "Game Central Station is one world that is exactly what I hoped it would be, but the artists took it and made it infinitely better."

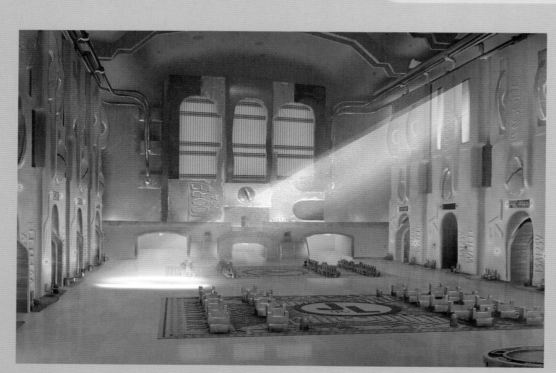

Ryan Lang / Digital

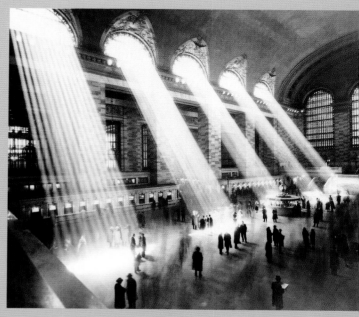

New York Grand Central Terminal / *Photo by Hal Morey, 1930*

Ryan Lang / Digital

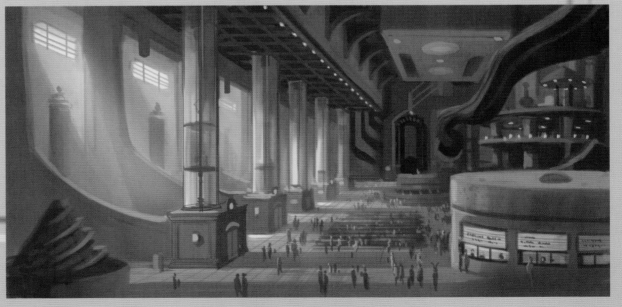

"Grand Central is gorgeous,
just like in those iconic photos
of the station from the 1930s,
with the 'God light' shining
through the vaulted windows."
— Phil Johnston, writer

James Finch / Digital

"It's pretty awesome to animate game characters that you knew as a child. It's like living in a dream world. All your favorite heroes and villains are in your hands."
—Renato dos Anjos,
 animation supervisor

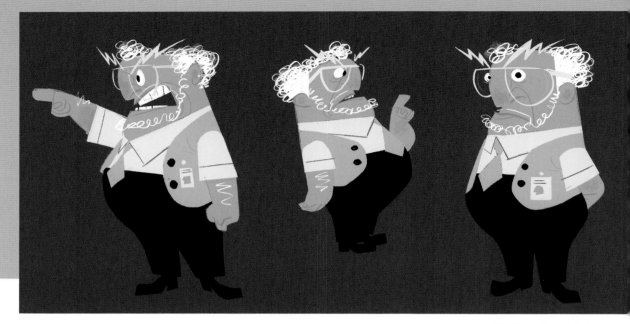

Bill Schwab / Digital

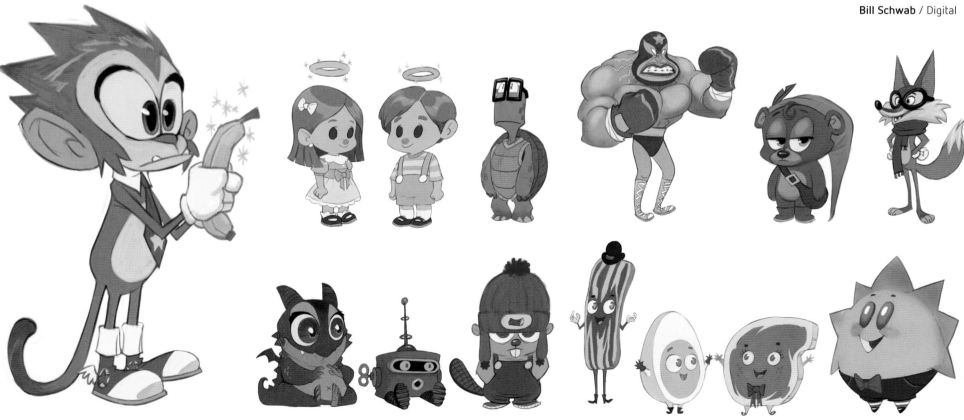

Cory Loftis / Digital

48

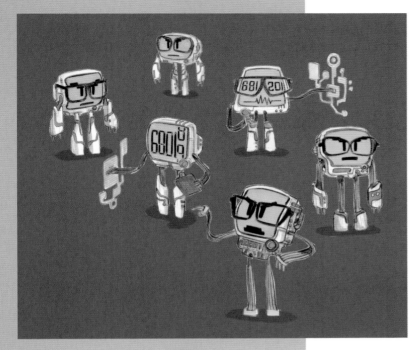

Scott Watanabe / Digital

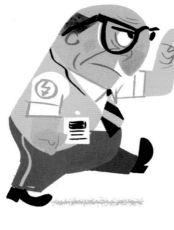
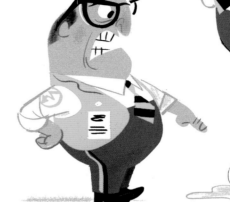
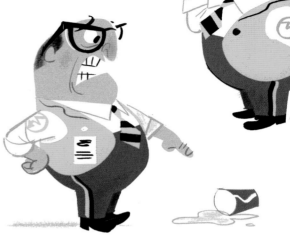

Bill Schwab / Digital

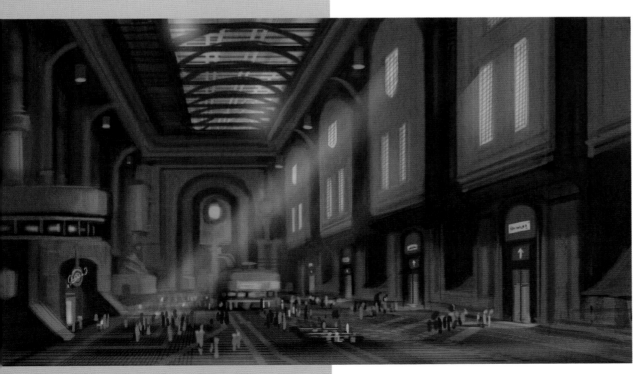

James Finch / Digital

Cory Loftis / Digital

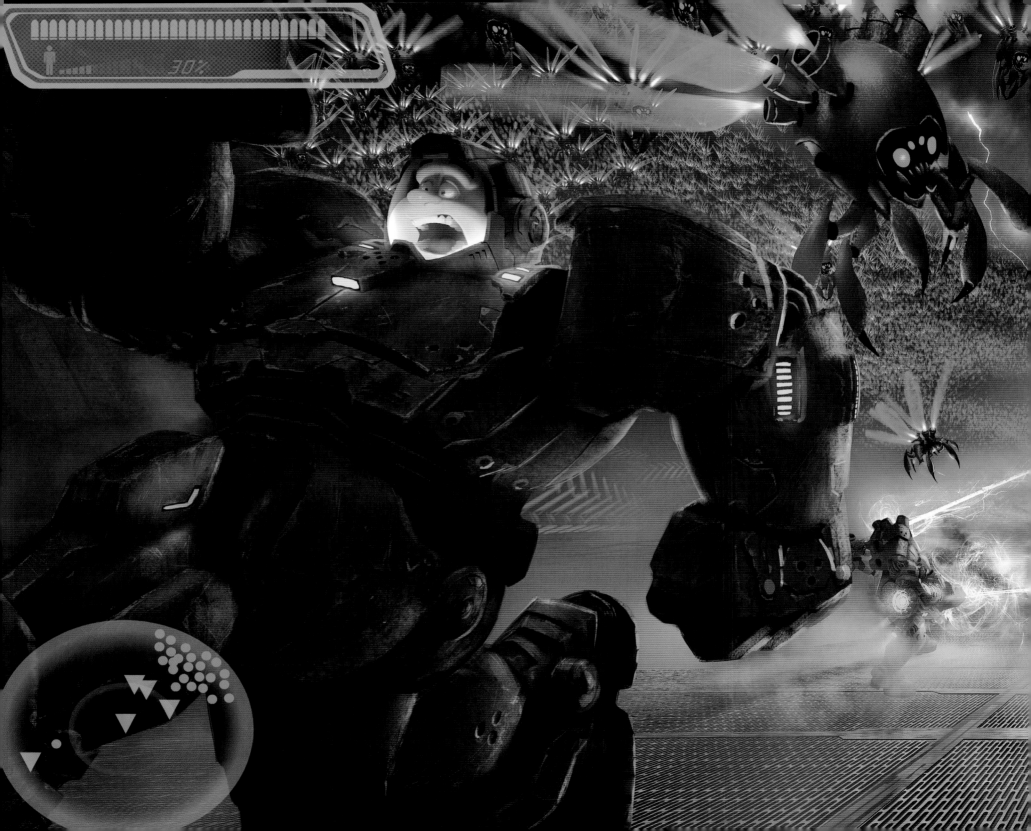

30%

HERO'S DUTY

AN ARTIFICIAL INTELLIGENCE EXPERIMENT GONE HORRIBLY WRONG

"THE KEYWORD FOR HERO'S DUTY IS HOSTILE." —MIKE GABRIEL

From the start, the creative team loved the idea of a 1980s 8-bit game character infiltrating a modern, high-definition game. They were inspired by realistic, first-person shooter games like Halo, Gears of War, and Mass Effect. But such games were incredibly complex and involved years of development. As Mike Gabriel explained, "These game designers are brilliant. They've been doing it for a generation now. We were jumping into an intimidating league." Hero's Duty had to stand up to the best in the genre, while also feeling fresh and new. So it stands to reason that of all the games in the movie, the look of Hero's Duty took the longest to nail down.

From a story perspective, a futuristic, science-fiction world seemed the best contrast to the classic style of Fix-It Felix, Jr. The team imagined that in Hero's Duty, the scientists hated nature and had turned the planet into a "thing," building the landscape out of caustic materials. To capture that, Mike Gabriel started with shapes. Where Fix-It Felix, Jr. embraced squares and perpendiculars, Hero's Duty would utilize triangles and diagonals, which, as Rich Moore said, "really fit the idea of chaos, broken edges, violence, and wind."

Ryan Lang / Digital

51

Mike then worked with architects Edgar Bove and Andres Fuentes, who focused on the game's 99-story building. Bove and Fuentes provided sketches inspired by contemporary, multi-faceted skyscraper designs. Mike Gabriel recalled: "It was so exciting to see the level of complexity and detail in these designs. My mind kind of went, 'Wow, this is what we should be doing—to contrast Fix-It Felix—a world of hostility multiplied upon itself.'" Disney Artists Cory Loftis and Ryan Lang expanded on Bove and Fuentes's ideas and designed a building that looked like it had clawed its way out of the twisted land around it, beaten by wind, abandoned, infested, and a near impossible climb to the top.

When it came to animation, Renato dos Anjos said his team decided that it all came down to gravity: "In Fix-It Felix gravity is less of a deal. Felix jumps around like gravity barely exists. But the world of Hero's Duty has a lot of gravity. Every movement has to fight against the atmosphere." Finally, to further deepen the intensity of the world, the team desaturated the colors of Hero's Duty almost to the point of black and white, with only accents of green. The end result truly is a hostile world, where only the most desperate 8-bit game character would dare to tread.

"HERO'S DUTY IS THIS HYPER-REALISTIC, INTENSE WORLD THAT FROM A LIGHTING AND DESIGN STANDPOINT WILL BE AMAZING, ESPECIALLY IN CONTRAST TO THE WORLD OF FIX-IT FELIX, JR. SEEING THAT WORLD COME TO LIFE WITH THE BUGS AND THE BIG ATTACK SCENE THAT'S GOING TO BE IN IT, THAT'S GOING TO BE UNBELIEVABLE."
— CLARK SPENCER, PRODUCER

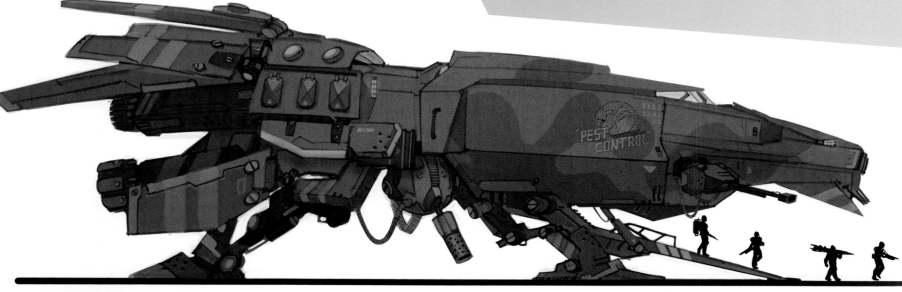

Cory Loftis / Digital

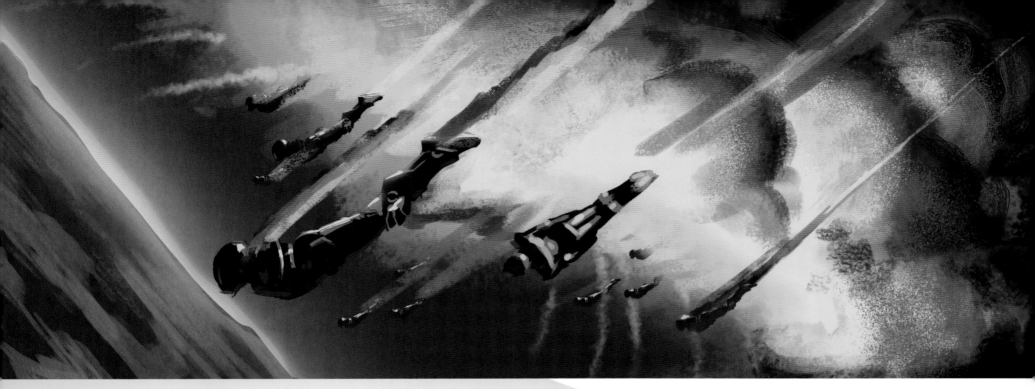

Ryan Lang / Digital

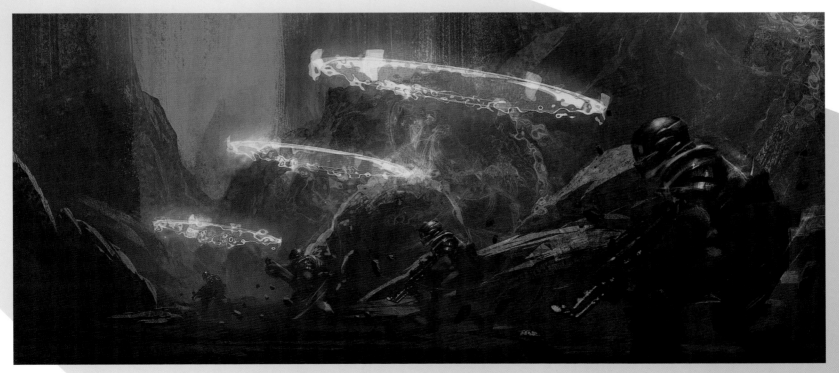

Ryan Lang / Digital

Justin Cram / Digital

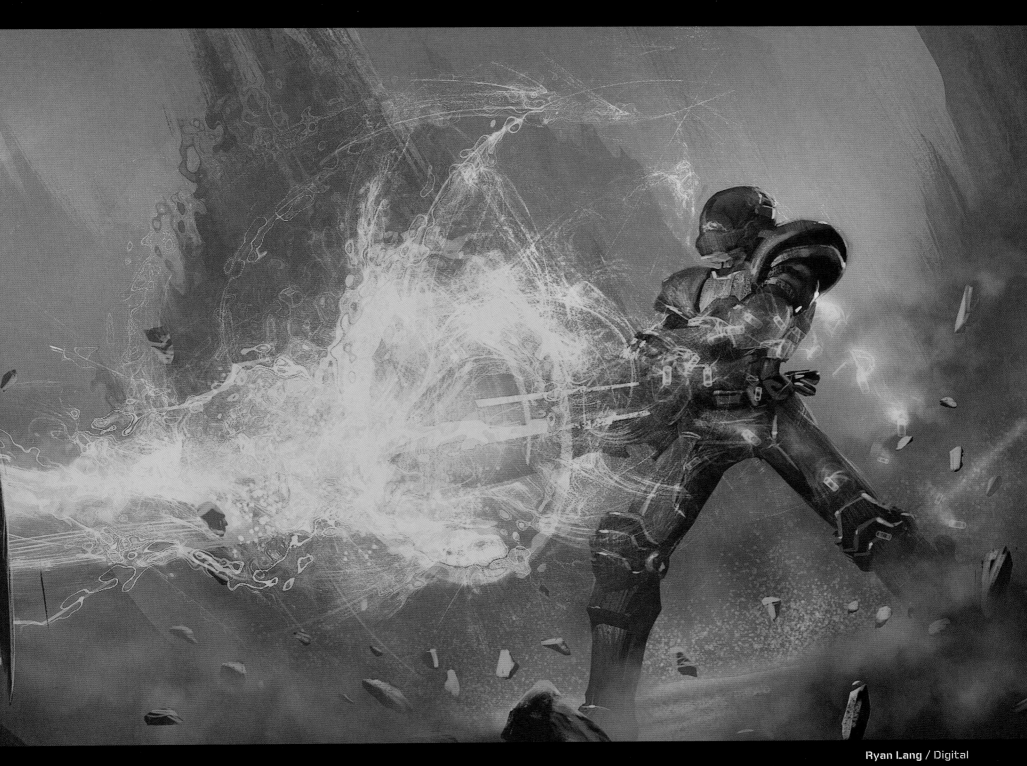

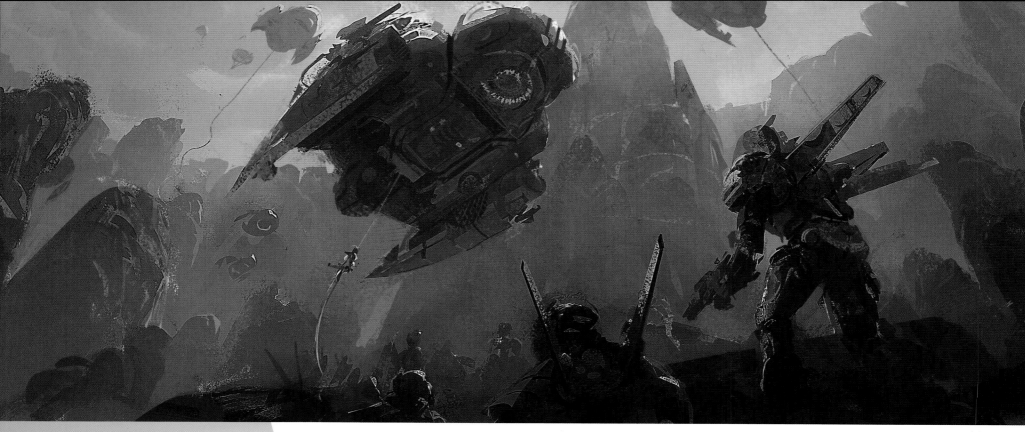

Jeff Turley / Digital

Minh Duong (Model), Cory Loftis (Paintover) / Digital

"AS FAR AS THE OVERALL HEAVY ATMOSPHERE, THE REASON THEY DO THAT IN FIRST-PERSON SHOOTERS IS BECAUSE THE FASTER THINGS BUILD UP WITH ATMOSPHERE THE SIMPLER THINGS CAN BE AS THEY GET AWAY BECAUSE YOU CAN'T SEE MUCH."
—ADOLPH LUSINSKY,
 DIRECTOR OF LOOK & LIGHTING

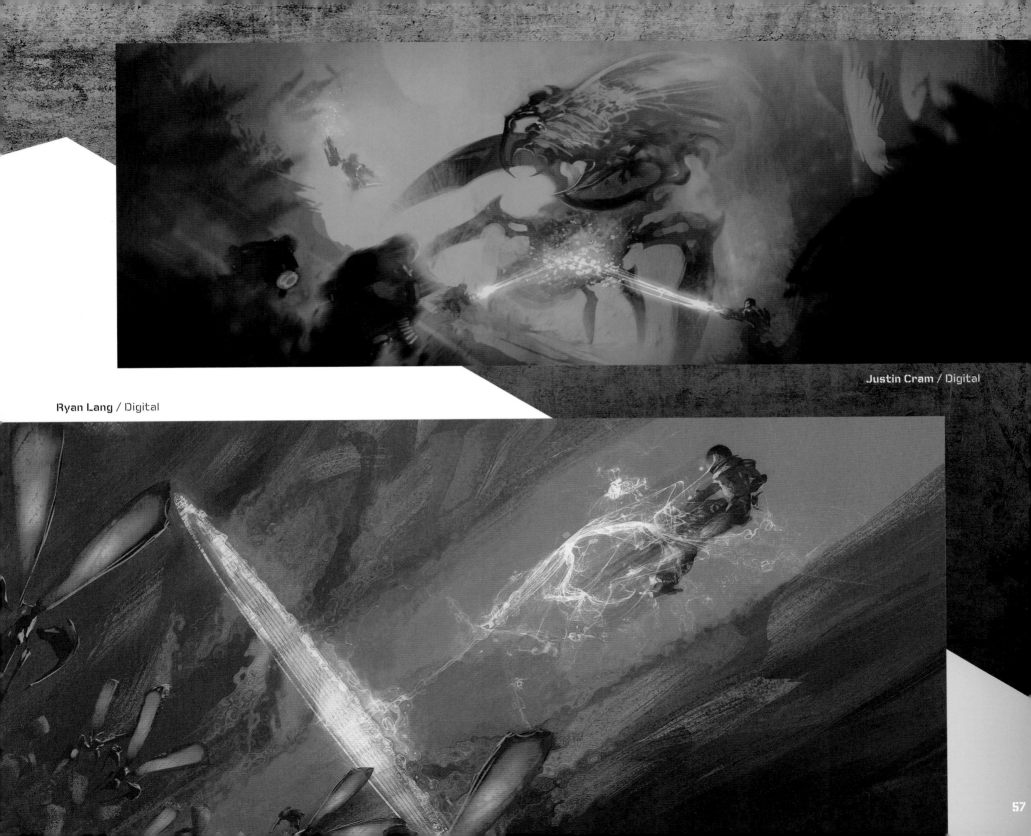

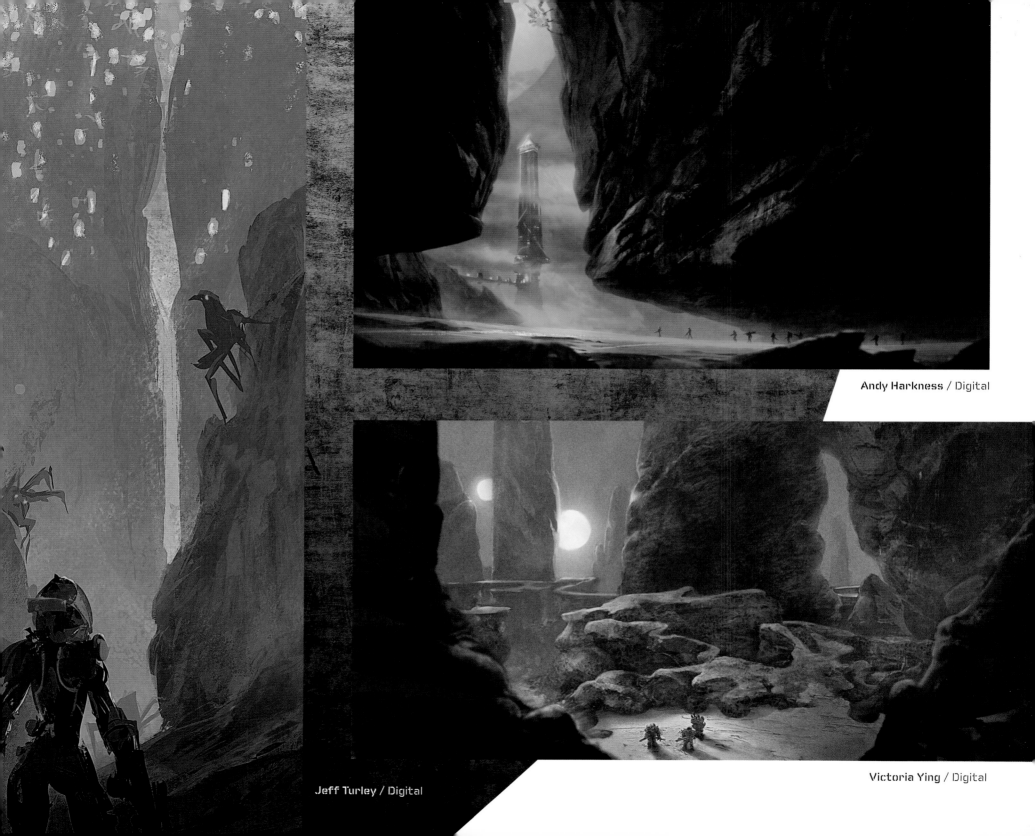

Jeff Turley / Digital

Andy Harkness / Digital

Victoria Ying / Digital

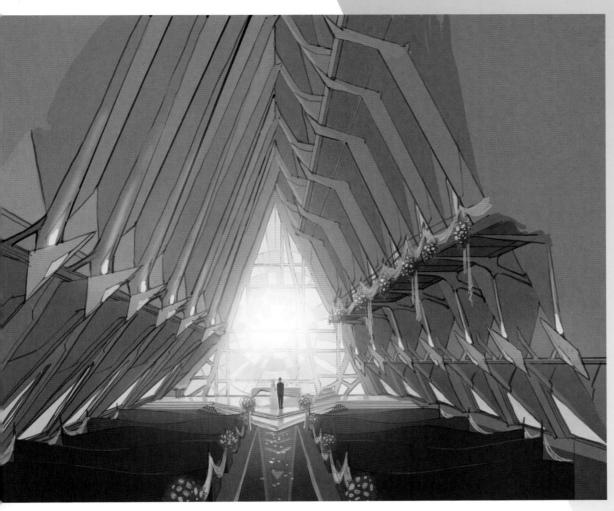

Cory Loftis / Digital

"THERE'S SO MUCH TIME SPENT THINKING ABOUT THE LOGIC
OF WHY THE SCIENTISTS WOULD CHOOSE TO BUILD ON THIS
PLANET OR WHY THEY WOULD CONSTRUCT THE BUILDING THIS
WAY OR HOW THE MECHANISM OF THE BEACON WORKS OR
WHY THEY WOULD CHOOSE TO MAKE BUGS. WE'RE WORRIED
ABOUT THIS, BUT WHEN I WORKED ON GAMES EVERYONE
WOULD JUST GO, 'WHO CARES? IT'S A GAME!'"
—CORY LOFTIS, VISUAL DEVELOPMENT ARTIST

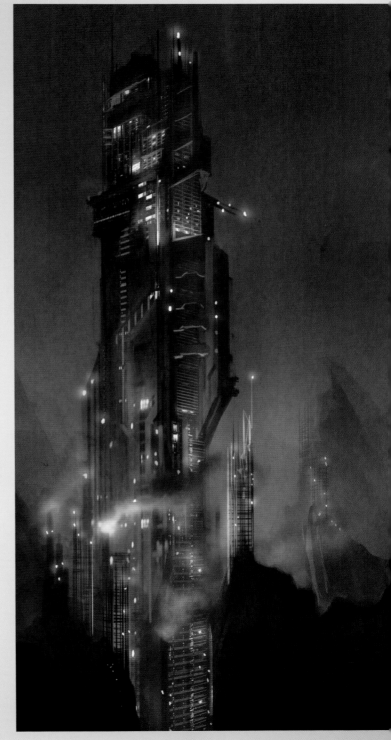

Ryan Lang / Digital

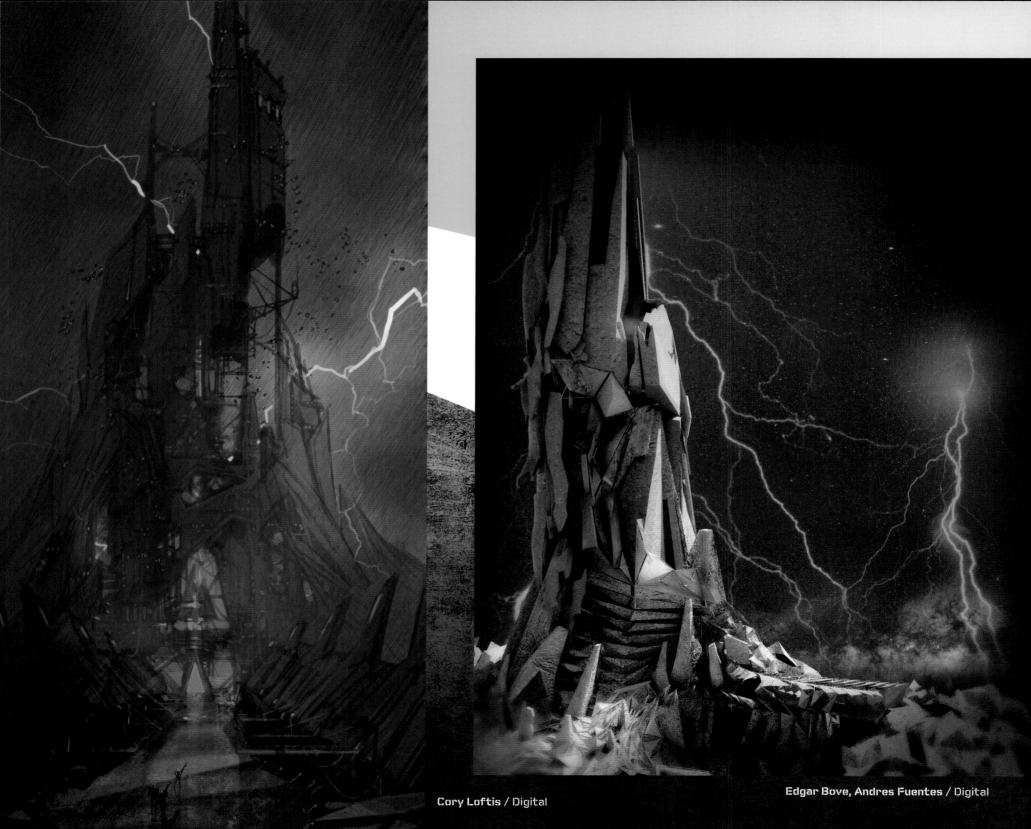

Cory Loftis / Digital

Edgar Bove, Andres Fuentes / Digital

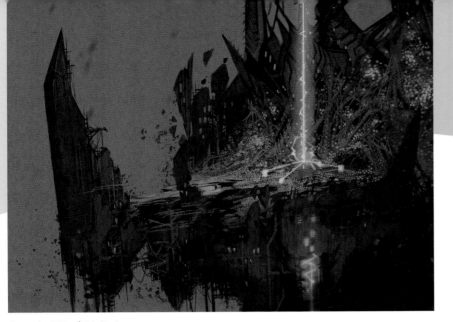

Cory Loftis / Digital

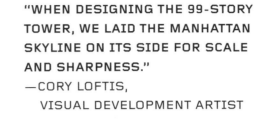

"WHEN DESIGNING THE 99-STORY
TOWER, WE LAID THE MANHATTAN
SKYLINE ON ITS SIDE FOR SCALE
AND SHARPNESS."
—CORY LOFTIS,
 VISUAL DEVELOPMENT ARTIST

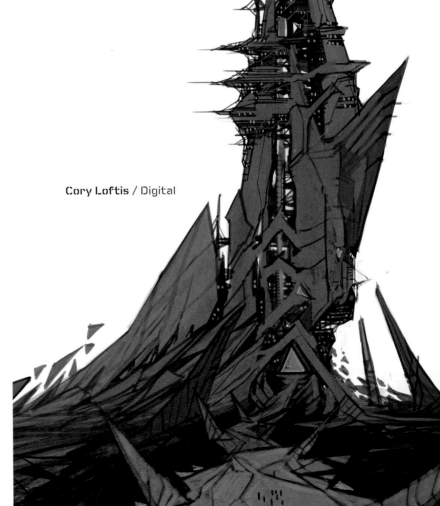

Cory Loftis / Digital

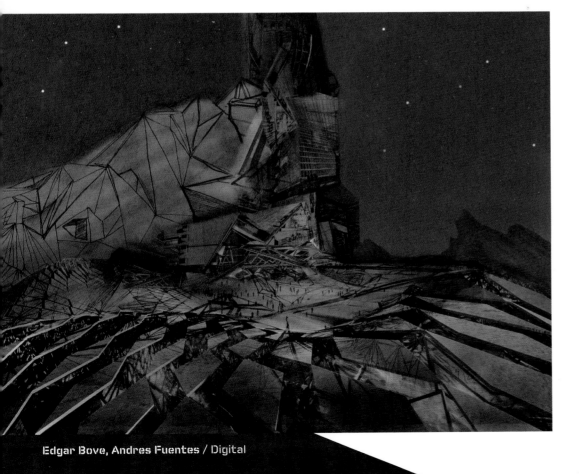

Edgar Bove, Andres Fuentes / Digital

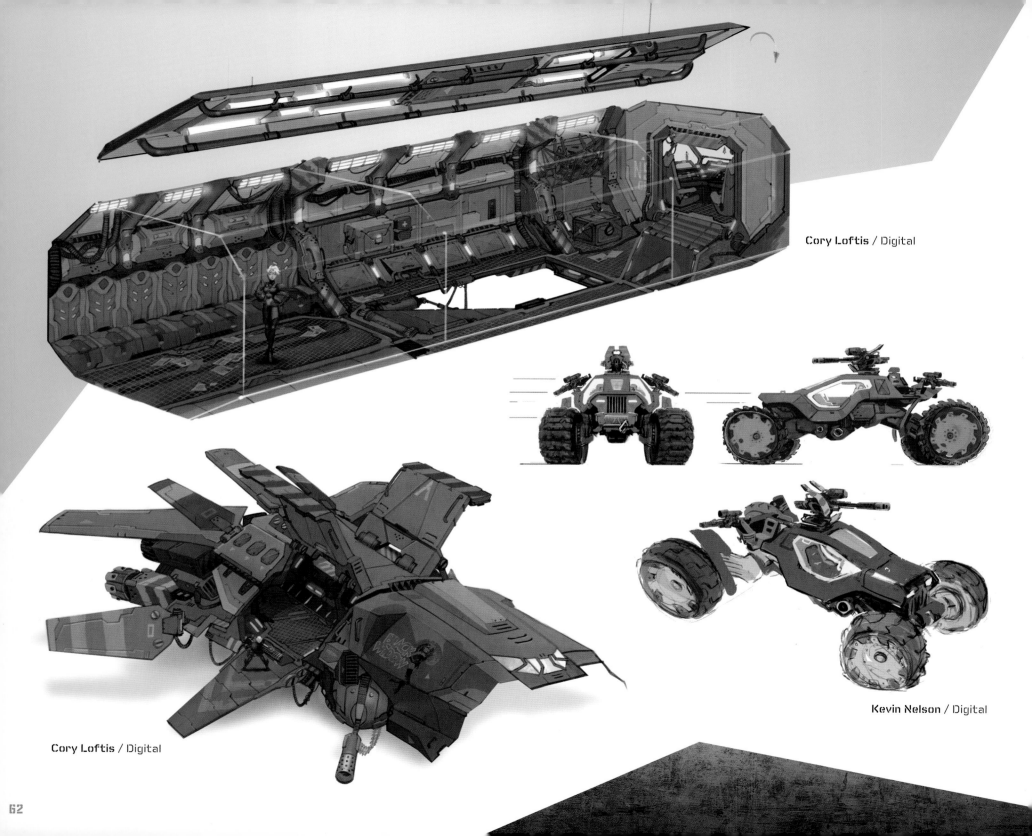

Cory Loftis / Digital

Kevin Nelson / Digital

Cory Loftis / Digital

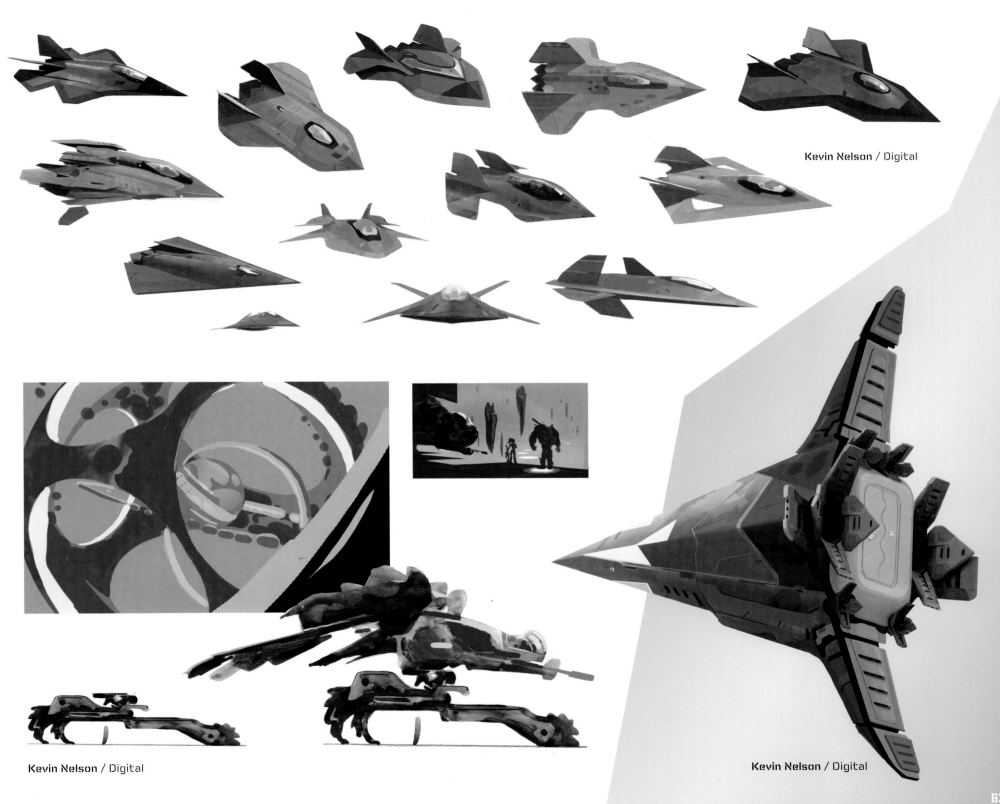

Kevin Nelson / Digital

Kevin Nelson / Digital

Kevin Nelson / Digital

"CORY LOFTIS IS LIMITLESS IN HIS INVENTION AND HIS RESOURCEFULNESS. HIS CHARACTERS HAVE SUCH A RANGE OF TONE. HE'S ABLE TO GO FROM COMPLETELY IMAGINED CHARACTERS TO INVENTING THE CAR THAT VANELLOPE MAKES IN THE BAKERY. WE GAVE HIM THE LANDING PAD IN HERO'S DUTY AND HE CAME UP WITH A REALLY COOL DESIGN FOR THAT. I DON'T KNOW HOW ONE GUY CAN GET ALL THAT INTO HIS HEAD, OTHER THAN CORY."
—MIKE GABRIEL, ART DIRECTOR

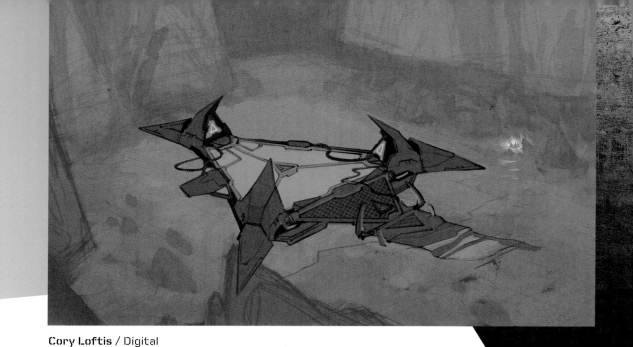

Cory Loftis / Digital

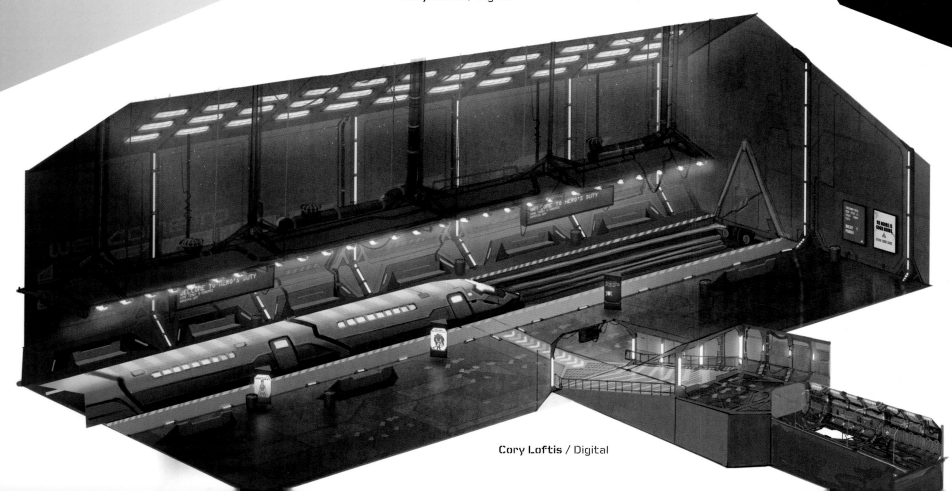

Cory Loftis / Digital

RALPH IN HERO'S DUTY

One question that took a lot of exploration to answer was: How would Ralph's look change when he entered Hero's Duty? The animators considered enhancing the textures and definition of his clothes, face, and hair to fit the more detailed, modern game, but Rich felt it was important to keep his design consistent for the audience. So they instead turned to lighting. Adolph Lusinksy explains, "The lighting in Hero's Duty will be the opposite of Fix-It Felix. Everything far away is milky just like in a first-person shooter game. When you get close, you get the darkest blacks." So when Ralph entered Hero's Duty, he'd be cast in dark shadows with deep contrasts. We'd see a distinct difference, but he'd still be our Ralph.

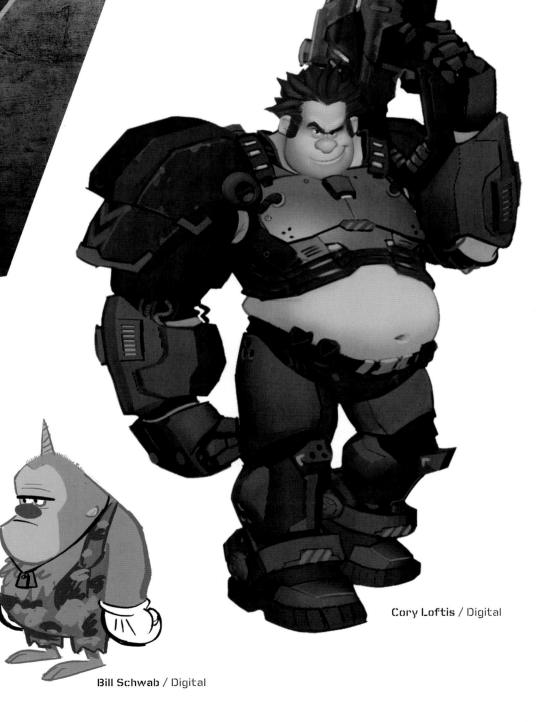

Cory Loftis / Digital

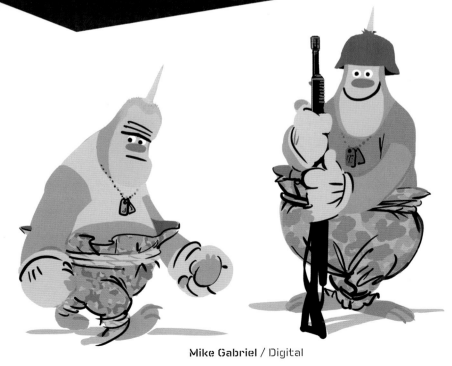

Mike Gabriel / Digital

Bill Schwab / Digital

SERGEANT TAMORA JEAN CALHOUN

In the wee early days of developing the story, Sergeant Calhoun was going to be a man. But then screenwriter Phil Johnston casually asked, "What if Calhoun were a woman and became Felix's love interest?" Rich loved the idea and named her Tamora Jean.

In designing her, the team knew that a futuristic female Sergeant in charge of the most dangerous game in the arcade needed to be strong, intimidating, but still appealing. Artist Kevin Nelson really helped set the look of Calhoun. He gave her the strong legs and lean muscle tone of a sprinter. He created a sleek hover-board for her to travel on that emphasized her agile grace. To push the science fiction angle, he gave her skin camouflage abilities, so she could take on any color she wanted. Since she was closed off emotionally, she could hide behind her camouflage. The overall response to his designs was strong, though there were concerns that the camouflage might make it hard for the audience to relate to her.

It was then that her design got caught in the tug-of-war between strength versus appeal, forceful versus inspirational. But when Jane Lynch joined on as the voice, Bill Schwab remembered: "Calhoun suddenly became so much clearer." Inspired by Jane, Glen Keane did some fresh drawings, designing Calhoun as more commanding and statuesque. He gave her a bit of Jane's hairstyle—with an Anime flair—as well as her mannerisms, and with that, the filmmakers all agreed, they'd found Calhoun.

Kevin Nelson / Digital

Tony Jung (Model),
Ryan Duncan, Mitchell Snary, and Vicky Lin (Look) / Digital

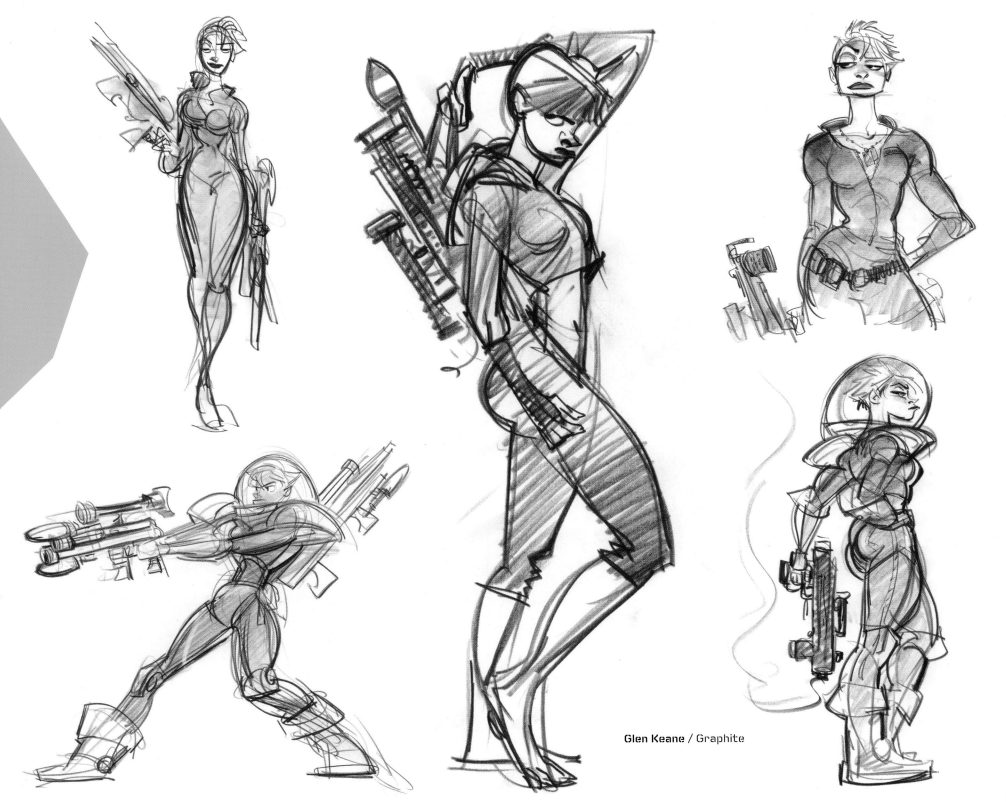

Glen Keane / Graphite

67

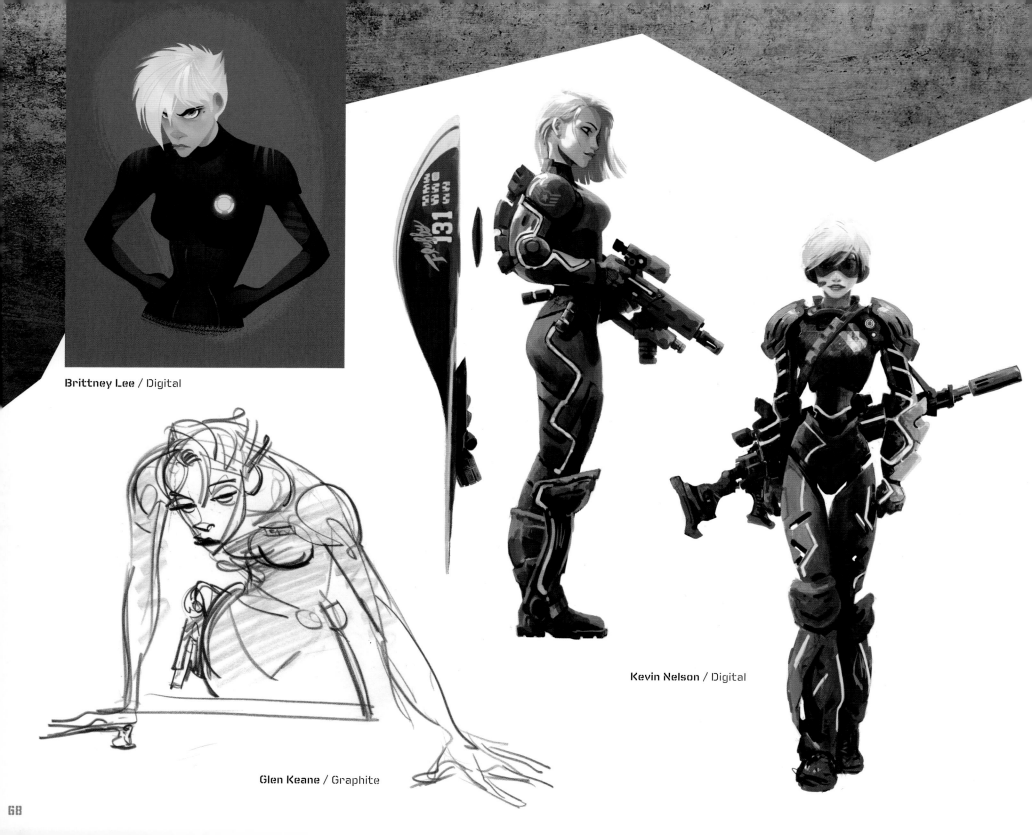

Brittney Lee / Digital

Glen Keane / Graphite

Kevin Nelson / Digital

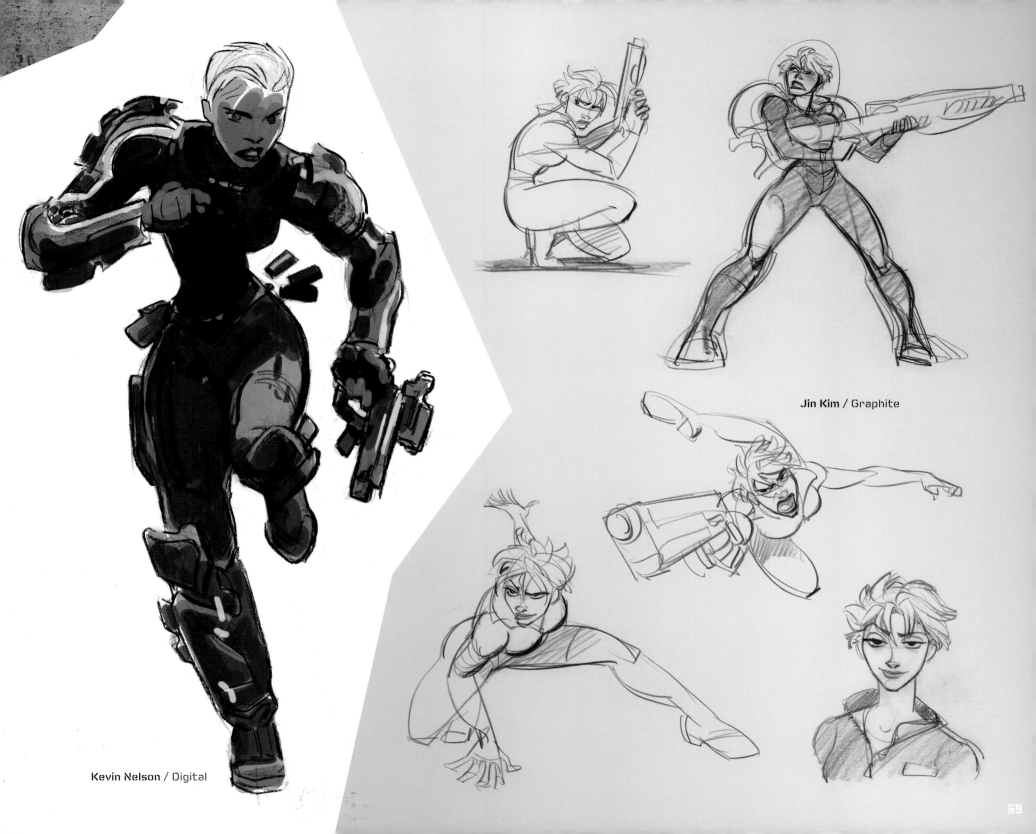

Kevin Nelson / Digital

Jin Kim / Graphite

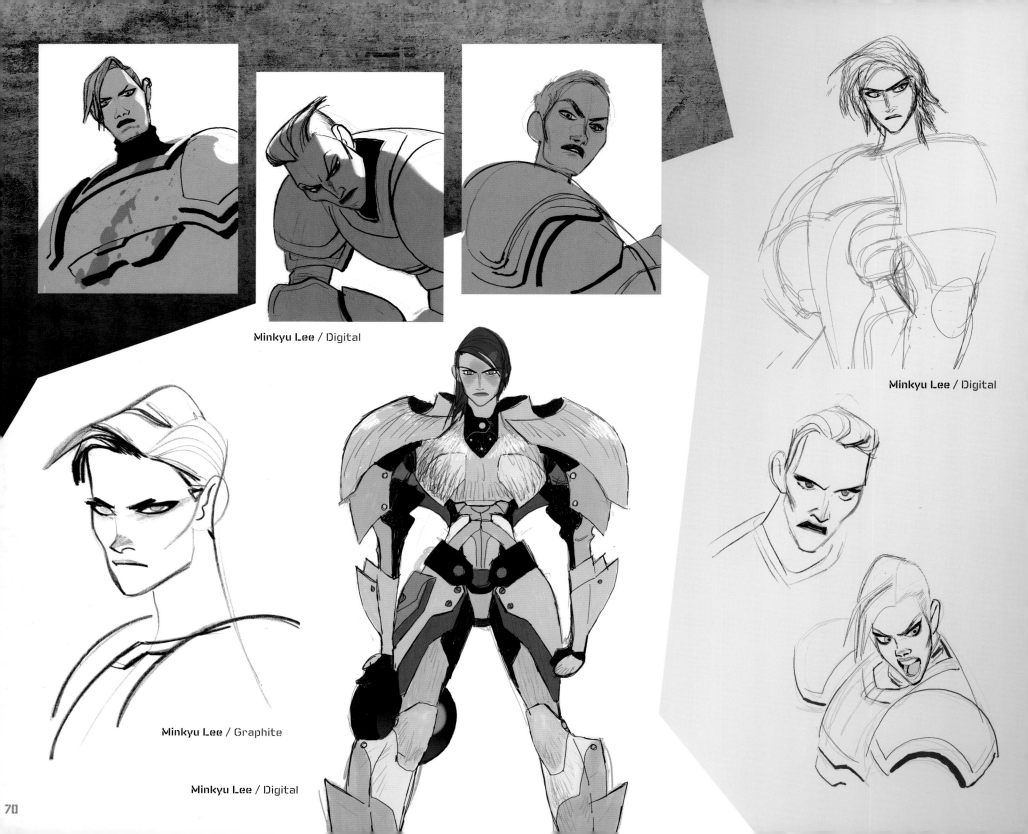

Minkyu Lee / Digital

Minkyu Lee / Digital

Minkyu Lee / Graphite

Minkyu Lee / Digital

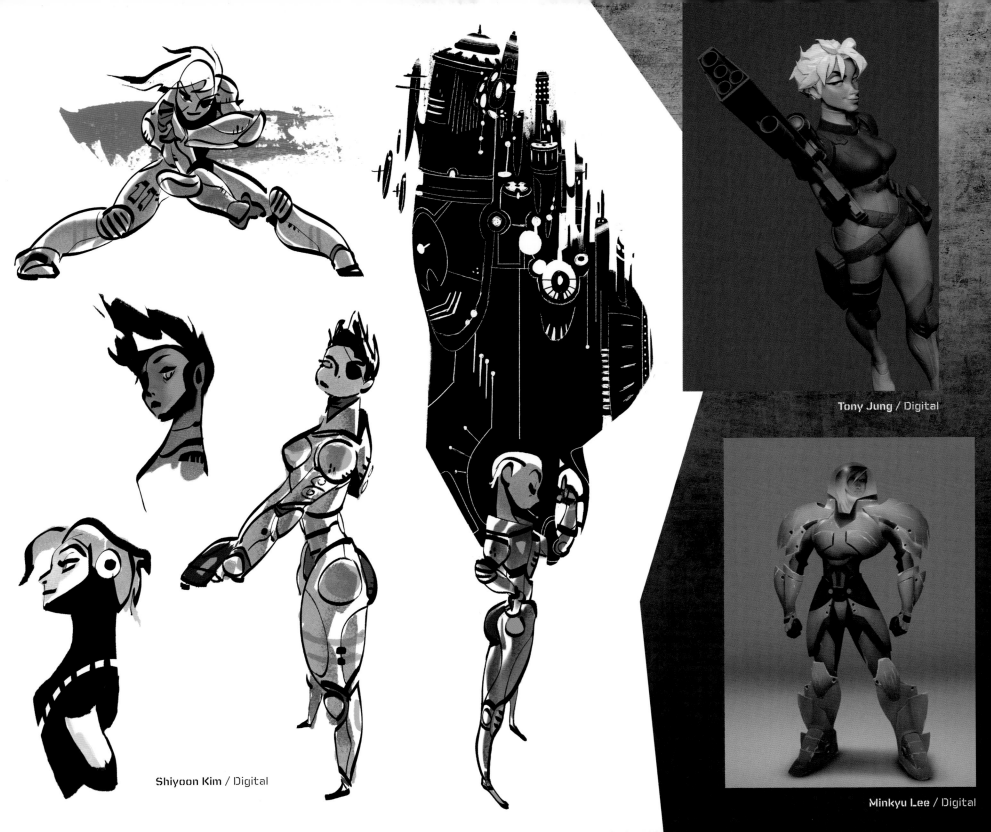

Shiyoon Kim / Digital

Tony Jung / Digital

Minkyu Lee / Digital

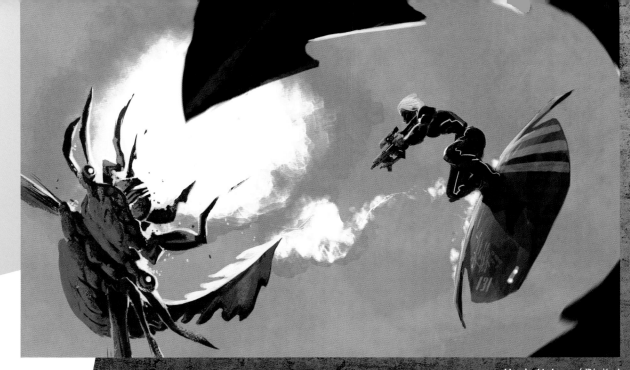

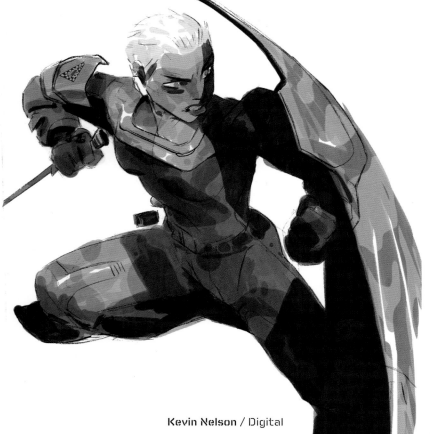

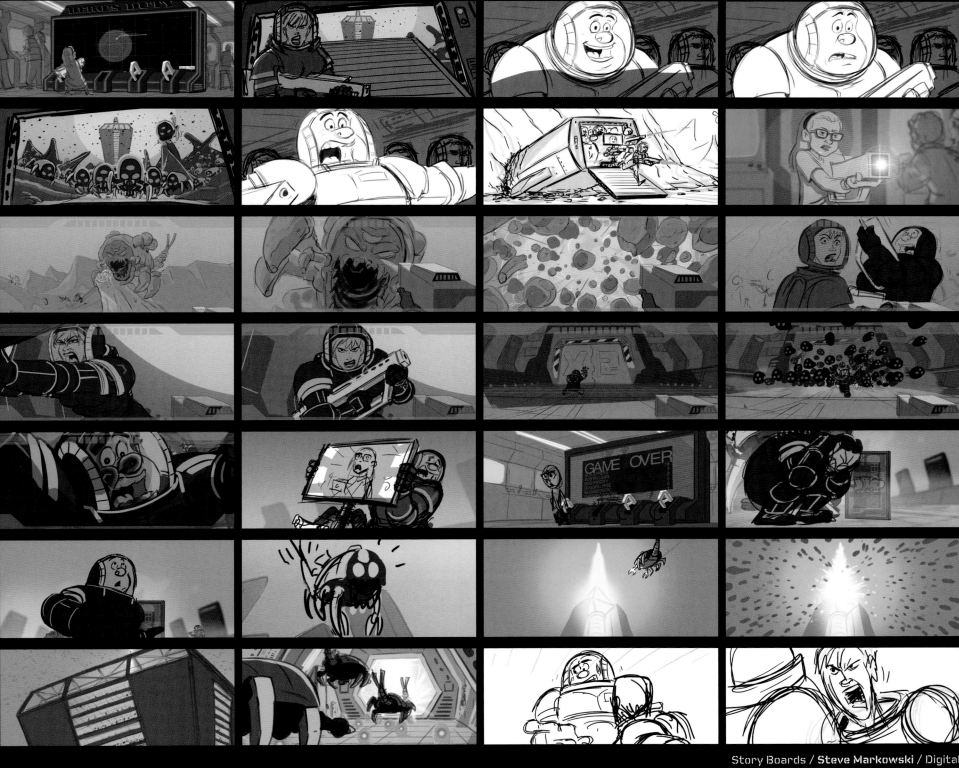

THE SOLDIERS

Soldiers and first-person shooter games go hand-in-hand, so making the Hero's Duty soldiers and their weaponry feel original was not easy. After much research, including visits to actual military bases, Kevin Nelson designed some very believable weaponry and soldiers. But, as Mike Gabriel says, "We weren't yet going into fresh snow." Then they noticed that many videogames had started to become more caricatured. Inspired, Artist Shimon Kim did some drawings with unnaturally giant weapons that were very fun. In addition, the plot of *Wreck-It Ralph* changed: Ralph was going to masquerade as a soldier and needed to be able to fit into the armor. The change allowed Visual Development Artists Scott Watanabe and Cory Loftis to break from realism, and create the Disney version of gritty first-person game characters.

Minkyu Lee / Digital

Minkyu Lee / Digital

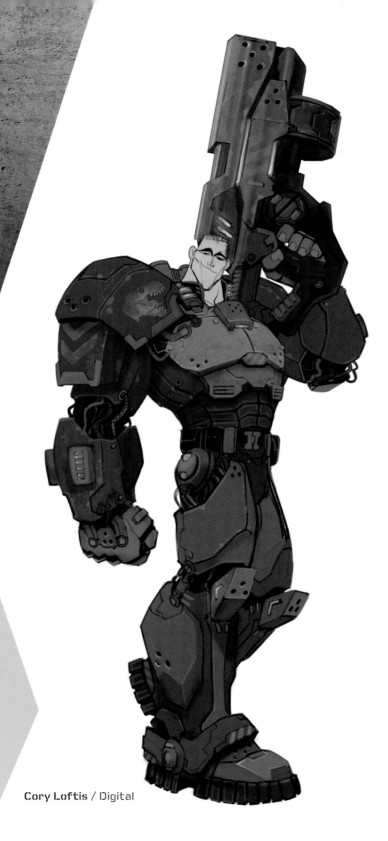

Cory Loftis / Digital

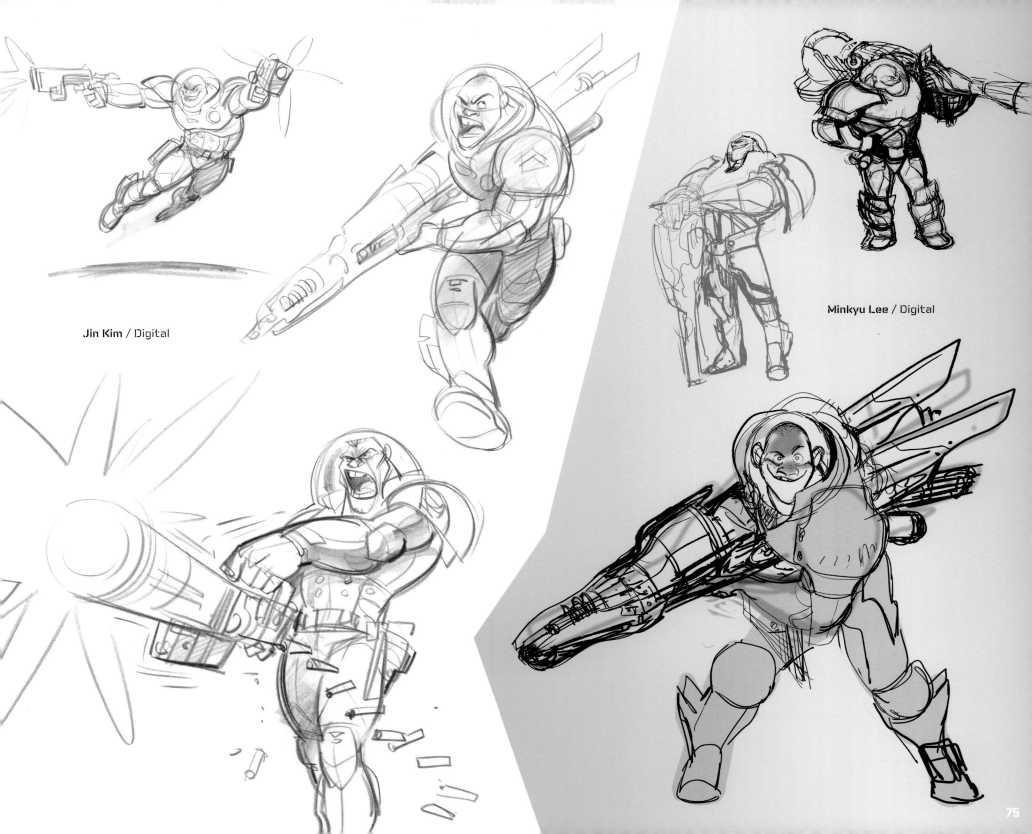

Jin Kim / Digital

Minkyu Lee / Digital

75

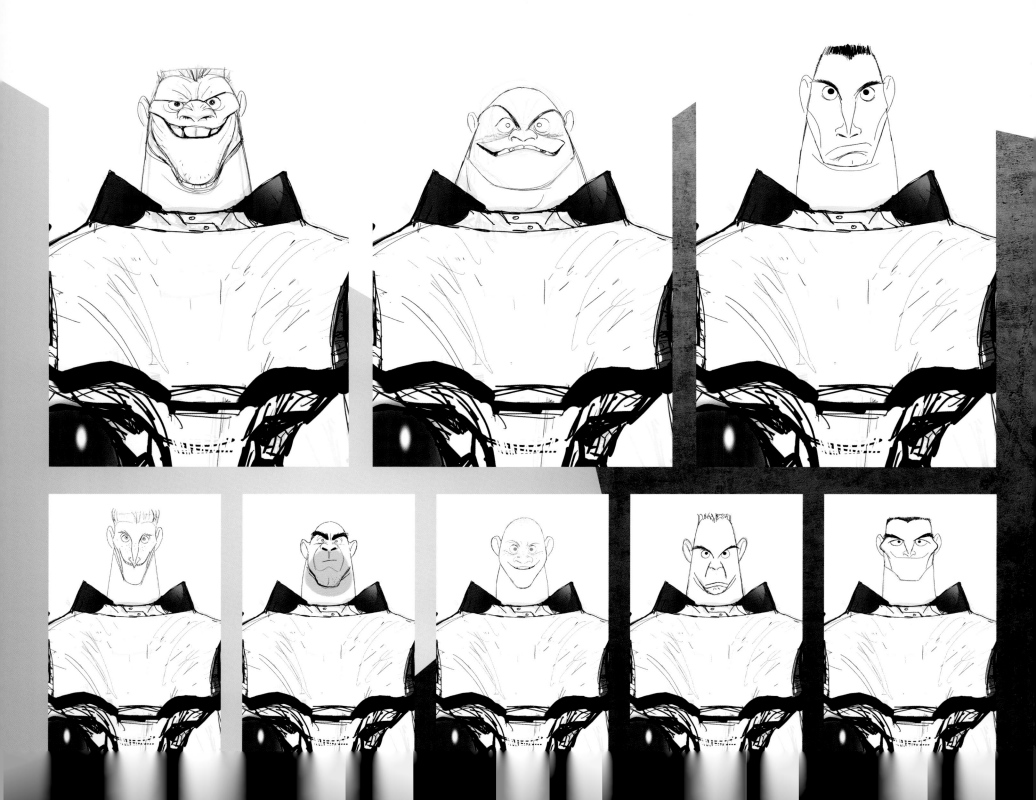

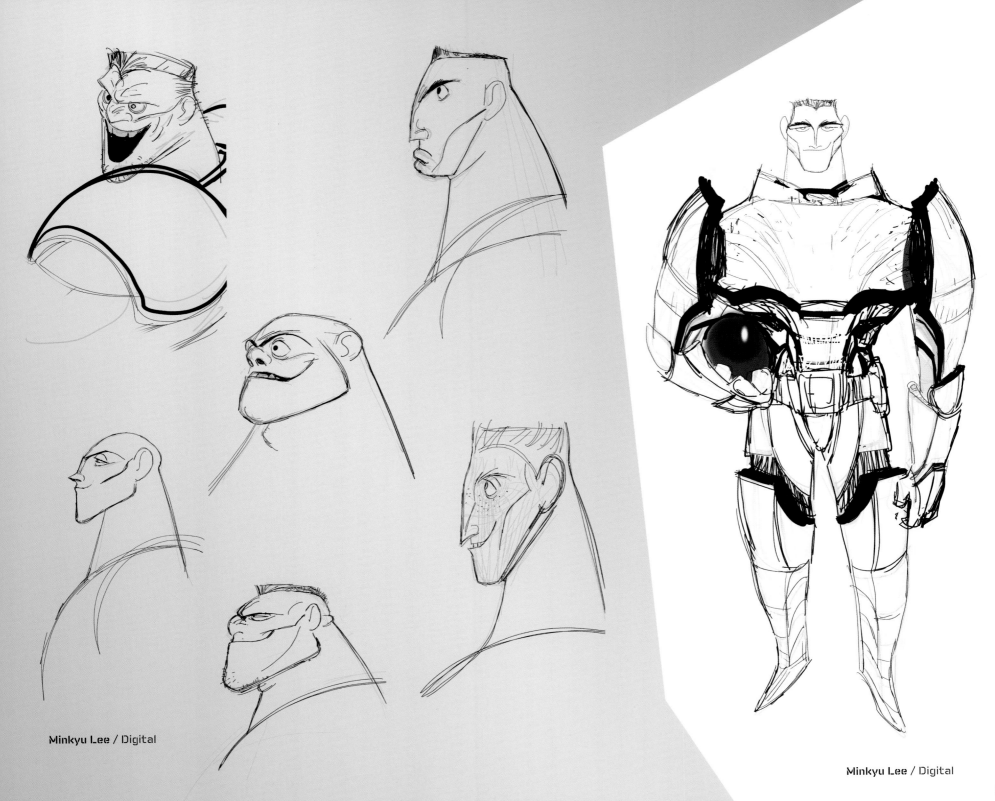

Minkyu Lee / Digital

Minkyu Lee / Digital

Justin Cram / Digital

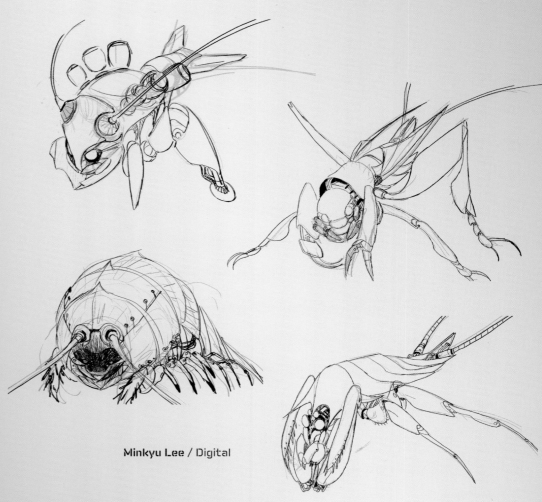

Minkyu Lee / Digital

Charles Scott / Digital

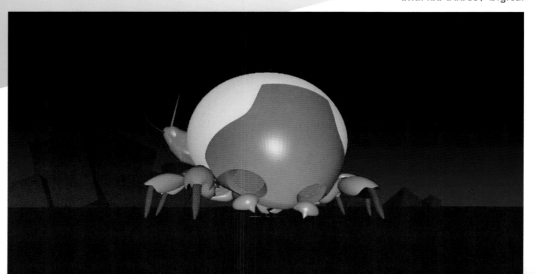

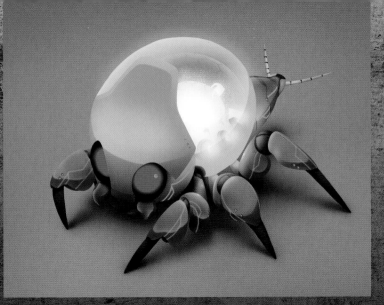

Ryan Lang / Digital

"EWW, BABY BUG!"

Rich Moore imagined that like all babies, baby cy-bugs couldn't help but be a little cute. To achieve this, Visual Development Artist Minkyu Lee broke from the constraints of the triangle language of Hero's Duty and gave the baby bugs a giant round head on little legs. Mike Gabriel commented, "He threw cute on top of creepy, and we all immediately said, 'Yes,' because it looked so appealing. You can never beat appealing."

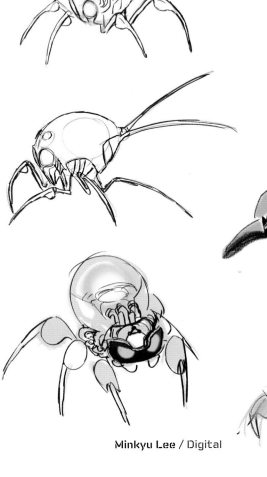

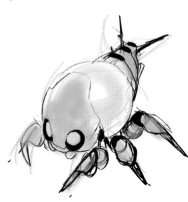

Minkyu Lee / Digital

EGG LANDS WITH PRONGS OPEN

PRONGS DIG INTO THE GROUND

PRONGS PULL TOGETHER TO GRIP

EGG IS ACTIVE (GREEN STATE)

CRACK

EGG CRACKS ALONG HEX LINES

SHELL HEXES DITHER OUT FROM TOP DOWN

TAIL UNFOLDS DOWNWARD AS LAST SET OF LEGS EXTEND AND BODY SPREADS OUT

Cory Loftis / Digital

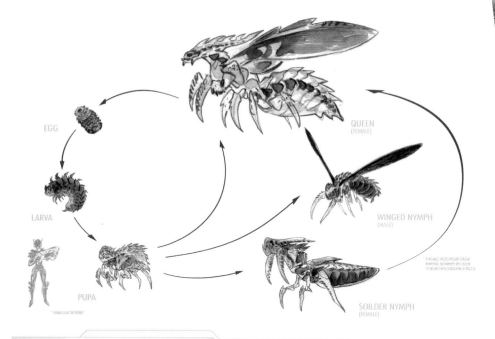

EGG

LARVA

PUPA
* SCRAM SCALE REFERENCE

QUEEN
(FEMALE)

WINGED NYMPH
(MALE)

IF NO MALE SPECIES PRESENT SOLDIER
NYMPH WILL METAMORPH INTO QUEEN
TO ENSURE A NEW GENERATION OF INSECTA

SOILDER NYMPH
(FEMALE)

INSECTA LIFE CYCLE

Scott Watanabe / Digital

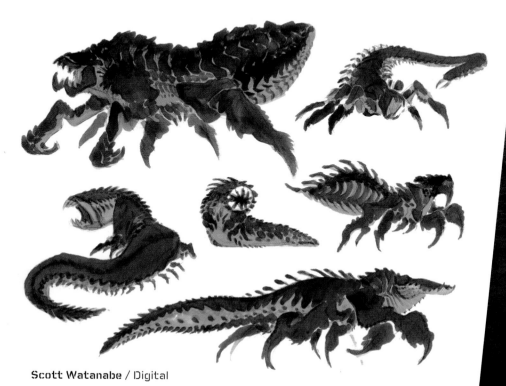

Scott Watanabe / Digital

CY-BUGS

"THEY ARE WHAT THEY EAT!"

Like soldiers, having bugs in a videogame was not a new idea, so the creative team faced the challenge of figuring out what made the Hero's Duty bugs unique. Bill Schwab thought back, "I did a lot of the early bug designs. In the beginning, I thought about the film *Wrath of Khan*, where they put those bugs in peoples' ears. I drew a lot of really creepy bugs. They made your skin crawl." But Bill knew that, in keeping with the tone of the film, the bugs needed to be more than just creepy; they needed to be compelling and at times even funny. To him, "the first great discovery was the idea that they are part machine. It made it easier to look at them without being completely grossed out." They dripped oil instead of blood. They laid eggs from a cargo hatch. Ian Gooding adds, "Once they were part machine, we felt like we could shoot lots of them without feeling like we were annihilating an actual species." That's when the Hero's Duty bug found its name: the cy-bug, a play on cyborg, evoking the idea of something manufactured and not fully organic.

The cy-bug was a great find, but Rich wanted to push it even further. Clark Spencer recalls, "Then the story artists came up with the idea that the cy-bugs become what they eat. That was a seminal moment for the cy-bugs. Rich and John Lasseter latched onto the idea right away. They loved the thought of the cy-bug eating, say, a truck and transforming into a truck-bug."

Even more exciting to everyone was the thought of the cy-bugs in Sugar Rush eating candy. Mike Gabriel spoke about it: "When imagining the cy-bugs in Sugar Rush, Scott Watanabe followed some undersea creature patterns and turned them into candy patterns. They have such a great look, unlike anything I've ever seen."

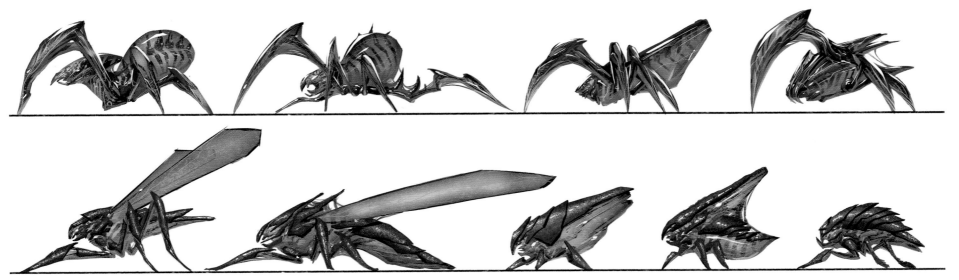

Ryan Lang / Digital

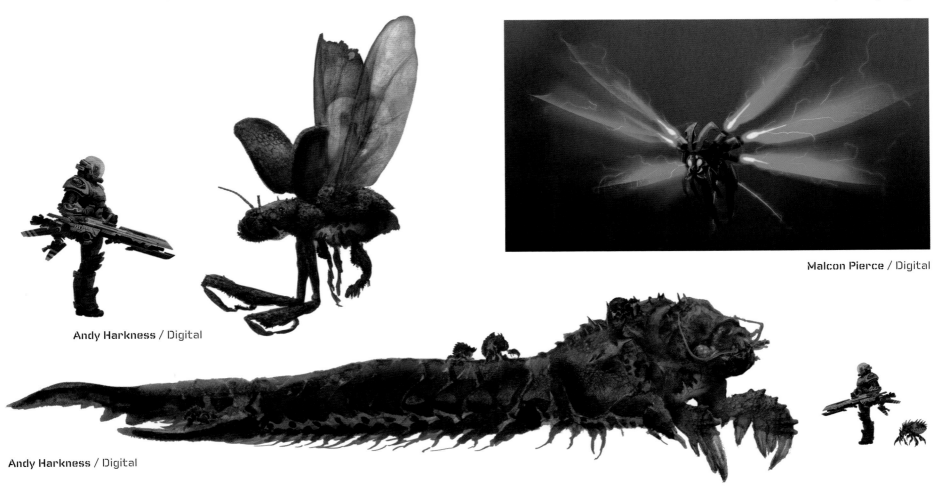

Malcon Pierce / Digital

Andy Harkness / Digital

Andy Harkness / Digital

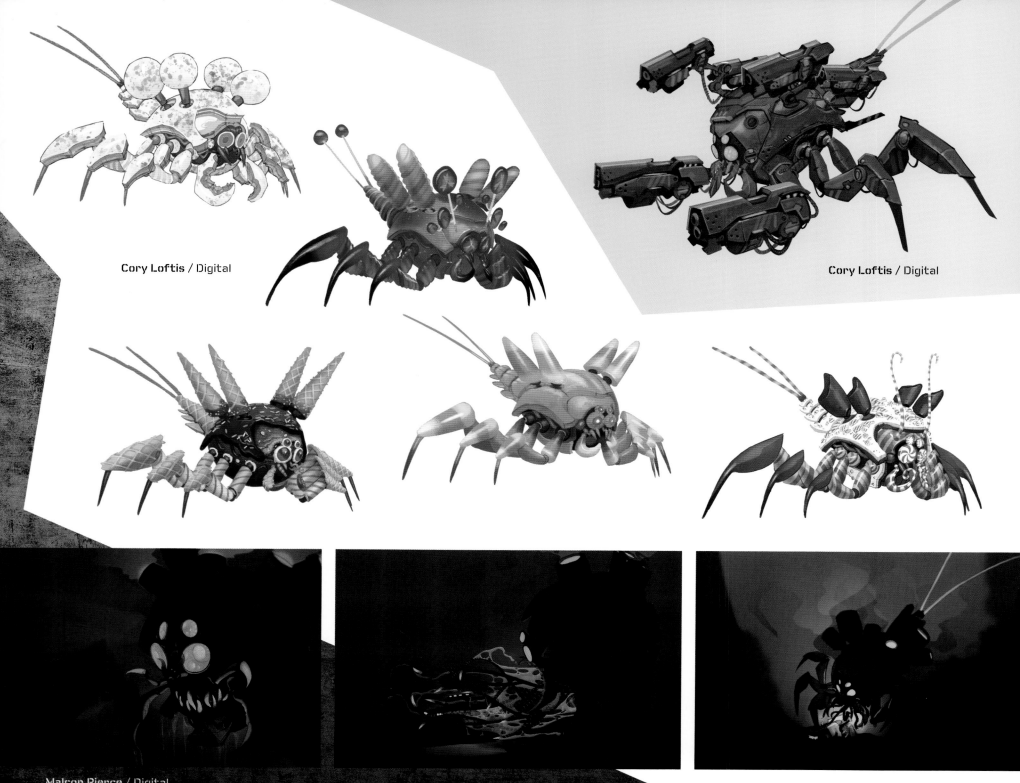

Cory Loftis / Digital

Cory Loftis / Digital

Malcon Pierce / Digital

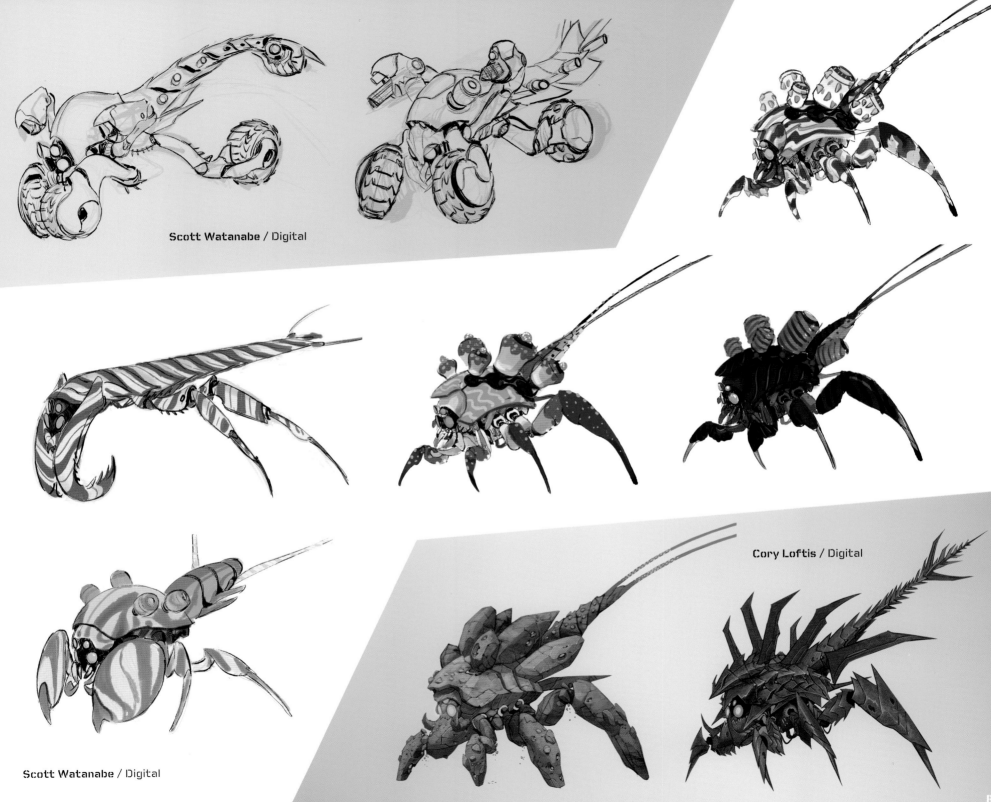

Scott Watanabe / Digital

Scott Watanabe / Digital

Cory Loftis / Digital

83

THE FIRST-PERSON SHOOTER

There were many discussions about what makes a modern first-person shooter game different from the old classics like Fix-It Felix, Jr. Visual Development Artist Cory Loftis, who'd spent years designing for videogames, describes it best: "A first-person shooter game is actually the epitome of what videogames are trying to be; they're trying to put you in a situation. Fix-It Felix is stuck in the third-person view, but in Hero's Duty it should feel like you're in there with the characters." The creative team knew they had to come up with a way of capturing this idea.

Rich Moore remembers, "For a while we had a soldier named FPS, as in 'First-Person Shooter,' who was like the other soldiers except he had a camera for a head. But people found him confusing. Did he have emotions and a soul like Calhoun or was he more like a robot?"

Taking inspiration from video conferencing and "telepresence robots," the creative team designed a droid with a flat screen for a head that displayed the player. It really felt in line with what Cory described. It was like the players were right there in the game and the game characters were free to interact with them. John Lasseter loved the idea but suggested one last adjustment: "Make the droid as dorky as possible to contrast the strong soldiers."

Cory Loftis / Digital

Tony Jung / Digital

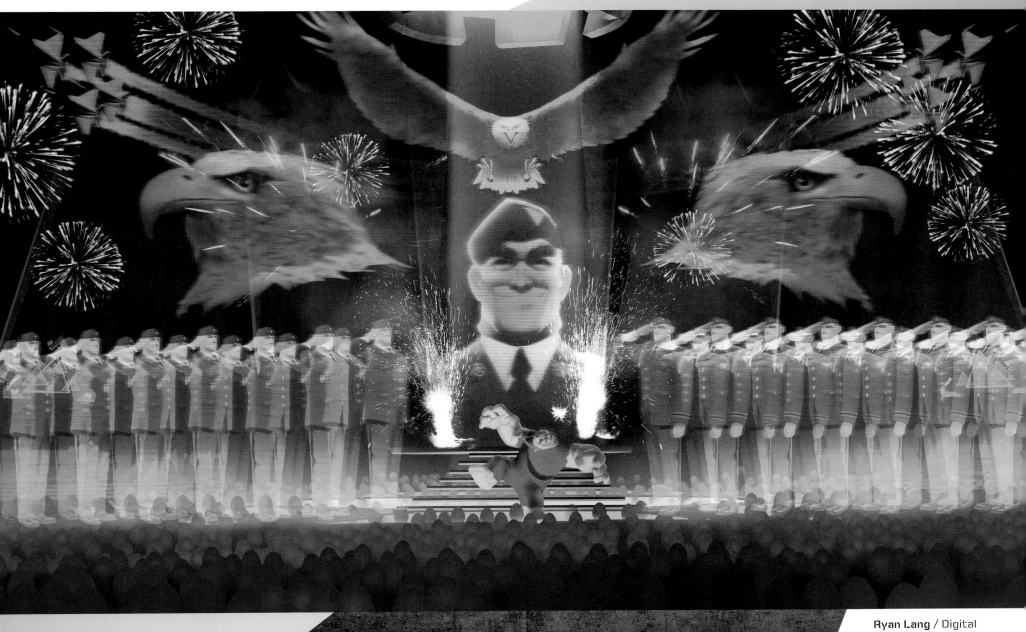

Ryan Lang / Digital

"I LIKE FIRST-PERSON SHOOTERS, AND I'M A
VIDEOGAME GUY SO I TRIED TO FIT AS MANY
COOL THINGS AS I COULD INTO ONE IMAGE
AND, HOPEFULLY, GET PEOPLE EXCITED."
—RYAN LANG, VISUAL DEVELOPMENT ARTIST

Color Script / Mike Gabriel, Helen Chen, Jim Finn, Lorelay Bove, Ryan Lang, Dan Cooper, Cory Loftis, Ian Gooding / Digital

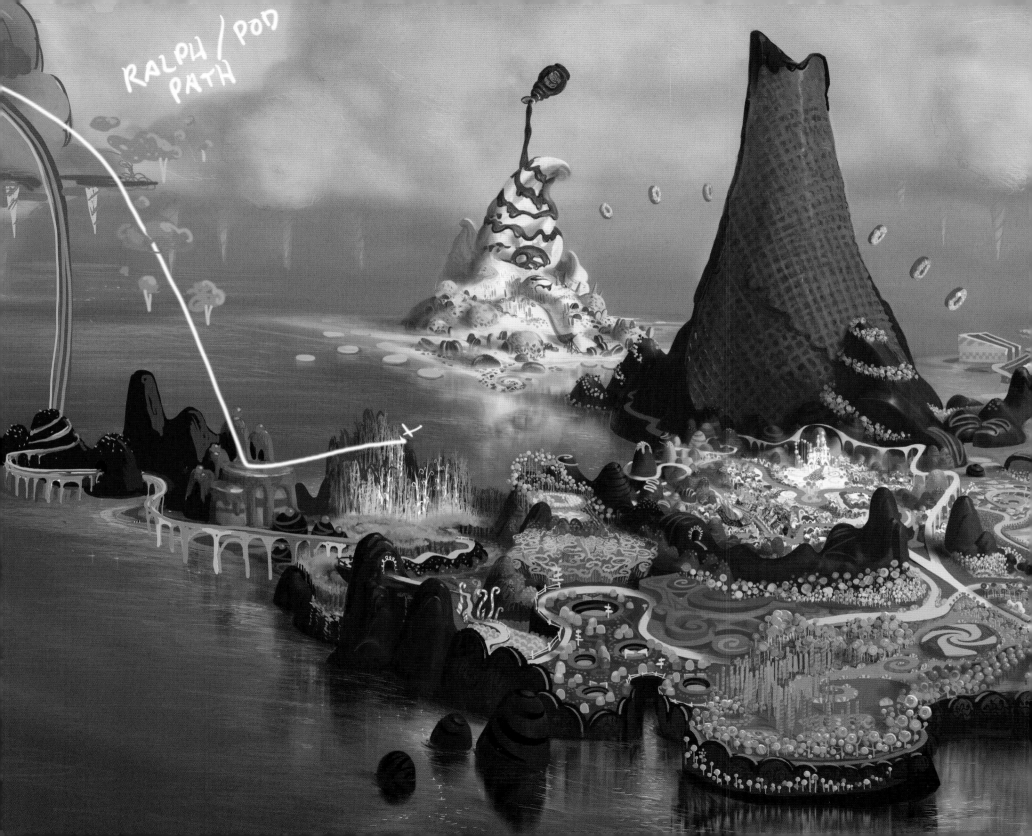

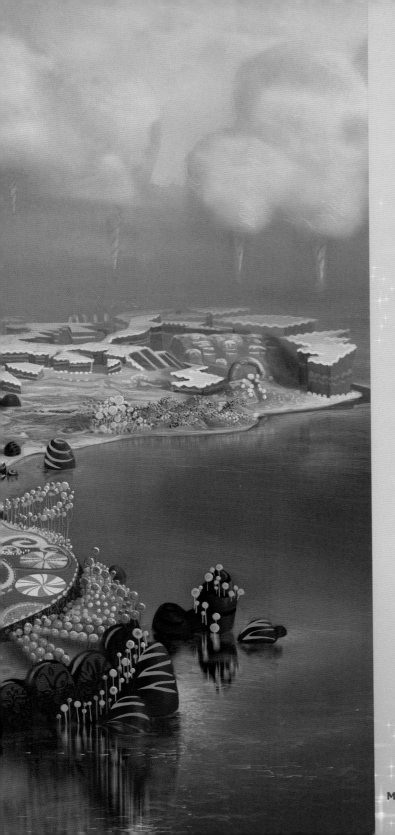

Sugar Rush

Sophisticated Palette

When it came to designing Sugar Rush, the creative team knew that world needed to be more than just appealing—it also needed to be mouth-wateringly appetizing.

The risk of creating a world completely out of confectionary foodstuffs, however, is that it might come off as juvenile. While the character Ralph may feel that he's trapped in a sickeningly sweet racing game, the audience can't feel the same way. The artists needed an overall design for the world that was sophisticated and original. Using the traditional Hansel and Gretel gingerbread cottage was out.

The shape language of Sugar Rush clicked into place when Lorelay Bove, a visual development artist from Spain, introduced the creative team to the whimsical architecture of Catalan artist Antoni Gaudí, who flourished around the beginning of the twentieth century. "Ever since I was a little girl growing up in Spain," explains Lorelay, "I always thought that Gaudí's buildings looked like candy houses. I would see them and think, 'Those look like ice cream swirls, this looks like frosting, and there are pretzel shapes everywhere.'" So Mike Gabriel, Lorelay, and the visual development

Mike Gabriel / Digital

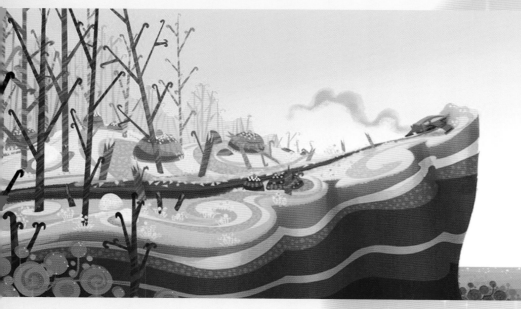

Lorelay Bove / Digital

team took a research trip to Barcelona to walk through Gaudí's buildings and, indeed, everyone fell in love with the architect's curvilinear shapes.

Lorelay quickly became a key designer in defining the world, not only because "she has Gaudí in her DNA," as Lorelay's former mentor Ian Gooding explains it, but also because "she's got fantastic taste in color." And a unified color palette was also a key in achieving a sense of sophistication in Sugar Rush. Lorelay explains: "Instead of using every color of the rainbow, pinks, reds, and chocolates are the hero colors of Sugar Rush. Whenever we put too many colors and patterns together, it looked overwhelming, like a little kid made it—not as yummy as if a pastry chef had."

"When you go into Sugar Rush," summarizes Mike Gabriel, "you'll immediately notice it's all silky and smooth. If Hero's Duty is 'hard,' then Sugar Rush is 'soft.' You're going from a metallic, sharp world into creamy, even values. The pale orange and pink trees are very close to the cloud color, which is very close to the sky value. If you squint your eyes, it looks like a wedding cake."

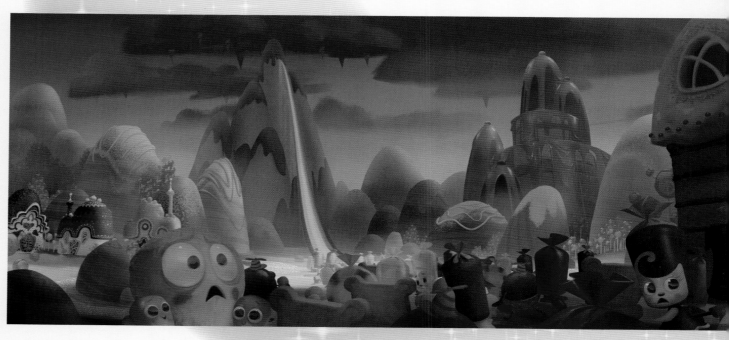

Helen Chen / Digital

Mike Gabriel / Digital

"We went to Cologne, Germany, to see the International Candy Market. We looked at incredible candies from every nation in the world. Oddly, the more you become familiar with what's out there, the more you're able to generate something original, in your own style."
—*Mike Gabriel, art director*

Ryan Lang / Digital

Helen Chen / Digital

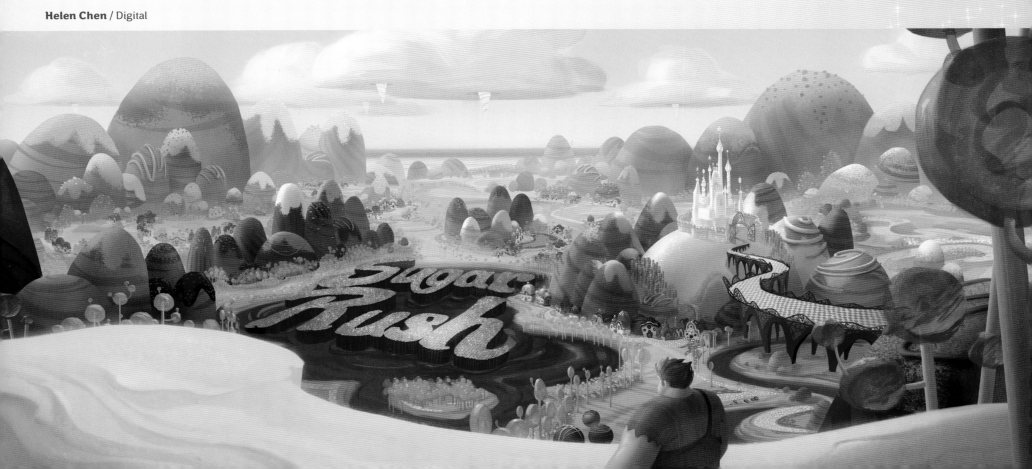

Ryan Lang / Digital

"When we're picking colors or textures for any food element in Sugar Rush, we keep adjusting until we want to eat it."
—*Mike Gabriel, art director*

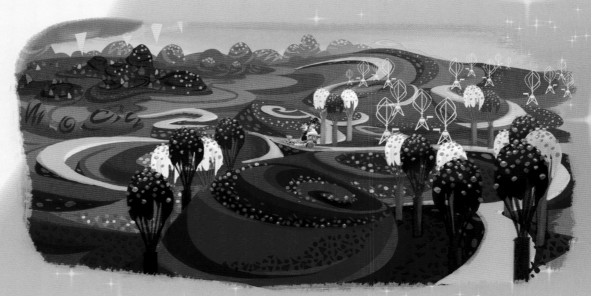

Lorelay Bove / Digital

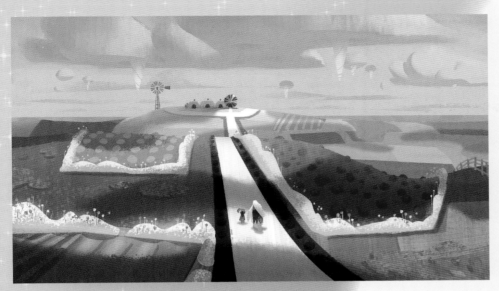

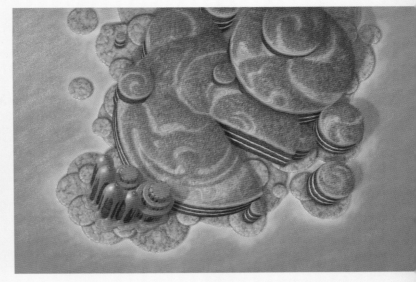

Jeff Turley / Digital

Doug Ball, Ian Gooding / Digital

Dan Cooper / Digital

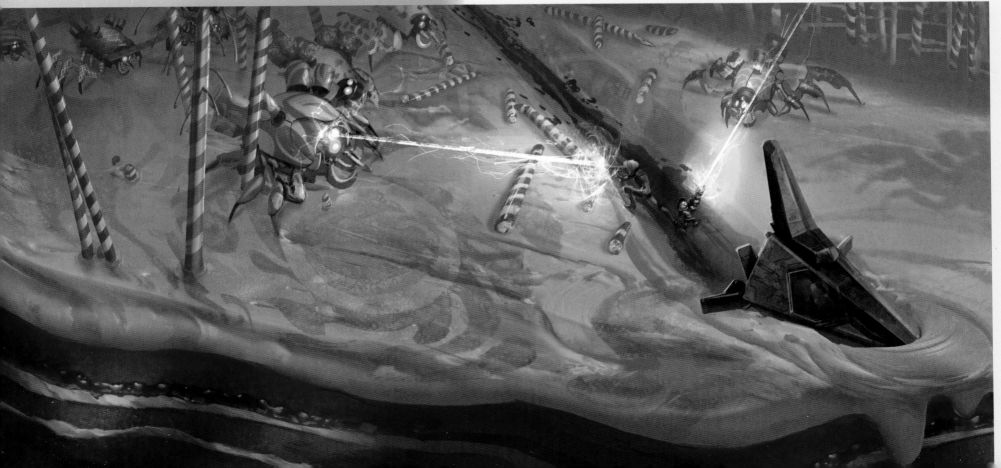

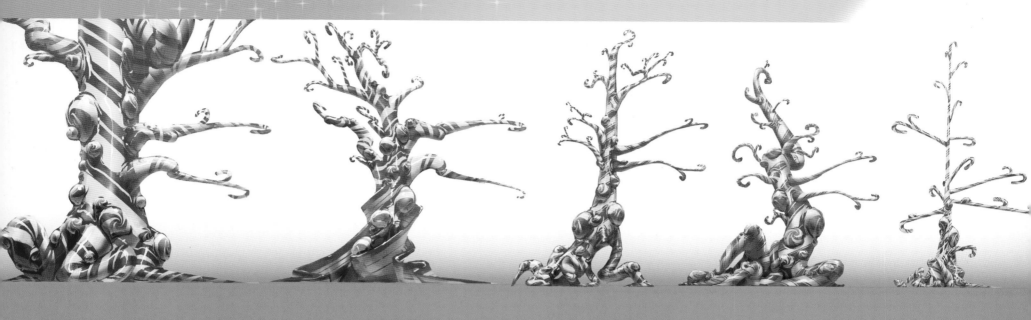

Ryan Lang / Digital

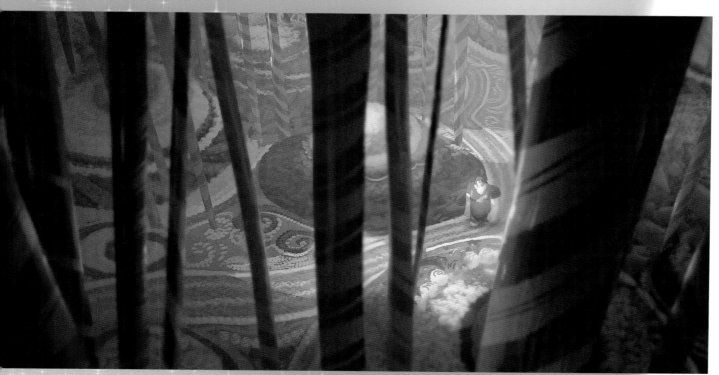

Ryan Lang / Digital

Mike Gabriel / Digital

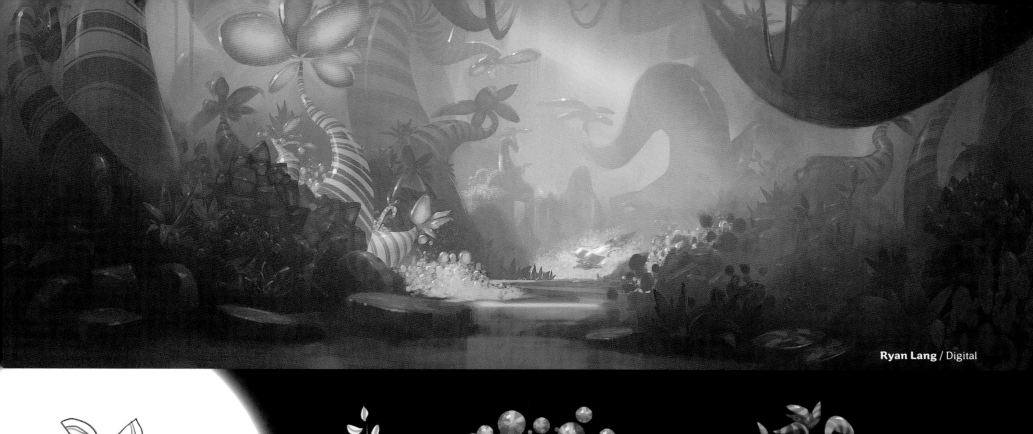
Ryan Lang / Digital

FRUIT SLICE TREES

Mike Gabriel / Graphite

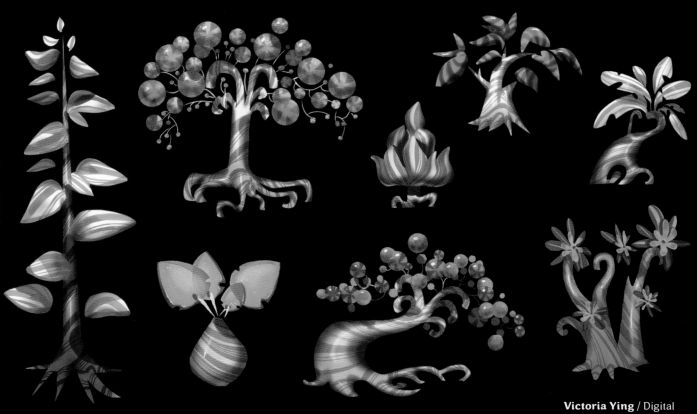
Victoria Ying / Digital

95

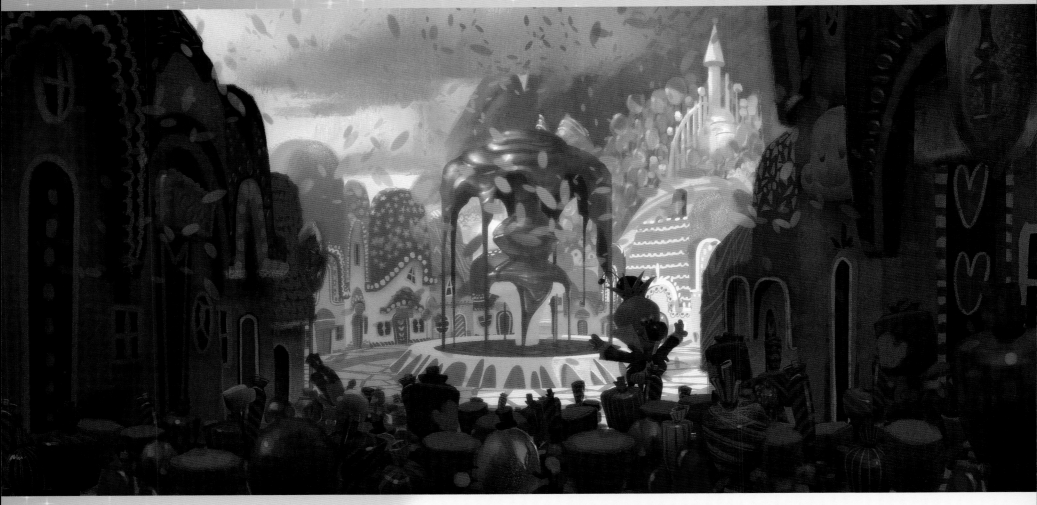

Ryan Lang / Digital

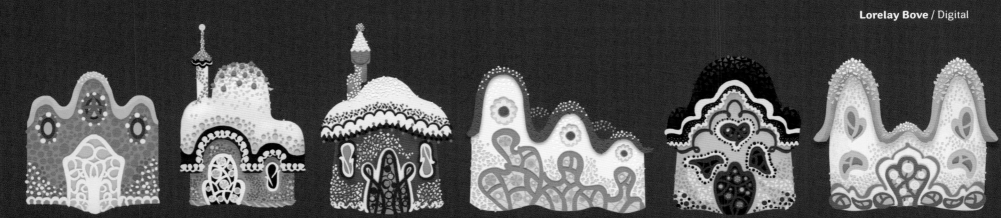

Lorelay Bove / Digital

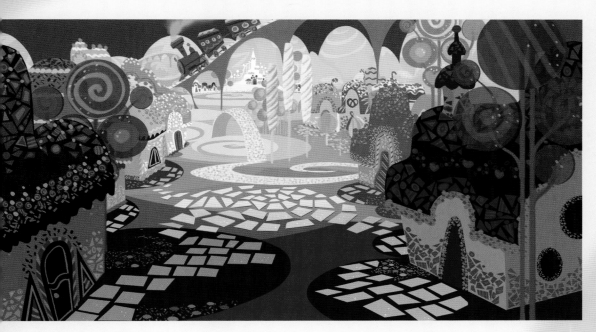

Lorelay Bove / Digital

"I can mimic Gaudí, but Lorelay reinterprets him in a completely fresh way that feels like you haven't seen it before. She's so brave and free with the way she roams with it. I think she's always been looking for an outlet for her love of Gaudí design, and she has finally found the perfect vehicle."
—*Mike Gabriel, art director*

Edgar Bove, Andreas Fuentes / Digital

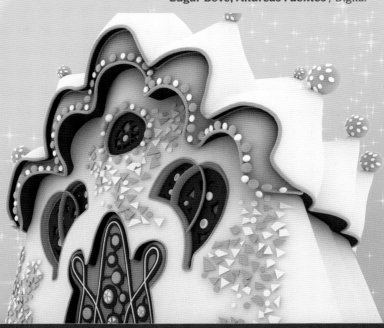

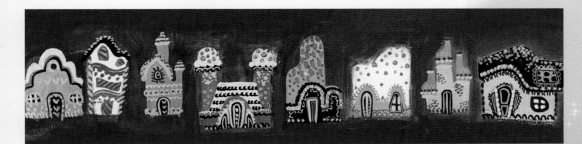

Lorelay Bove / Digital

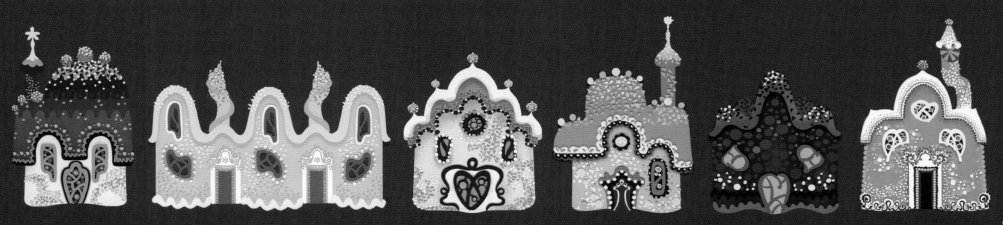

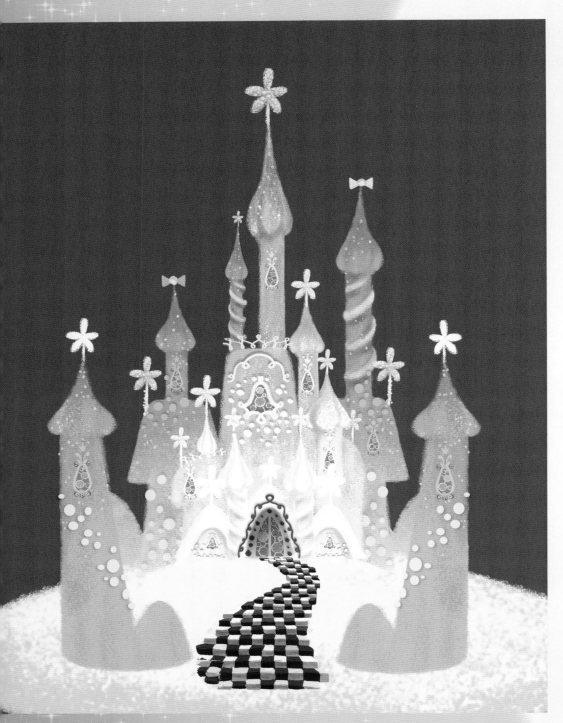

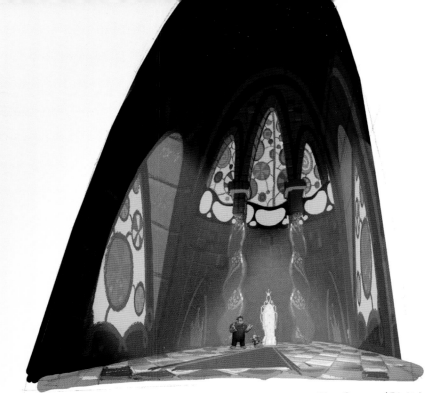

Mac George / Digital

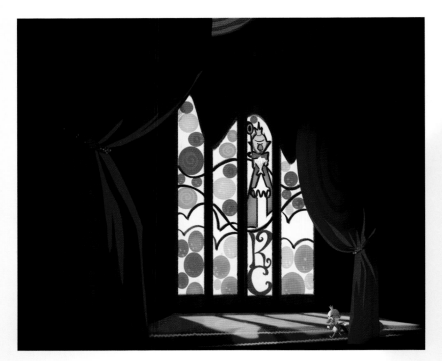

Lorelay Bove / Digital

Lorelay Bove / Digital

"The interior of King Candy's castle has been one of my favorite sets to design. We used white and brown sugar cubes to create a checkerboard pattern. And because King Candy is not the real king, we thought it would be funny to cover the whole castle in sugar coating just like him."
—Lorelay Bove, visual development artist

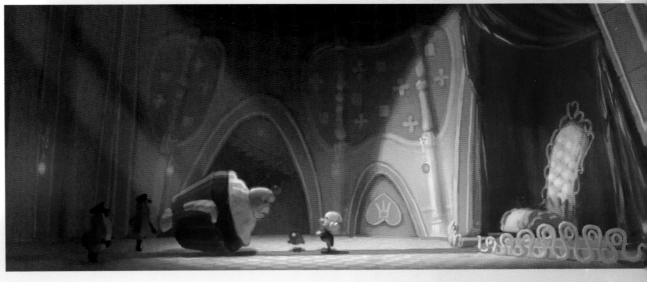

Ian Gooding / Digital

Cory Loftis / Digital

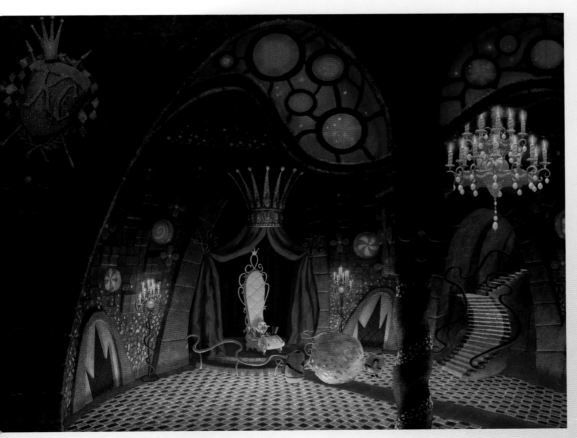

Lorelay Bove, Doug Ball / Digital

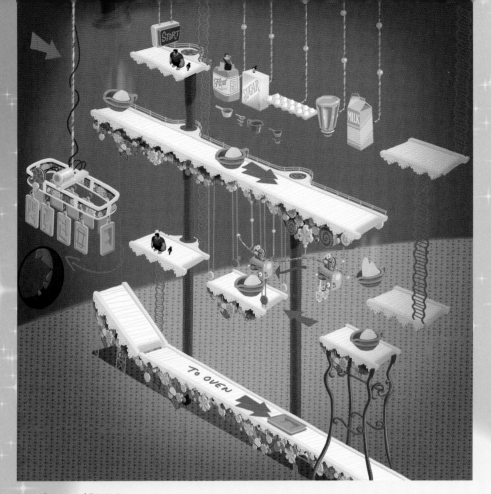

Mac George / Digital

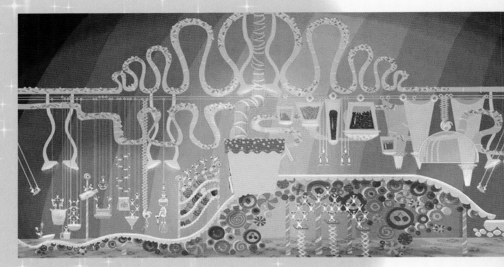

Lorelay Bove / Digital

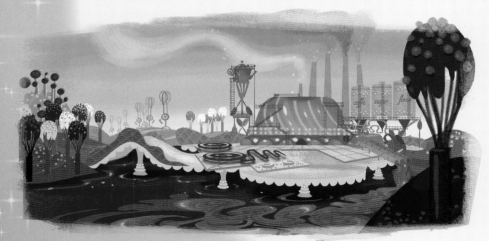

Lorelay Bove / Digital

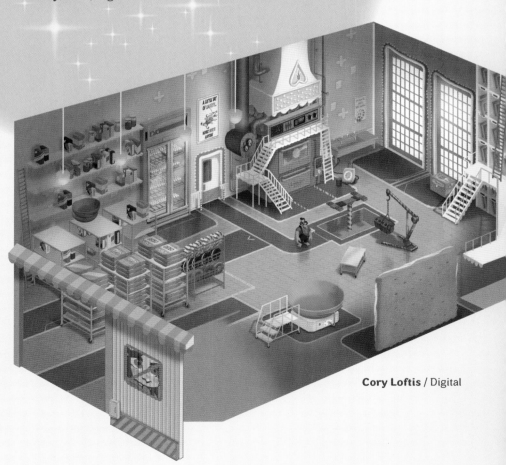

Cory Loftis / Digital

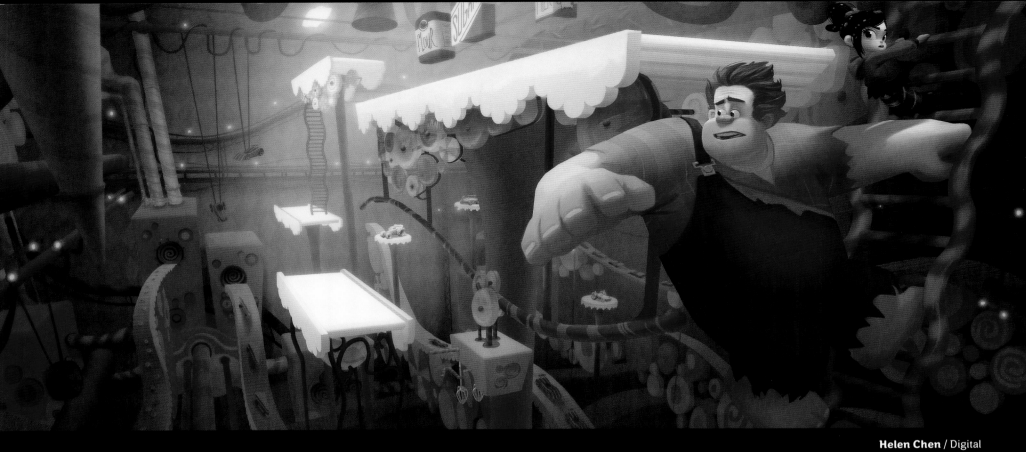

Helen Chen / Digital

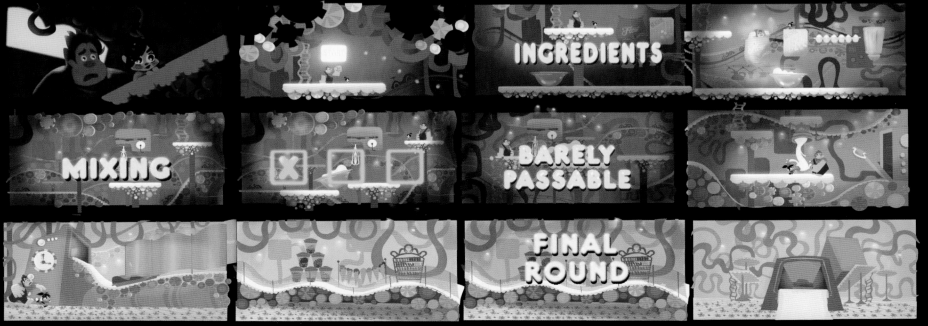

INGREDIENTS

MIXING

BARELY PASSABLE

FINAL ROUND

Lorelay Bove / Digital

"When I started designing the candy grandstands, I immediately thought of going to the grocery store and seeing all those candies on display. The tiered shelves naturally look like grandstands. I was inspired to put King Candy in a popcorn box, because it's the type of food you'd eat at a race. Then I tried to make the box look royal. It's a royal popcorn box."
—*Victoria Ying, visual development artist*

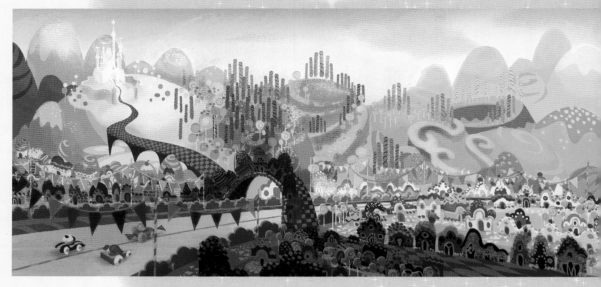

Lorelay Bove / Digital

Victoria Ying / Digital

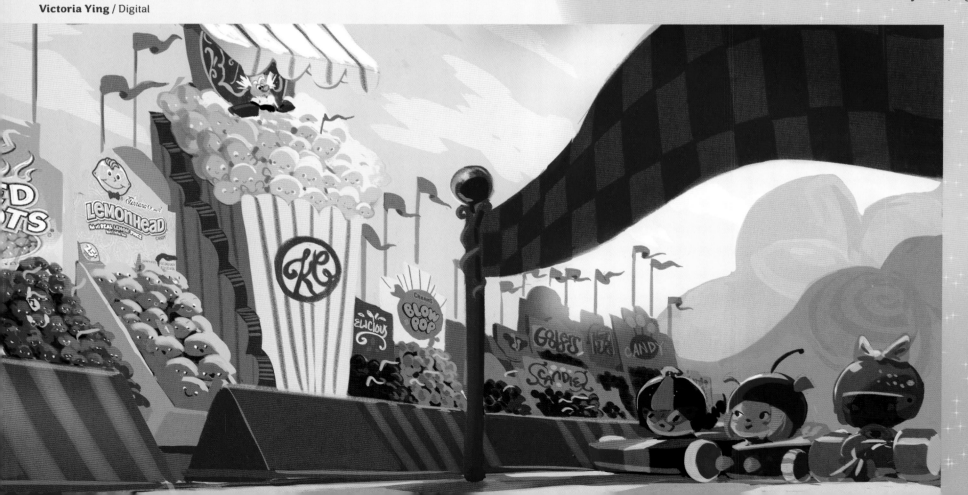

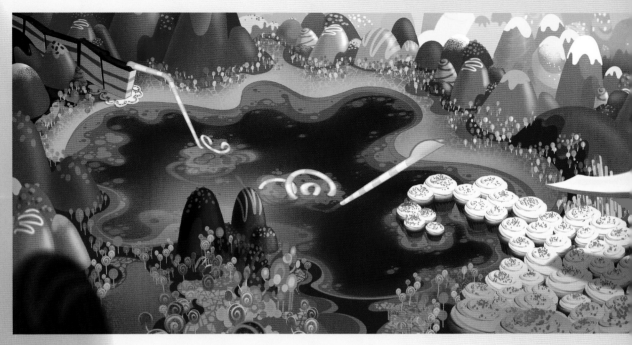

Scott Watanabe / Digital

Justin Cram / Digital

Lorelay Bove / Digital

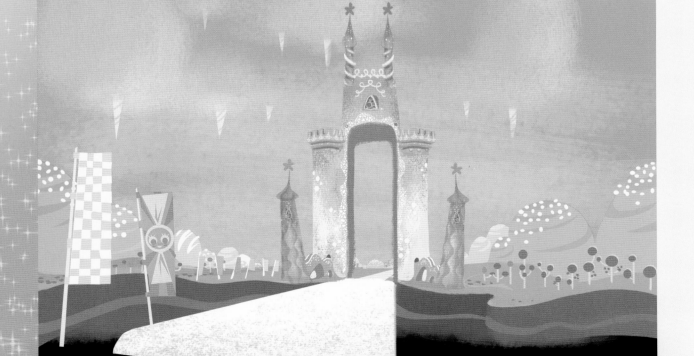

Jeff Turley / Digital

103

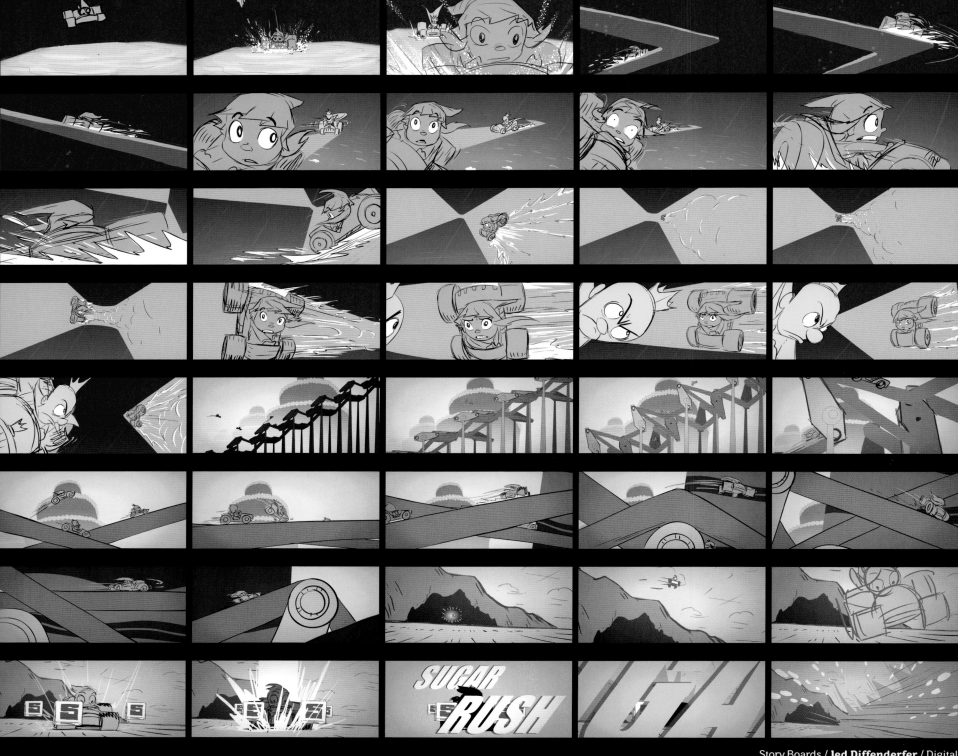

Story Boards / **Jed Diffenderfer** / Digital

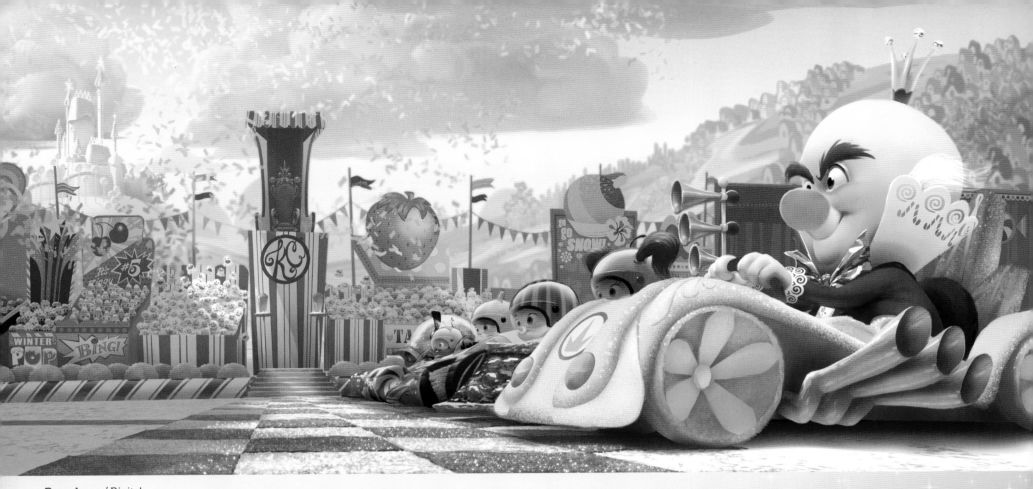

Ryan Lang / Digital

Ryan Lang / Digital

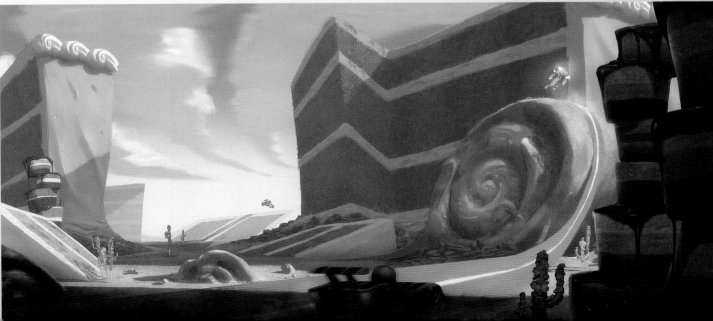

Scott Watanabe / Digital

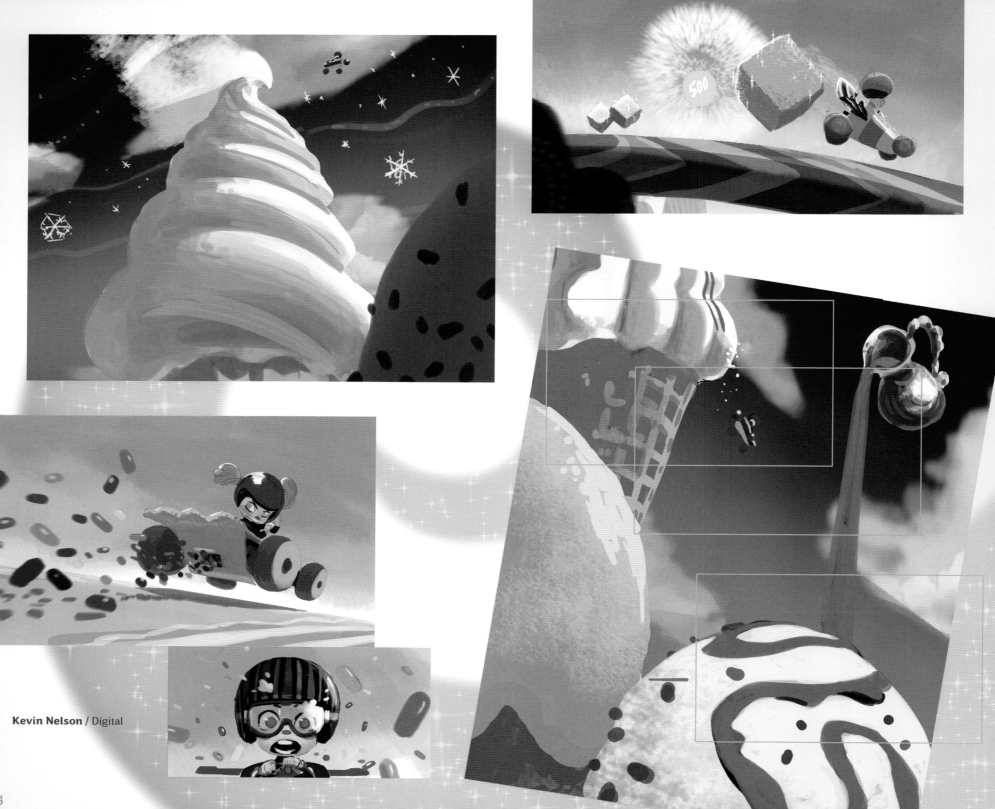

Kevin Nelson / Digital

106

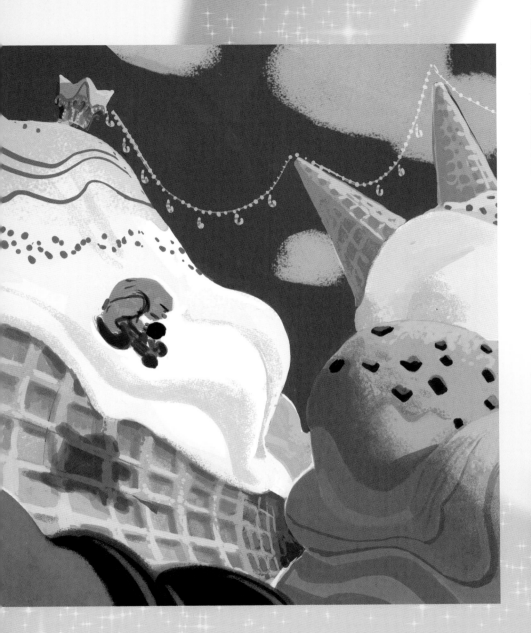

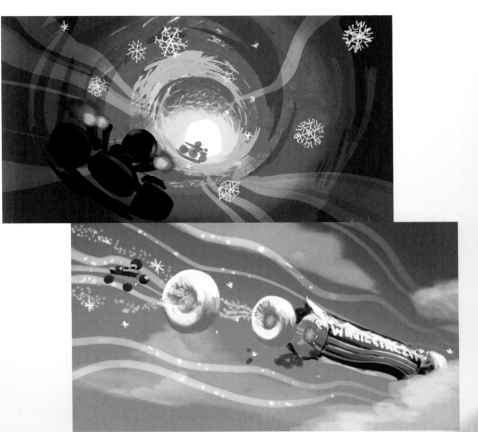

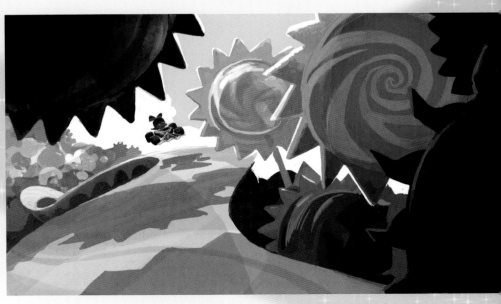

"When we get to the race there's a lot more saturation and punchy color. We tightened the shadows. Everything gets more intense."
—Adolph Lusinsky, *director of look & lighting*

Kevin Nelson / Digital

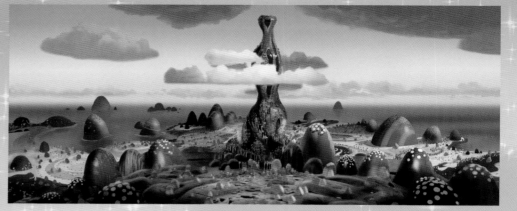

Paul Felix / Digital

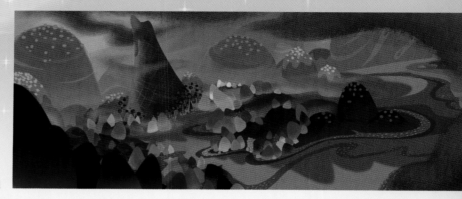

Lorelay Bove / Digital

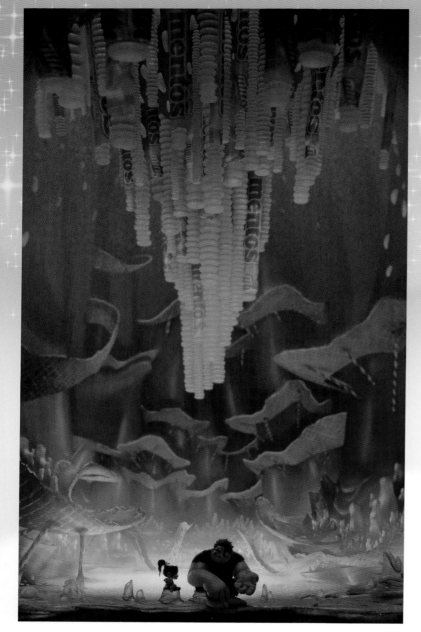

Ryan Lang / Digital

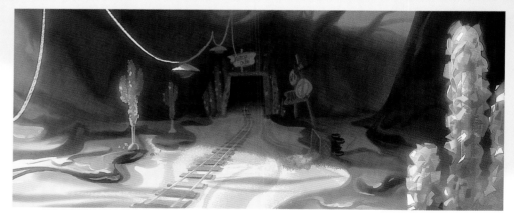

Jeff Turley / Digital

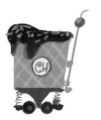 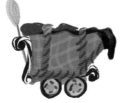 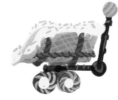 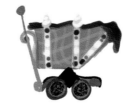 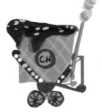

Jeff Turley / Digital

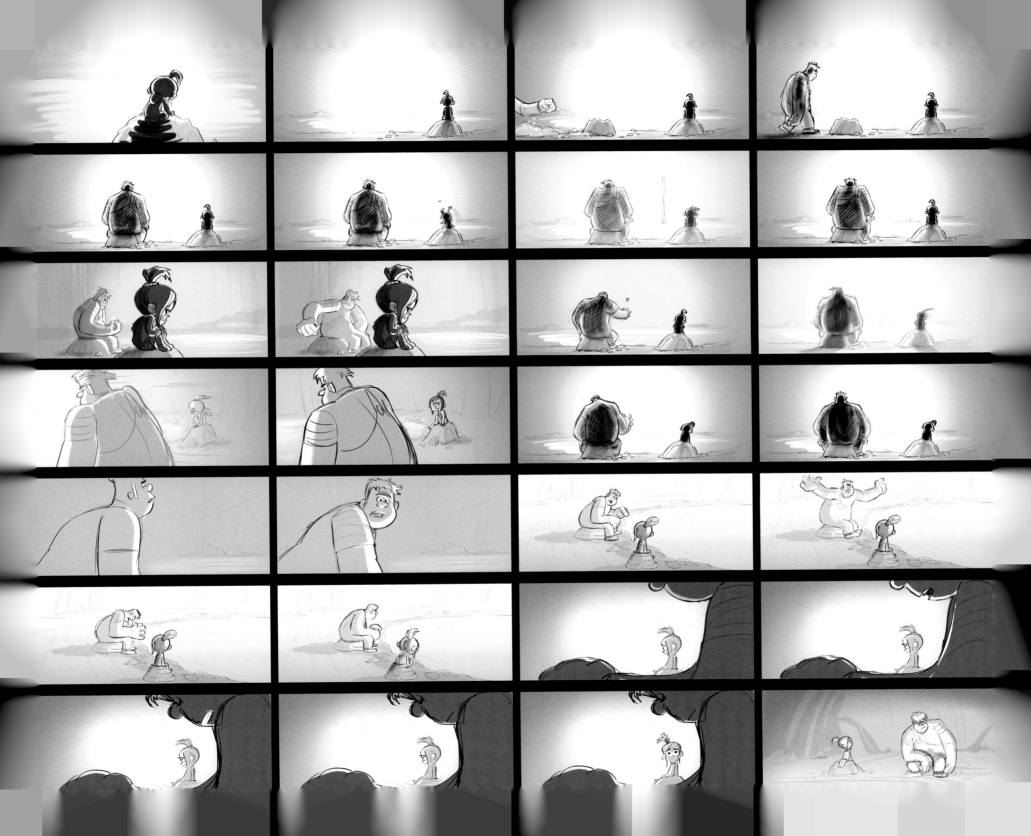

Building a Real Candy World

The proof that the visual development team was onto something exciting came when Mike asked Visual Development Artist Brittney Lee to build models of the Sugar Rush town square and racetrack out of actual candy.

"Brittney's models solved so many problems," explains Lorelay, "like how she figured out how to make the different textures of the ground. She covered some areas with frosting and others with crumbled cookies and cocoa powder." "Then," adds Clark, "our director of Look & Lighting, Adolph Lusinksy, photographed them and painted in some of our characters. The result was truly inspiring and established the benchmark for the authentic look the artists wanted for Sugar Rush."

Brittney recalls her diorama assignment with glee: "The day that I was painting faces on the popcorn people in King Candy's grandstand, I was like, 'There is no better job on the planet. Nobody else is doing something as cool and silly as I am right now.'" "Those models were phenomenal," Clark concludes. "When John Lasseter saw all of those candy faces in the grandstands, he just went crazy."

Brittney Lee / Confectionary

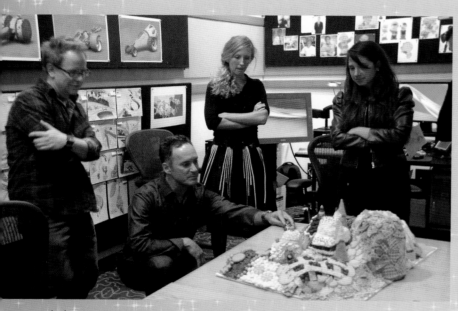

(l–r) Rich Moore, Mike Gabriel, Brittney Lee, Lorelay Bove

"In a lot of Lorelay's paintings, she did these quaint European walkways that were supposed to be sugar cubes. I couldn't actually get sugar cubes to make the right shapes, so I used white Necco wafers instead. I had to buy a ton of those multicolored Necco wafer sleeves and pull out all the white ones and break them into stone shapes."
—*Brittney Lee, visual development artist*

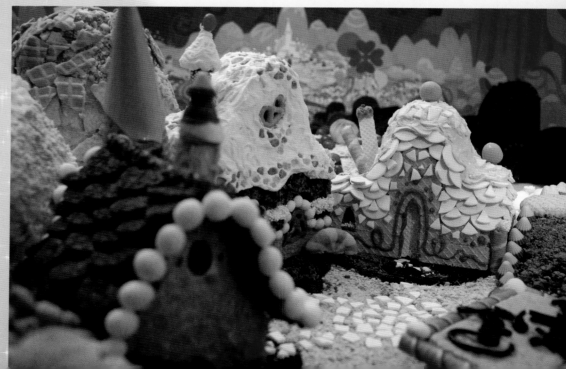

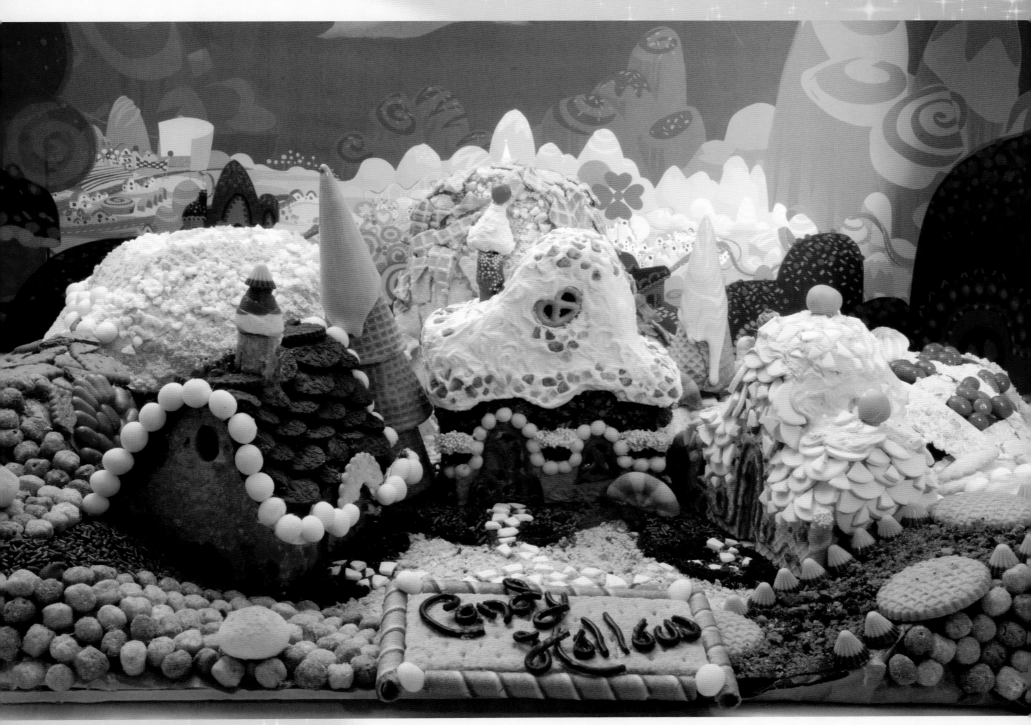

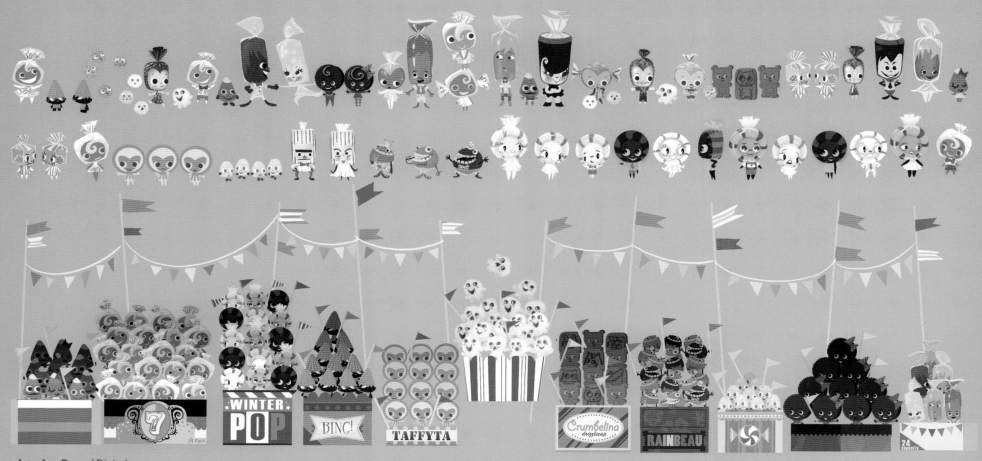

Lorelay Bove / Digital

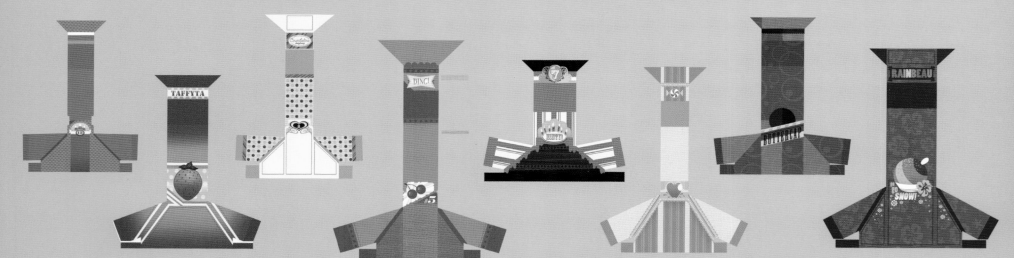

Brittney Lee / Digital

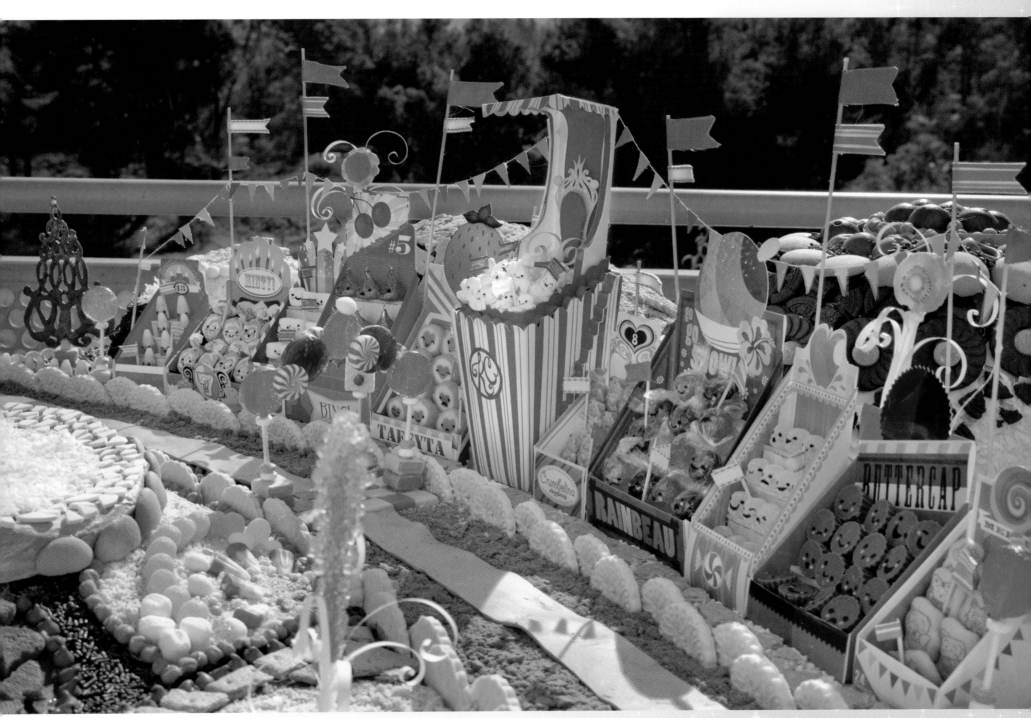

Brittney Lee / Confectionary, Paper

113

Delicious Lighting

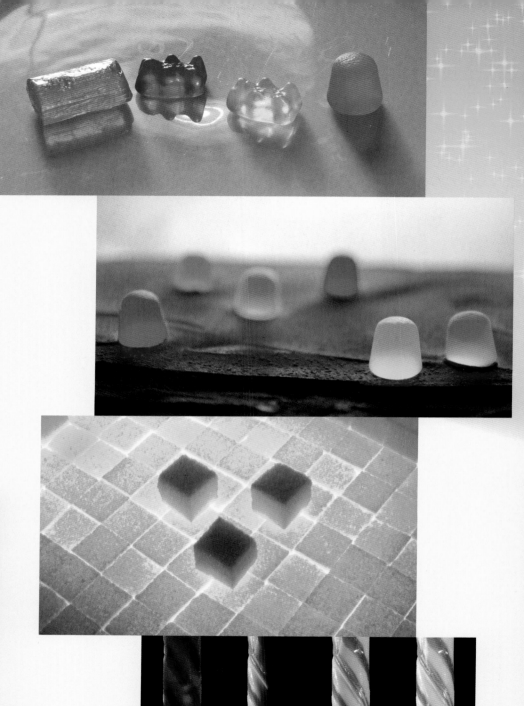

For a world made out of candy, the artists also needed to do some research on how to light food and maximize its mouthwatering appeal.

"We had half a dozen different food photographers come into the studio and talk about what makes food photographs appealing," explains Adolph. "Lighting is a huge part of it. It's really about keeping all the textures and forms really distinct and clear. Your eye wants to see what you're going to eat. The sessions were also inspirational for how to paint textures and exaggerate forms. For instance, in food photography they sometimes use motor oil for syrup because it's so thick."

The team discovered that in order to make food look both real and appetizing on screen, they would need to caricature it—a perfect prescription for a cartoon candy world.

Photos by Adolph Lusinsky

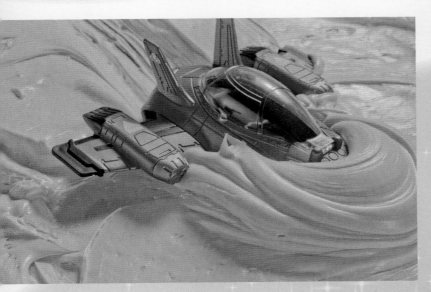

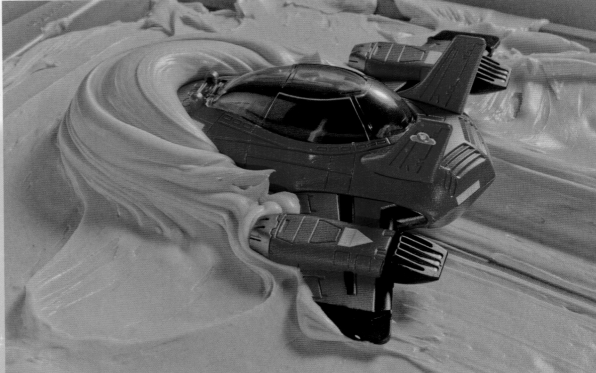

Photos by Adolph Lusinsky

Vanellope Von Schweetz

In Sugar Rush, Ralph meets his match in the lovable, impish Vanellope Von Schweetz, an outcast candy racer with a need for speed but no candy go-kart to achieve her destiny. Casting stand-up comedienne Sarah Silverman as the voice of Vanellope early on helped define her tough but appealing character, as well as the ragamuffin's facial expressions and poses. "I had a picture of Sarah up on the board of visuals I used to pitch the story to John for the first time, to help him visualize her as a videogame character," Rich remembers. "It's one of the few things that has stayed consistent through the movie." Phil Johnston concurs: "Vanellope always had a hint of Sarah, a hint of Cindy Lou Who, combined with this grubby little Pippi Longstocking moppet kid."

Vanellope's loner status in Sugar Rush is due to her flaw—her glitchy "pixelexia." To distinguish her as an outcast among the other racers, the artists initially played around with the idea of Vanellope being an abandoned, unfinished character. Taking inspiration from half-built characters before the final texture and render process, Mike Gabriel and his team tried versions of Vanellope with gray and green skin. But, Mike explains, "Bottom line, she looked like a zombie. It just wasn't appealing." Ultimately, the artists gave her a warm flesh tone and expressed her glitchiness through her tendency to stutter visually on screen.

Shiyoon Kim / Digital

Chad Stubblefield (Model), **Michele Robinson** (Look) / Digital

Vanellope's costume also became key in defining her as an outcast. But early on, Rich recalls, the designs felt old fashioned. "She was wearing prairie dresses and felt a little too cutesy-poo. Even the poses were a little too soft. That's totally appropriate for Snow White, but for Vanellope, alarms were going off in my head." In order to make Vanellope feel more contemporary and a bit more aggressive, Rich got the idea to dress her in a hooded sweatshirt: "I started asking, what would you see a street kid wearing? Well, a hoodie. We put that on her and suddenly it all came together." "When Rich put her in that hoodie and those mismatched stockings, all of a sudden I could relate to her," says Mike. "I started sticking bits of candy in her hair and making it wilder, a little more unkempt, and then tied it back with a rope of red licorice, which is her theme candy. We wanted to make Vanellope look like she needs someone to take care of her, and she finally finds a surrogate parent in Ralph."

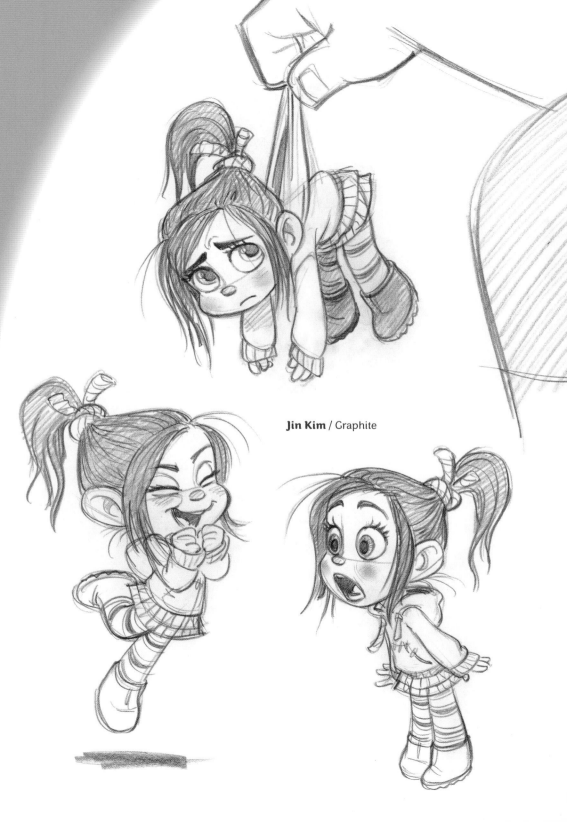

Jin Kim / Graphite

Lorelay Bove / Digital

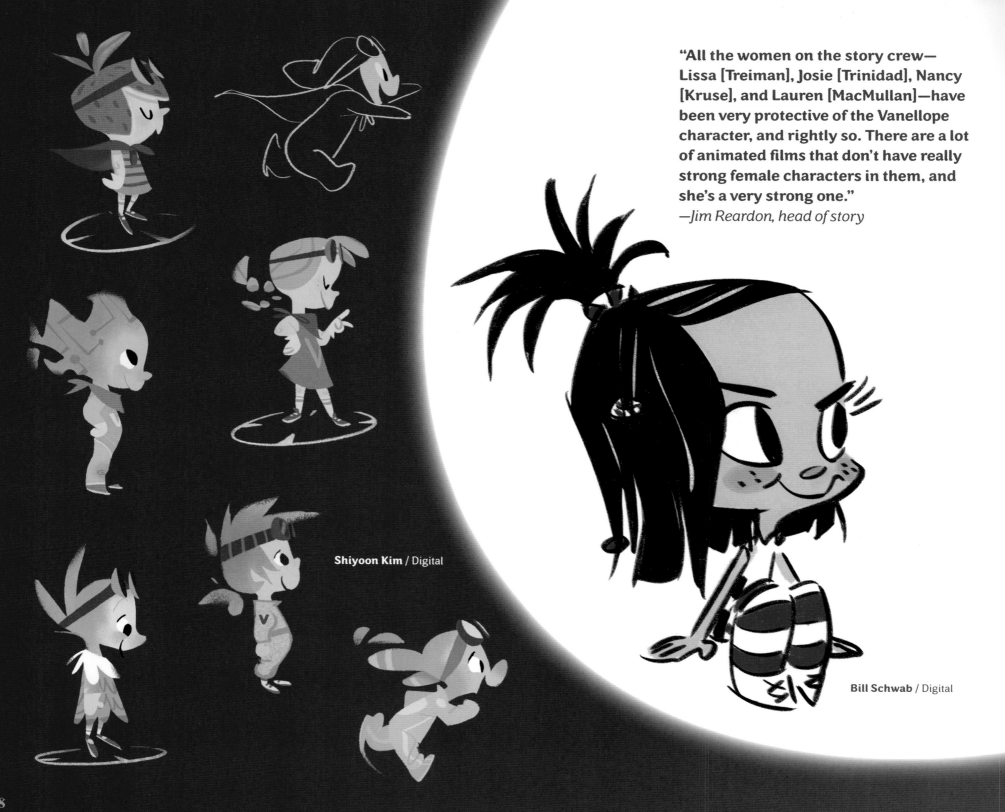

"All the women on the story crew—Lissa [Treiman], Josie [Trinidad], Nancy [Kruse], and Lauren [MacMullan]—have been very protective of the Vanellope character, and rightly so. There are a lot of animated films that don't have really strong female characters in them, and she's a very strong one."
—Jim Reardon, head of story

Shiyoon Kim / Digital

Bill Schwab / Digital

118

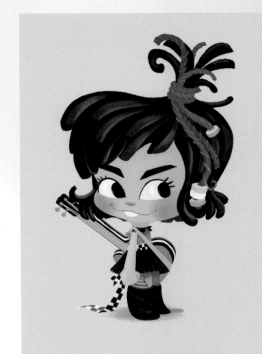

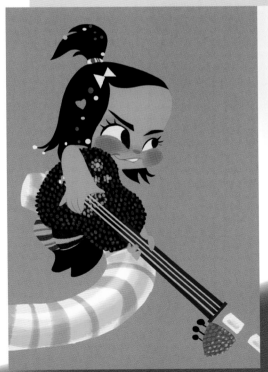

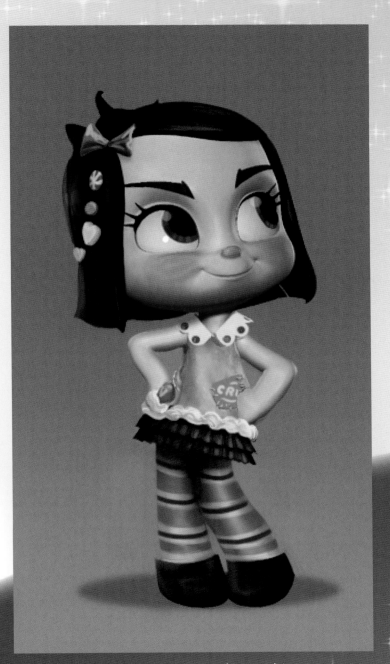

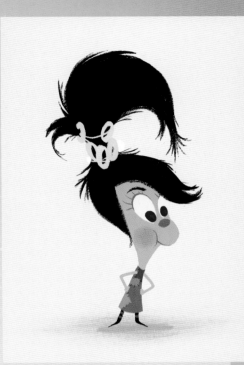

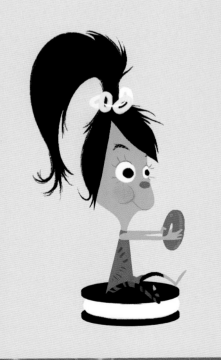

Chad Stubblefield (Model), **Mike Gabriel** (Paintover) / Digital

Lorelay Bove / Digital

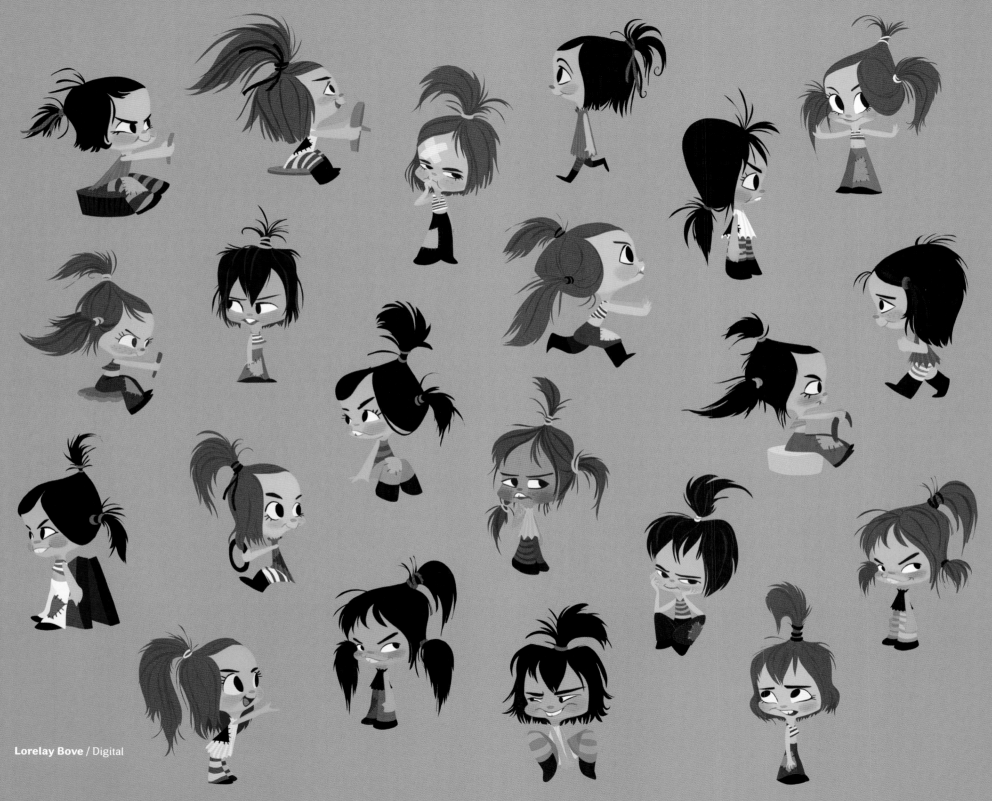

Lorelay Bove / Digital

120

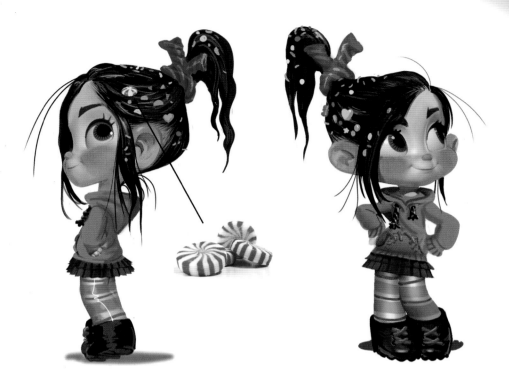

Chad Stubblefield (Model), **Mike Gabriel** (Paintover) / Digital

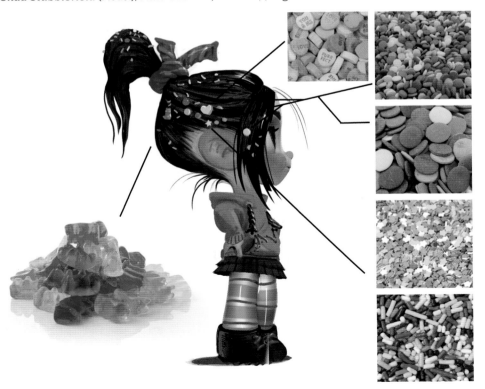

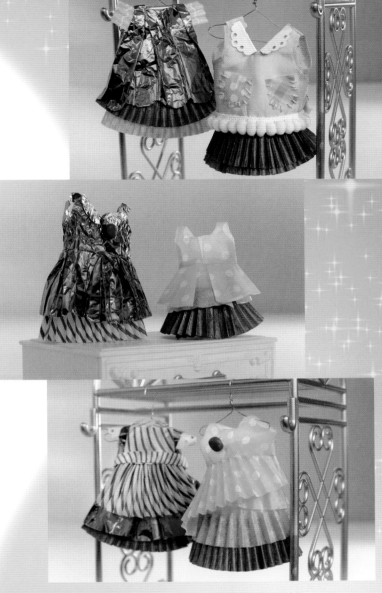

Victoria Ying / Candy Wrappers

"I've been sewing doll clothes for a long time, as a hobby. I designed clothes for Vanellope out of fabric and candy wrappers, because I wanted to help find a concept for how the character of Vanellope would hand-make her clothes, but with a sophisticated style."
—*Victoria Ying, visual development artist*

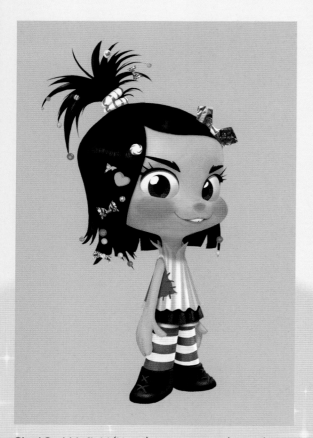

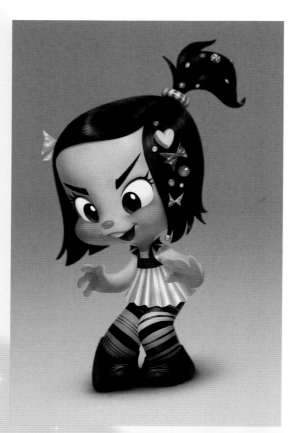

Ryan Lang / Digital

Chad Stubblefield (Model), **Lorelay Bove** (Design) / Digital

Rich Moore / Pen

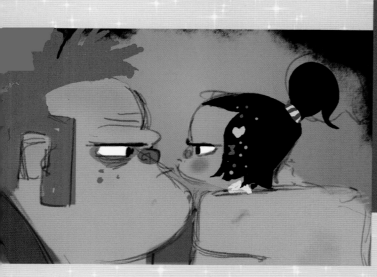

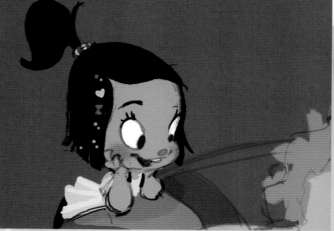

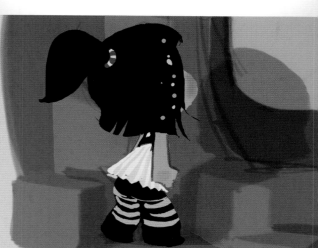

Byron Howard / Digital

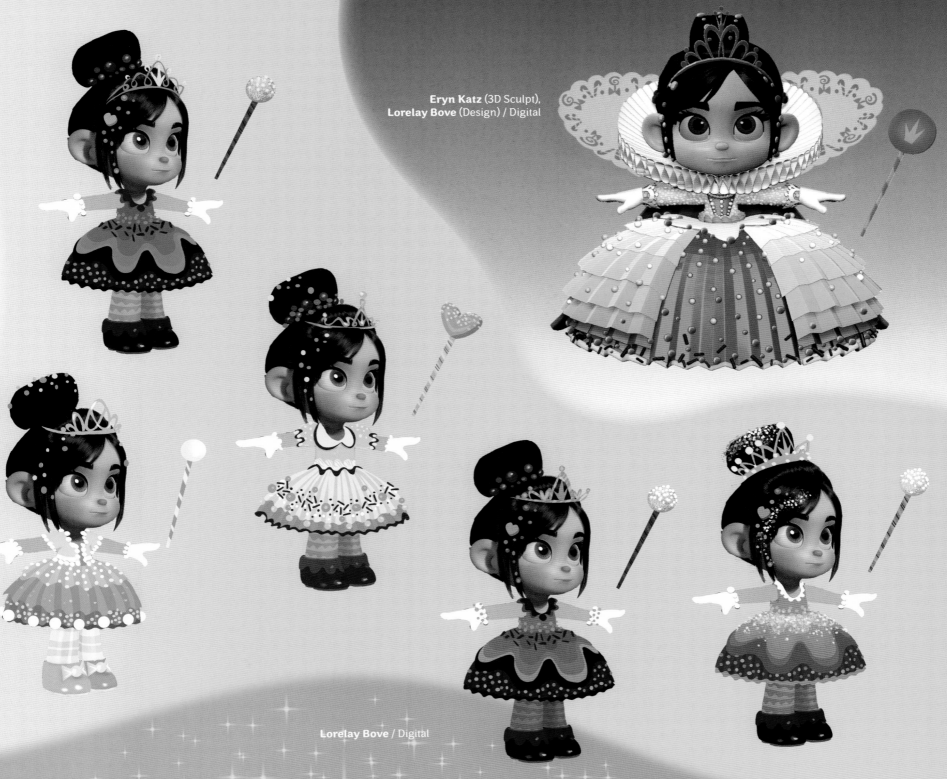

Eryn Katz (3D Sculpt),
Lorelay Bove (Design) / Digital

Lorelay Bove / Digital

Candy Racers and Go-Karts

Creating each custom-built candy go-kart for the Sugar Rush racers was truly a team effort.

Early on, Lorelay Bove did a painting of the candy racers sitting in little cakes, like muffins and petit fours. Mike remembers that "they were adorable, but we needed to make them a little more badass, so Visual Development Artists Kevin Nelson and Shiyoon Kim took a crack at them."

"What I tried to do," Kevin explains, "was to figure out what genre of race car each type of candy naturally wanted to be. For example, as soon as I turned a candy corn on its side, it looked exactly like a midget sprint car. And when I took two Rice Krispies Treats and moved one slightly higher than the other, it was a rat-rod! The best race cars were the ones for which I didn't have to change the foodstuff whatsoever."

"Then Visual Development Artist Ryan Lang took Kevin's designs and painted a lineup of the racers," continues Rich, "and made them look almost photorealistic. It's one of the pieces of artwork from the film that gets the most response from people coming into the studio from the outside. They look at those cars and they can suddenly see the movie."

Visual Development Artist Cory Loftis explains the design evolution of the most important kart of all: "The ultimate design for Vanellope's kart came from John Lasseter's suggestions to make it look like she, a child, made it. I spent a lot of time looking at pictures of cakes that little kids decorated for Mother's Day. They're terrible, covered in everything the kid could get on there. In comparison, my designs were way too orderly. After I started getting more random, the kart came together and was a lot of fun to do."

Lorelay Bove / Gouache

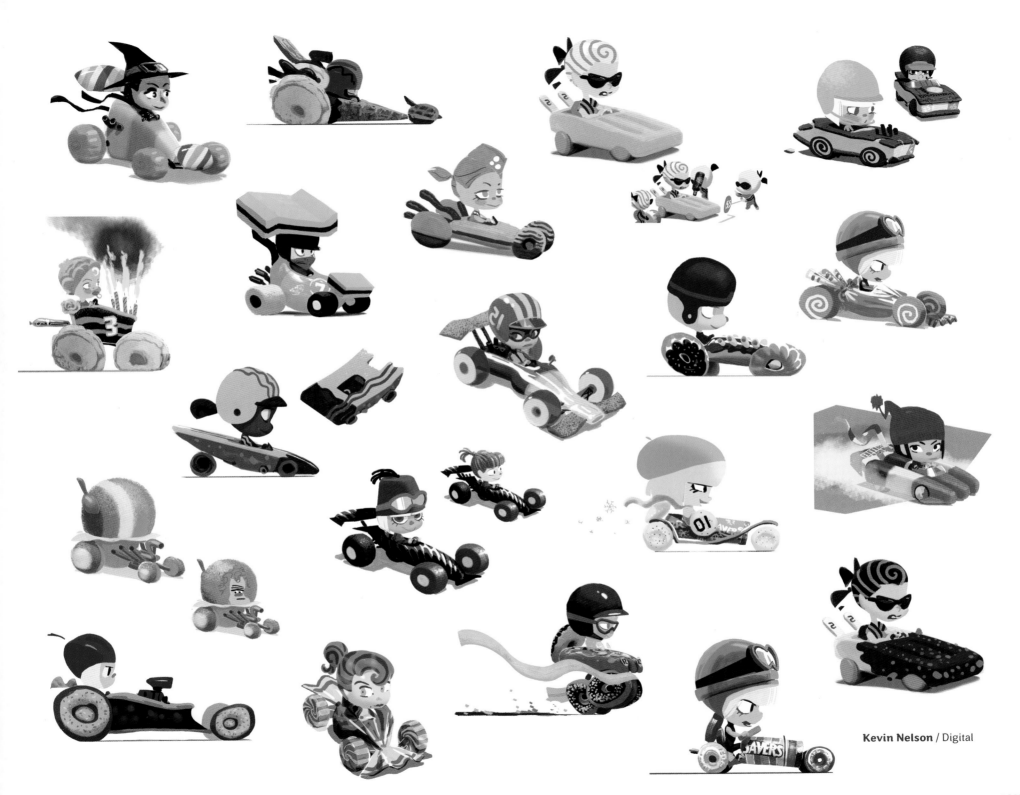

Kevin Nelson / Digital

125

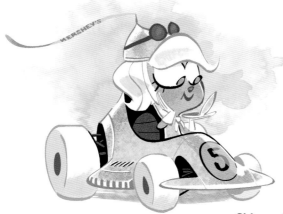

Shiyoon Kim / Digital

"Lorelay had some really amazing candy-themed go-kart designs. They inspired me to do this one Hershey's Kisses car. The racer's helmet was the top part of the Kiss and when she slid into the seat, her head fit right into the kart and turned into this one giant Hershey's Kiss. That was a fun idea."
—*Shiyoon Kim, visual development artist*

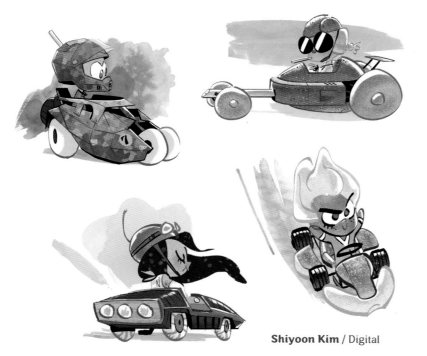

Shiyoon Kim / Digital

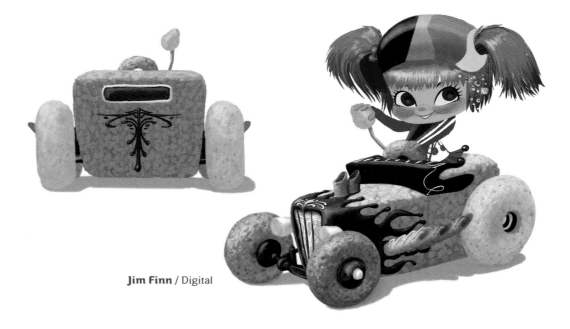

Jim Finn / Digital

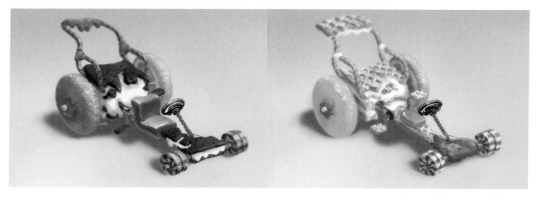

Scott Watanabe / Digital

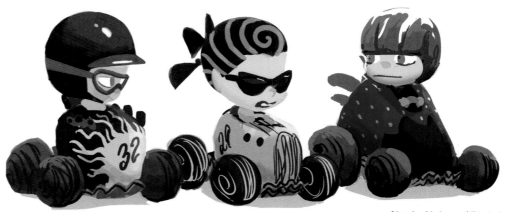

Kevin Nelson / Digital

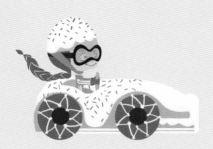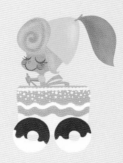

Lorelay Bove / Digital

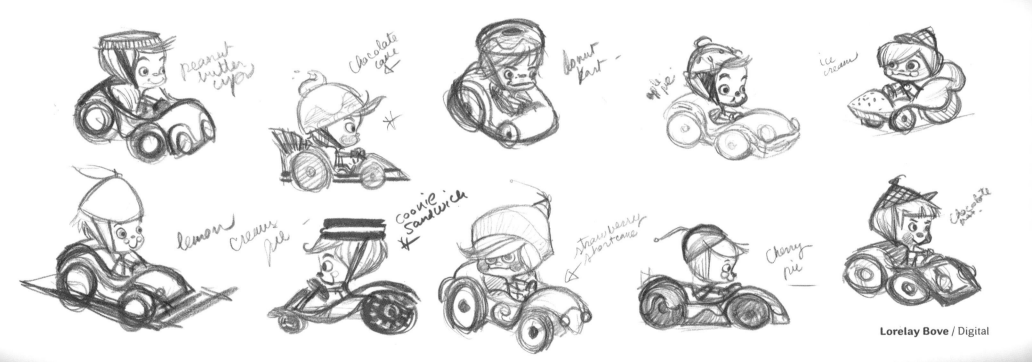

peanut butter cup

chocolate cake

donut kart

apple pie

ice cream

lemon creme pie

cookie sandwich

strawberry shortcake

cherry pie

chocolate

Lorelay Bove / Digital

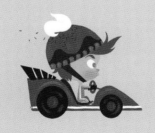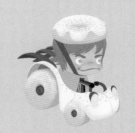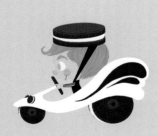

Lorelay Bove / Digital

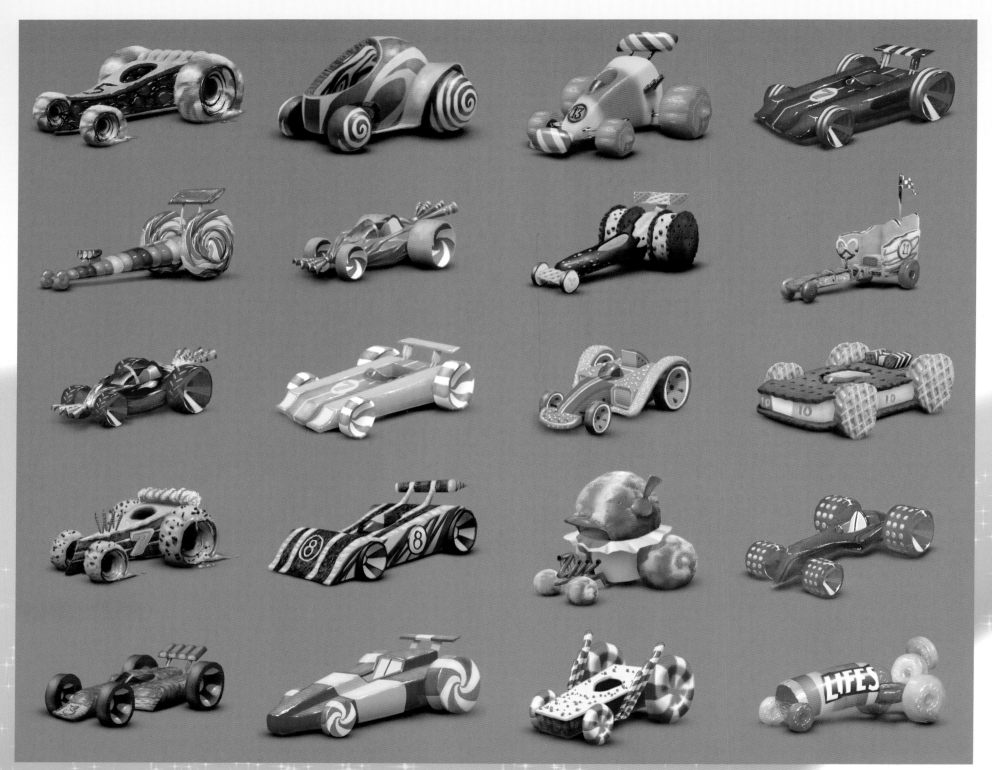

Ryan Lang / Digital

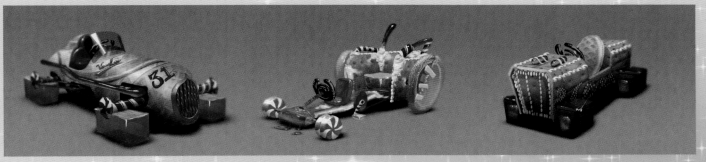

Scott Watanabe / Digital

Ryan Lang / Digital

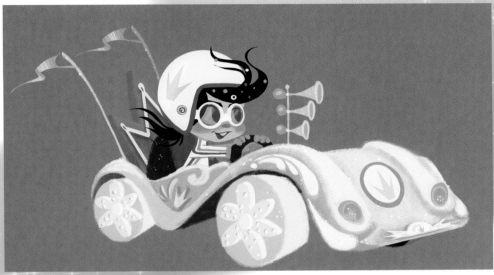

Lorelay Bove / Digital

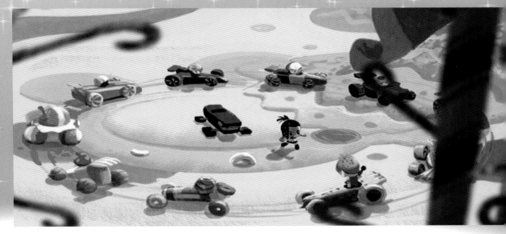

Kevin Nelson / Digital

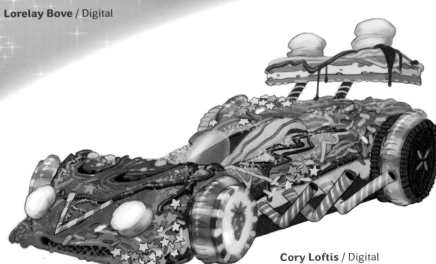

Cory Loftis / Digital

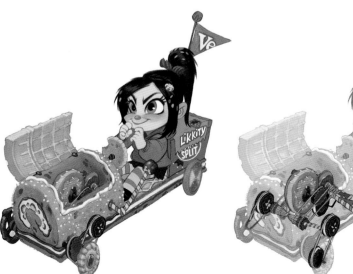

Cory Loftis / Digital

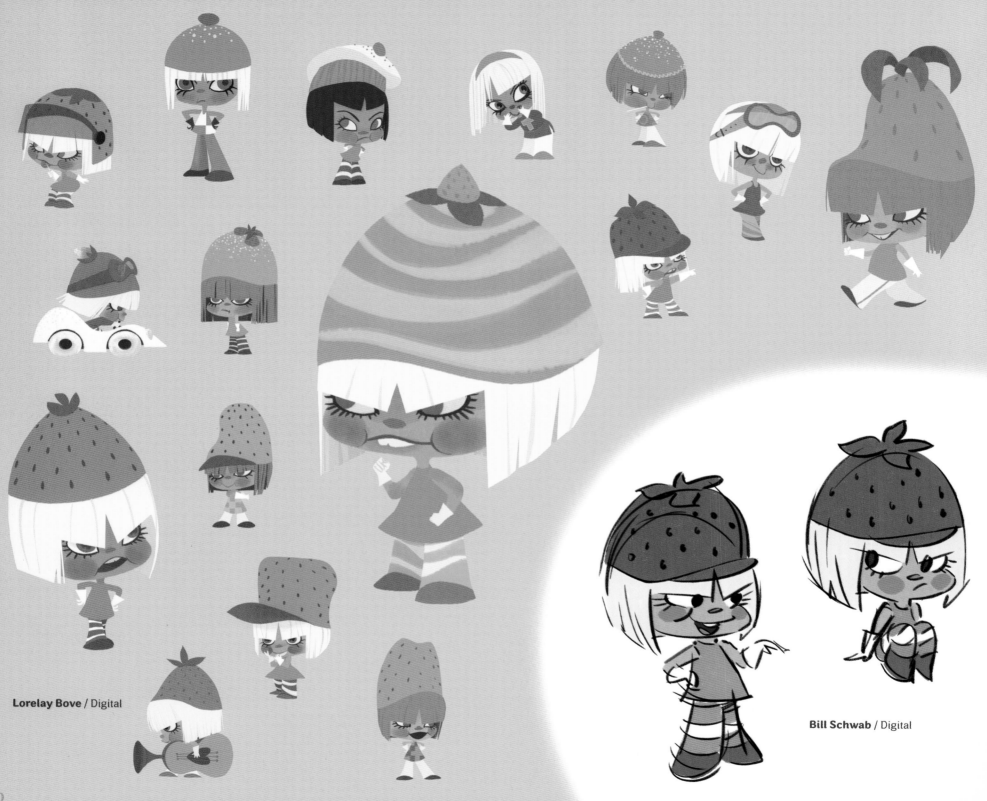

Lorelay Bove / Digital

Bill Schwab / Digital

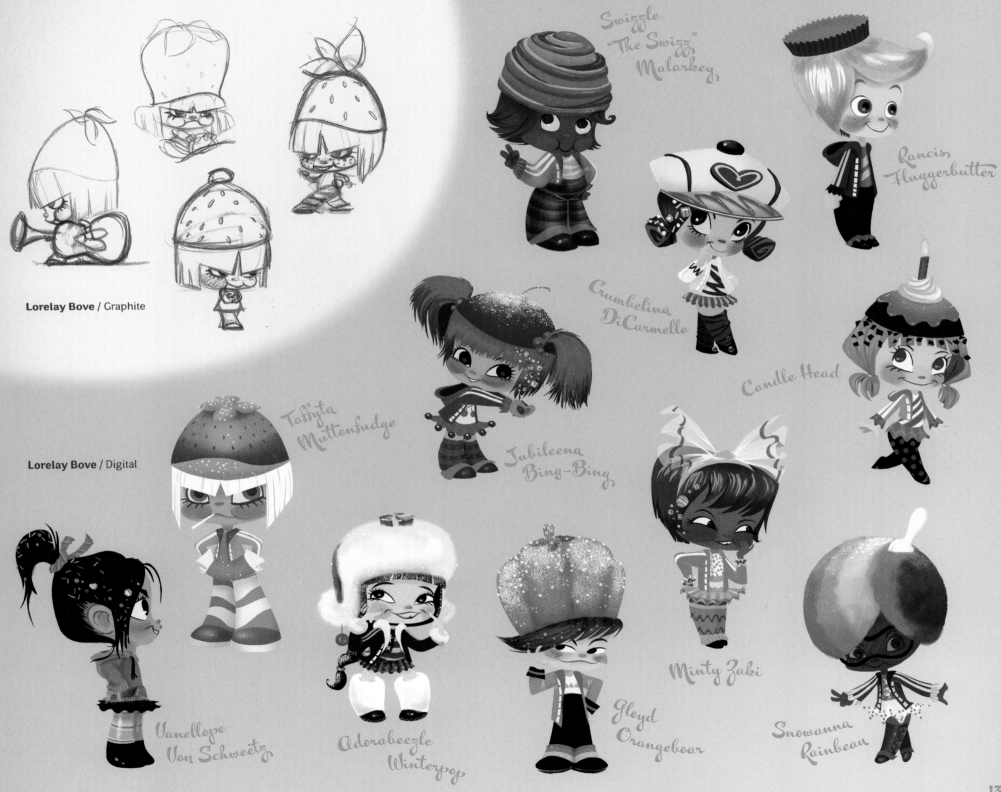

Lorelay Bove / Graphite

Lorelay Bove / Digital

Swizzle "The Swizz" Malarkey

Rancis Fluggerbutter

Crumbelina DiCarmello

Candle Head

Taffyta Muttonfudge

Jubileena Bing-Bing

Minty Zaki

Vanellope Von Schweetz

Adorabeezle Winterpop

Gloyd Orangeboar

Snowanna Rainbeau

In Search of a Great Villain

The very first villain of Sugar Rush was a truant officer who captured wayward children, like Vanellope. "But," remembers Head of Story Jim Reardon, "the character wasn't playing in the early script drafts. So we started spitballing about other comic villains in Disney films. Then, we started laughing at the idea of Ed Wynn, a lovable old vaudeville actor, playing against type, as a mob boss like a Tony Soprano." And King Candy was born.

The character of King Candy claims to be the rightful ruler of Sugar Rush, and its star racer. Over the course of the film, however, he reveals that his benevolence is just a sugar coating. "King Candy is a gold-mine character," laughs Mike. "He's one of those characters that falls in your lap and you've just got it from the beginning. We just made that nice bald head of his look like a bonbon in a paper candy dish. And in order to make him stand out in a realm full of all these vibrant colors, we've made everything associated with him pure sugar white."

"Mike Gabriel's design was fun to draw," says Tom Ellery, the story artist credited with helping define King Candy. "I just went with it. He was a fun character to play with, because you could pretty much do anything."

Chad Stubblefield and **Dylan Ekren** (Model), **Pamela Spertus** (Look) / Digital

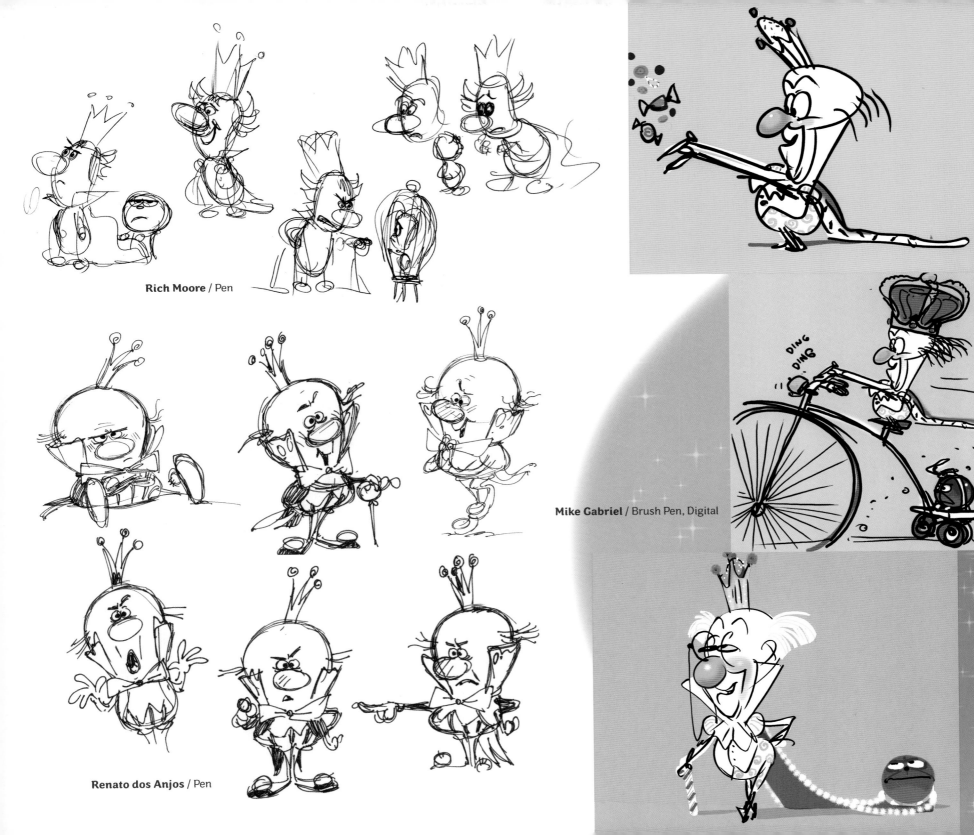

Rich Moore / Pen

Renato dos Anjos / Pen

Mike Gabriel / Brush Pen, Digital

DING DING

133

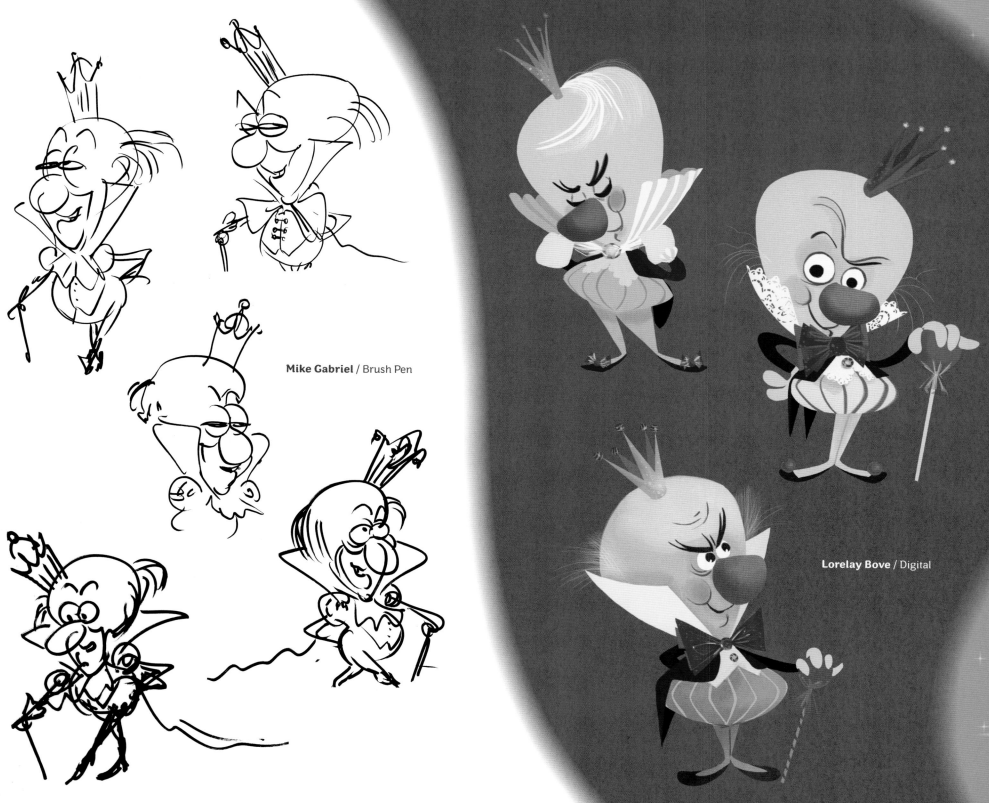

Mike Gabriel / Brush Pen

Lorelay Bove / Digital

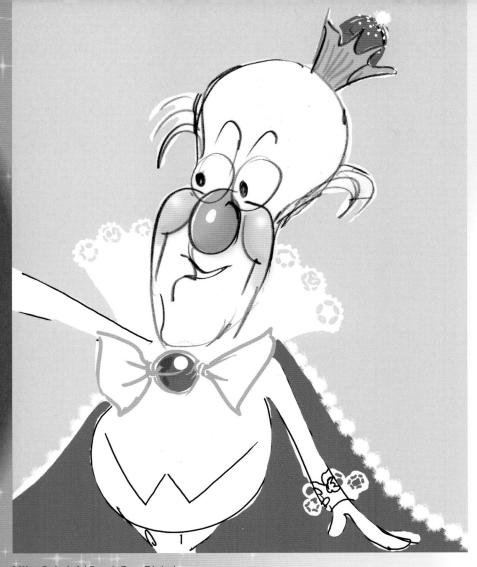

Mike Gabriel / Brush Pen, Digital

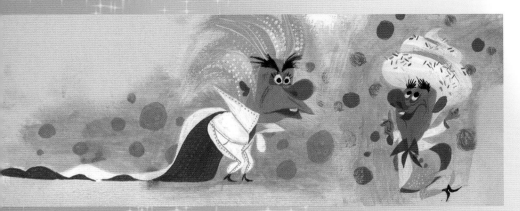

Jeff Turley / Gouache

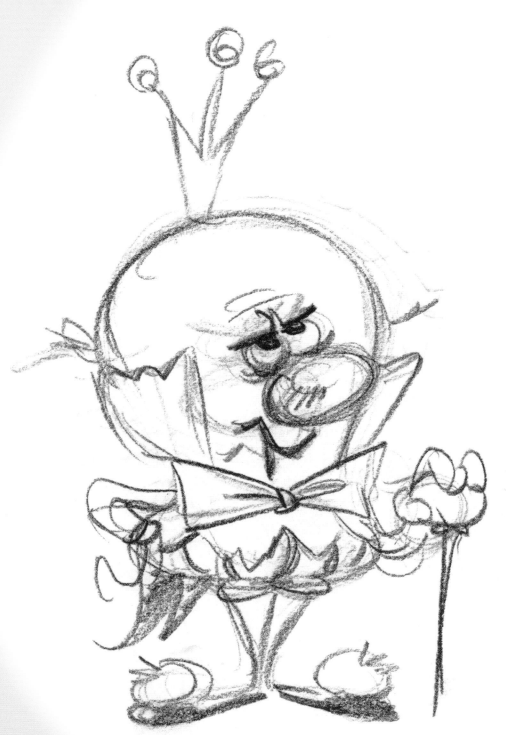

Renato dos Anjos / Graphite

135

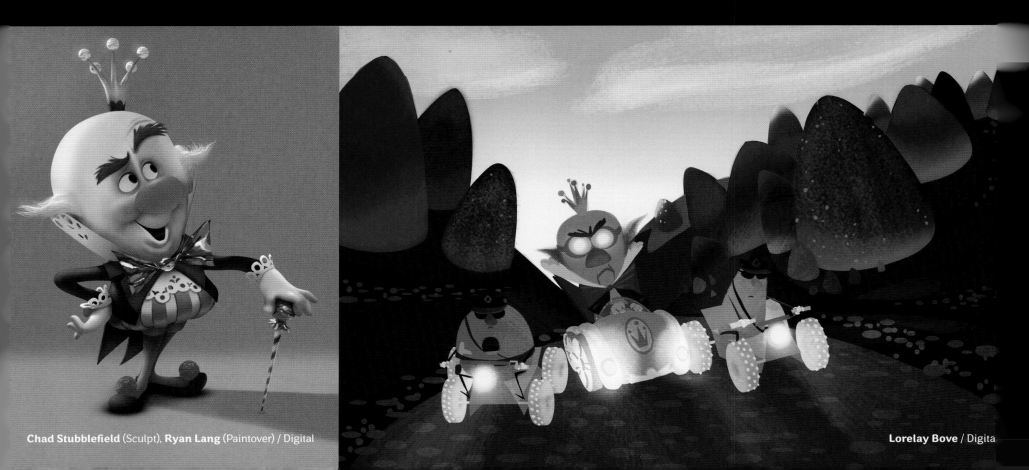

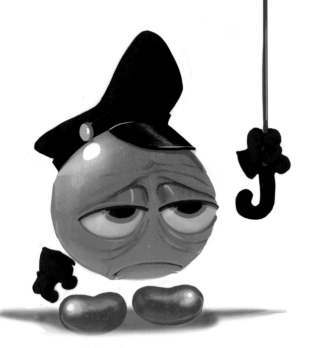

Mike Gabriel / Digital

Mike Gabriel / Digital

"For Sour Bill, Mike Gabriel had this idea of the character just having floating hands and floating jelly beans for feet. Eric Goldberg did some 2D tests with him and totally nailed it. We didn't even have a model built yet for Sour Bill but it was as if I already knew him."
—*Renato dos Anjos, animation supervisor*

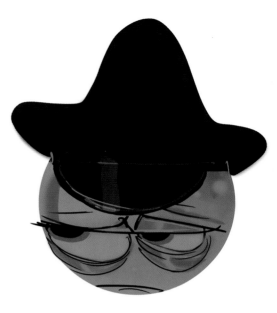

Mike Gabriel / Digital

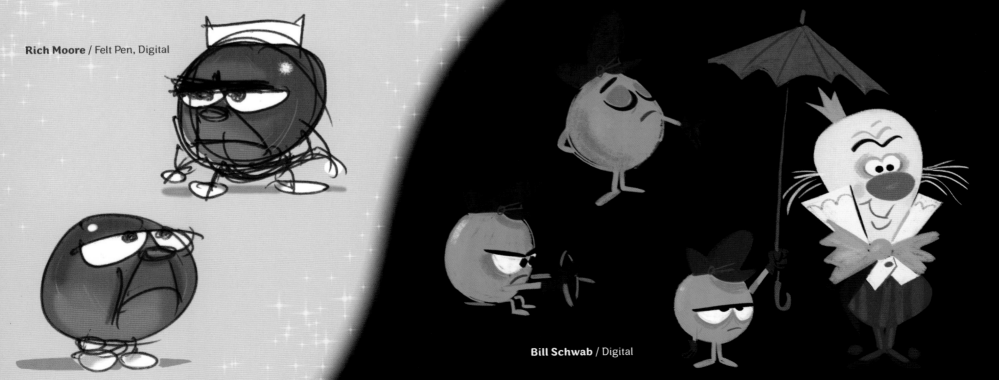

Rich Moore / Felt Pen, Digital

Bill Schwab / Digital

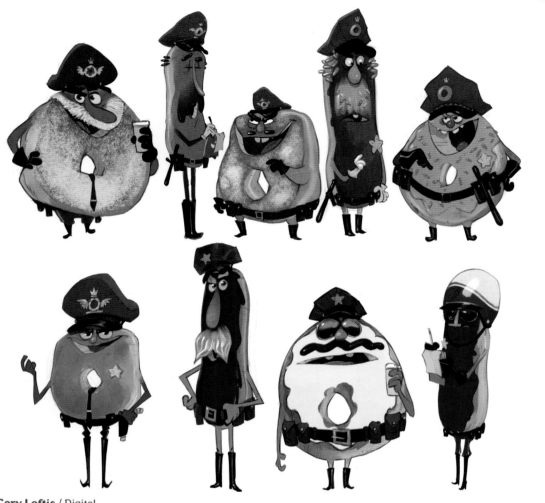

"Cory Loftis nailed the design on the donut cops. Sometimes you just have to be willing to put pants on donuts. He came up with the wafer cookie as their riot shield that was the perfect contrast of sweetness with rough-and-toughness. The bear claws came in at the end because Lasseter wanted to add a tougher quality to the squad. They're the heavy hitters, but Ralph really beats the pudding out of them."
—*Mike Gabriel, art director*

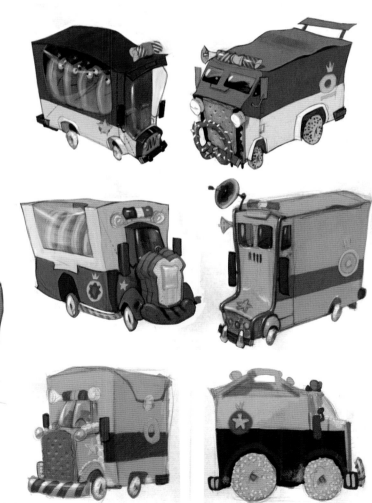

Cory Loftis / Digital

Hiroki Itokazu (Model), **Mike Gabriel** (Paintover) / Digital

Cory Loftis / Digital

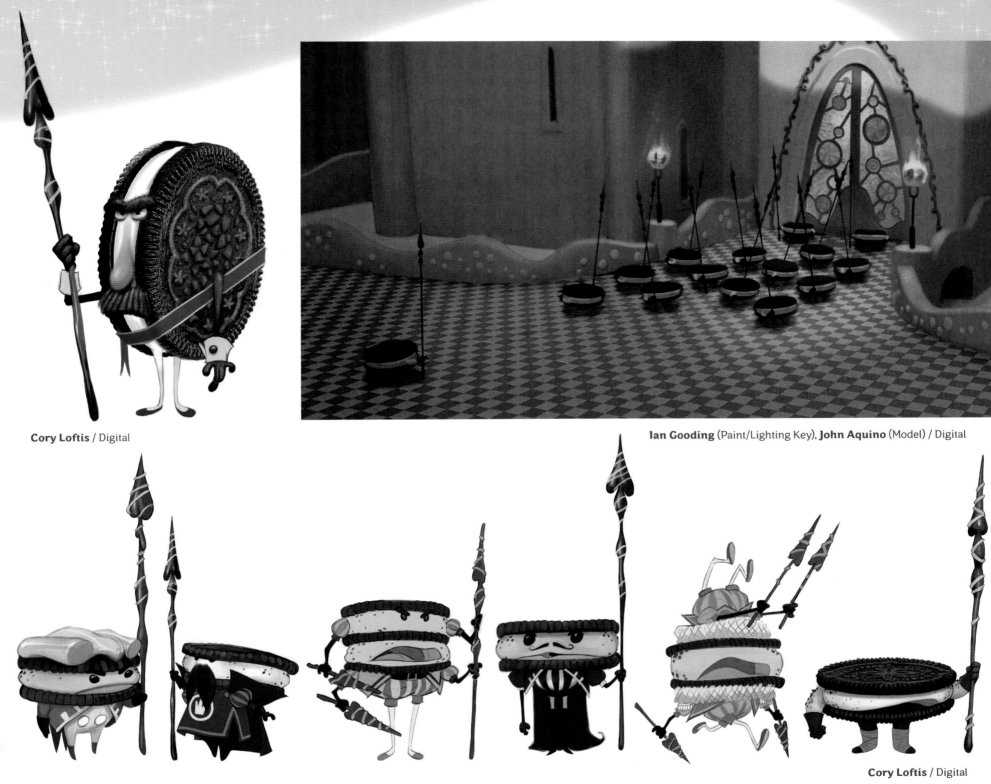

Cory Loftis / Digital

Ian Gooding (Paint/Lighting Key), **John Aquino** (Model) / Digital

Cory Loftis / Digital

139

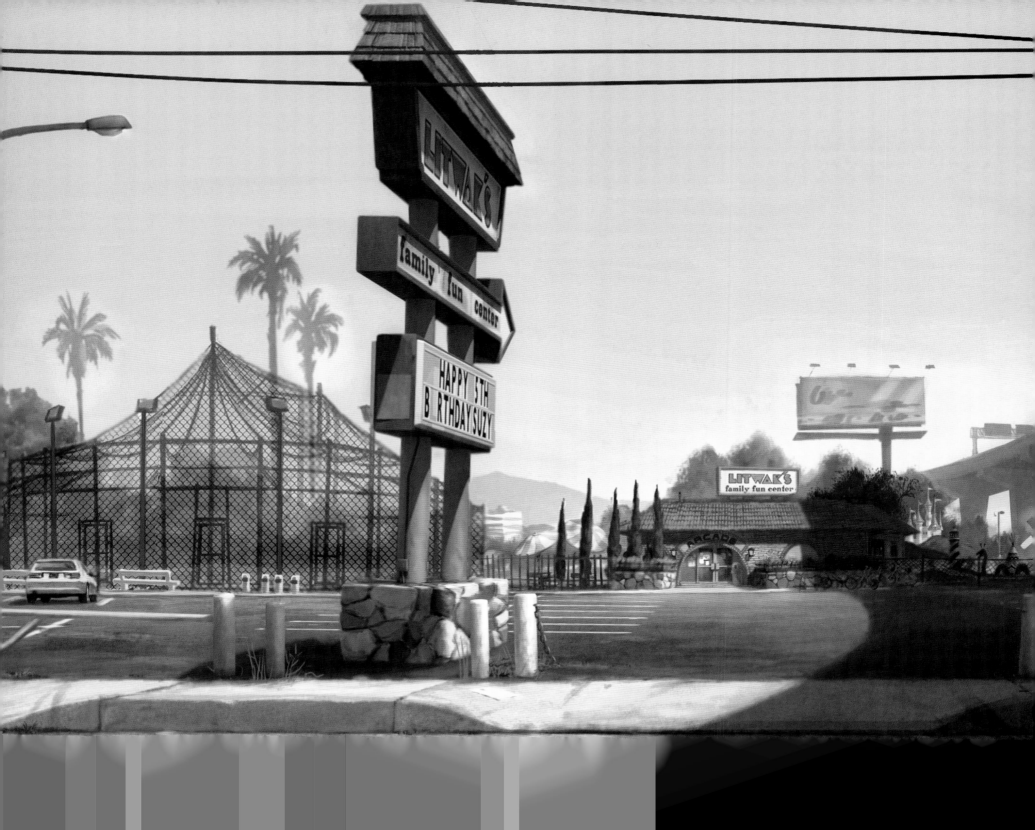

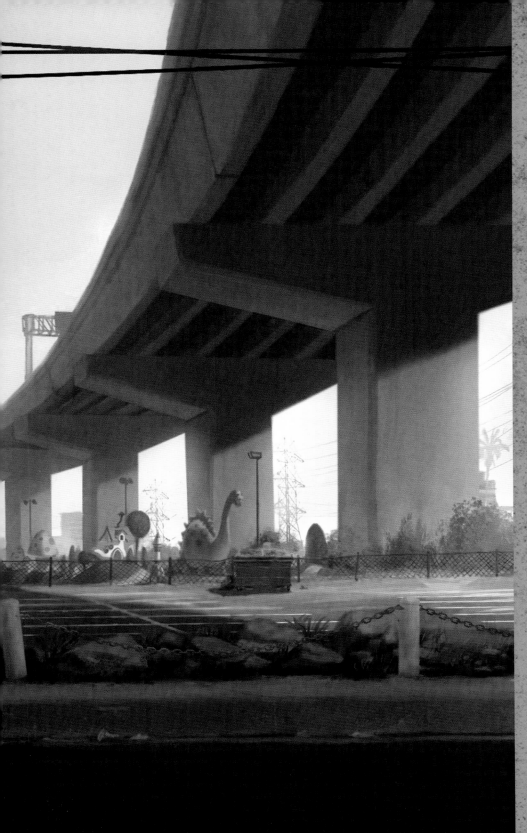

Mac George, Jim Finn / Digital

THE ARCADE

THE SECONDARY WORLDS OF WRECK-IT RALPH

While Fix-It Felix, Jr., Hero's Duty, and Sugar Rush are the primary game worlds through which Ralph journeys, Mike Gabriel, Ian Gooding, and the rest of the *Wreck-It Ralph* artists also had to create several additional worlds for the film.

PAC-MAN

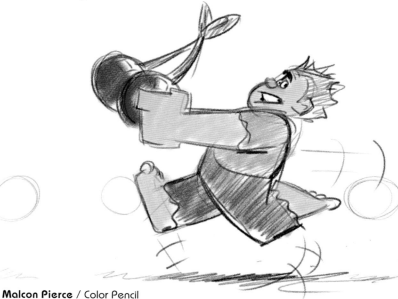

Justin Cram / Digital

W reck-It Ralph begins inside the cabinet of one of the most beloved videogames of all time. But the filmmakers wanted to delay the reveal of the location and let the setting initially read as just a group therapy meeting for bad guys, known as BadAnon.

The characters sit in a mundane room on folding chairs and clutch Styrofoam coffee cups. "Rich wanted the space to feel like a multipurpose room, like cubicles in an office space," says Mike. Ian elaborates, "The vacuuformed wall panels just repeat and repeat. They're so modular that you could make any maze pattern out of them that you wanted—or one maze in particular."

When the characters file out of the room at the end of the meeting, and the audience sees Pac-Man's iconic game screen, the key was to "Keep it simple, keep it pure. Don't try to be too clever with your designs," explains Mike. The design of the original game informed this philosophy. Mike continues, "We found a photo of the guy who invented the gameplay of Pac-Man. In it, he was holding up his original graph paper drawings of the game board and the characters. That was like looking at the Holy Grail."

Scott Watanabe / Digital

Malcon Pierce / Color Pencil

Wayne Unten / Digital

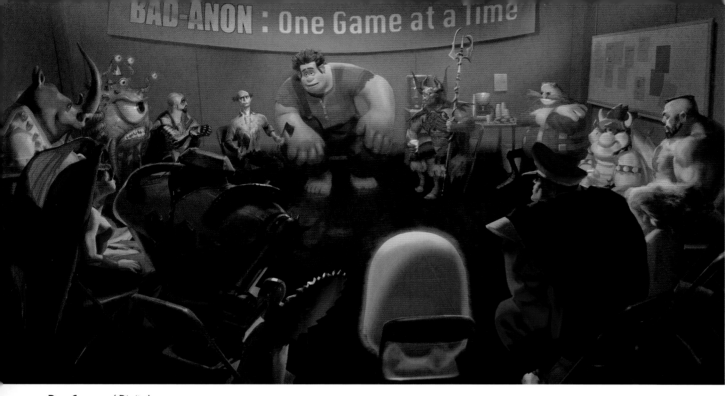

Dan Cooper / Digital

Ryan Lang / Digital

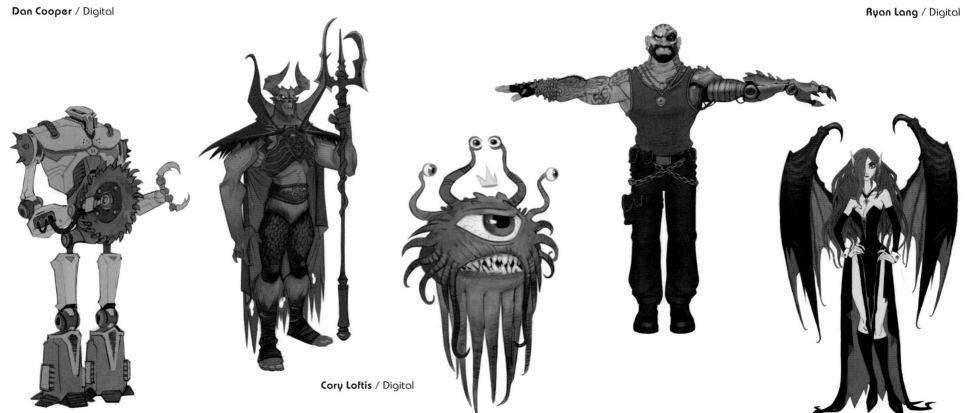

Cory Loftis / Digital

143

TAPPER'S

The bar that Ralph visits is another '80s-era videogame, called Root Beer Tapper's. In it, Ralph sees a Hero's Duty soldier for the first time and finds his mission.

But in creating Tapper's, Ian and the team found another design challenge. "Doing the literal version of the videogame environment with its intense ultramarine wallpaper was a little surreal as a bar," explains Ian. "Bars tend to have a lot of warm materials that make a place inviting and cozy. So we deviated from the original game design and added a few touches—old-fashioned wall sconces, crown molding and wainscoting on the walls—to warm the place up and try to make it feel more like a bar. It's an interesting balance. You have to walk a line between being faithful to the game and giving the film what it needs emotionally to get the story across."

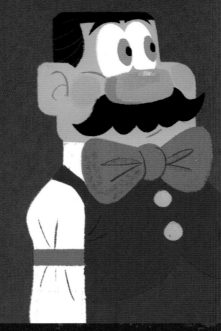

Bill Schwab / Digital

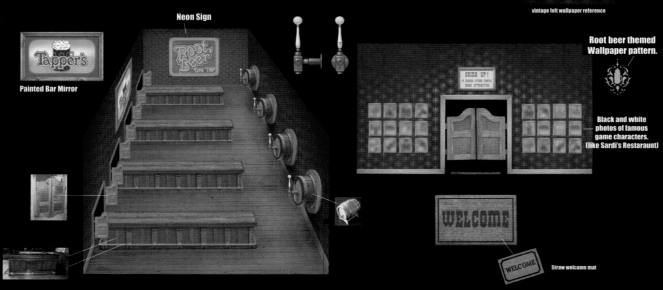

Neon Sign

Painted Bar Mirror

vintage felt wallpaper reference

Root beer themed Wallpaper pattern.

Black and white photos of famous game characters. (like Sardi's Restaraunt)

Straw welcome mat

Andy Harkness / Digital

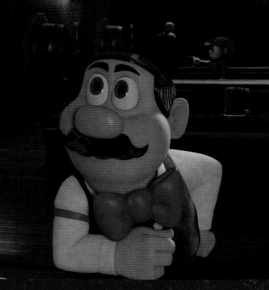

Susan Kim (Model),
Sara Cembalisty (Look) / Digital

144

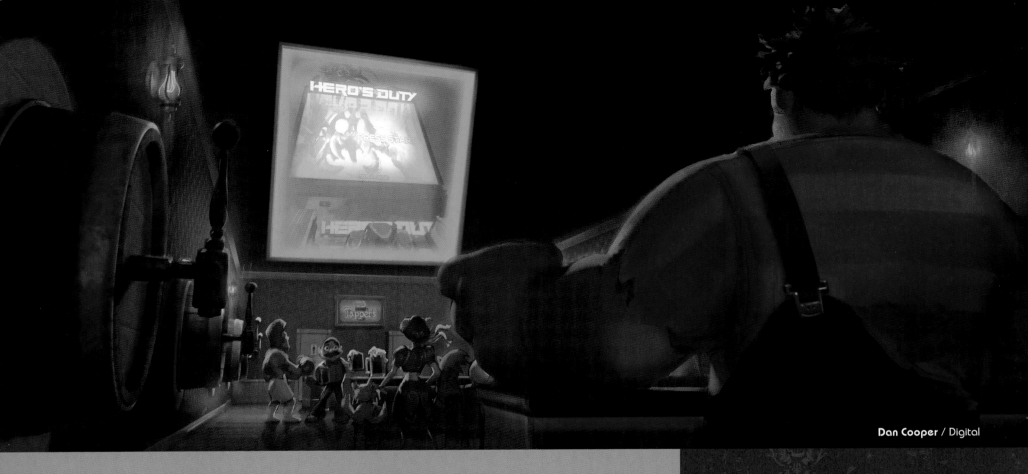

Dan Cooper / Digital

Justin Cram / Digital

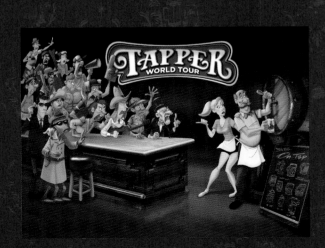

Tapper iOS Game for iPhone®/iPad®

Root Beer Tapper images provided courtesy of Warner Bros. Entertainment Inc.
ROOT BEER TAPPER is a trademark of and © Warner Bros. Entertainment Inc.

145

THE HUMAN WORLD

In a film full of extraordinary worlds, there's one ordinary location that also needs to be memorable and compelling—the domain of humans in Litwak's Family Fun Center. The filmmakers were also challenged to differentiate this "real world" setting from the hyper-realistic realm of Hero's Duty.

"The breakthrough came when Cory Loftis, one of our visual development artists, drew some designs for the humans that had a contemporary Rockwellian feel to them," says Rich, referring to Norman Rockwell, the twentieth-century American illustrator famous for his covers for the *Saturday Evening Post*. "Rockwell's paintings evoke realism," Rich explains, "but the people are caricatured well beyond how they would appear in reality. His paintings are a gorgeous celebration of the mundane." Rockwell, along with a host of Frank Capra movies, became a key inspiration for the style of the arcade world.

To capture these charmingly ordinary characters, Mike told the designers to observe real life: "We videotaped kids playing in actual arcades. We looked at the slope of their foreheads, the way they stand, their little pouch bellies. And we knew that our character designs weren't right until the whole team could look at a sketch and go, 'That girl is caricatured, but she looks just like my niece!' or 'I've seen that guy!'"

With the patrons of Litwak's Family Fun Center, Rich also wanted to capitalize on the recent breakthroughs that the studio had made with its critically acclaimed human animation in *Tangled*. "It was my goal to build on what *Tangled* did with the human acting, which was so funny, yet poignant and incredibly observational. I hope we achieved something equally elegant and underplayed, to continue this new tradition of the studio's—of producing the best, most subtle animation of human beings."

Cory Loftis / Digital

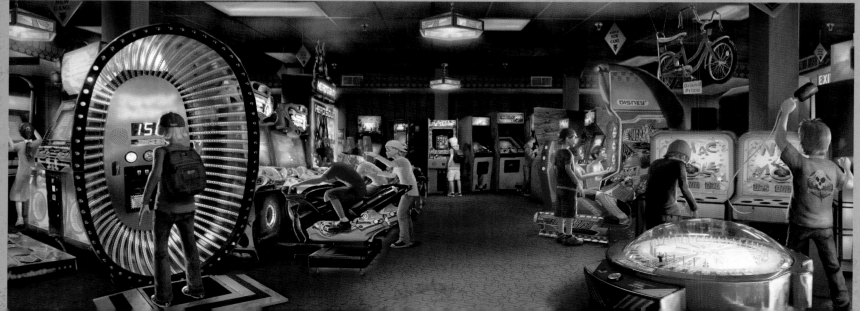

Jim Finn (Paintover/Lighting Key), **Jon Krummel and John Aquino** (Model) / Digital

146

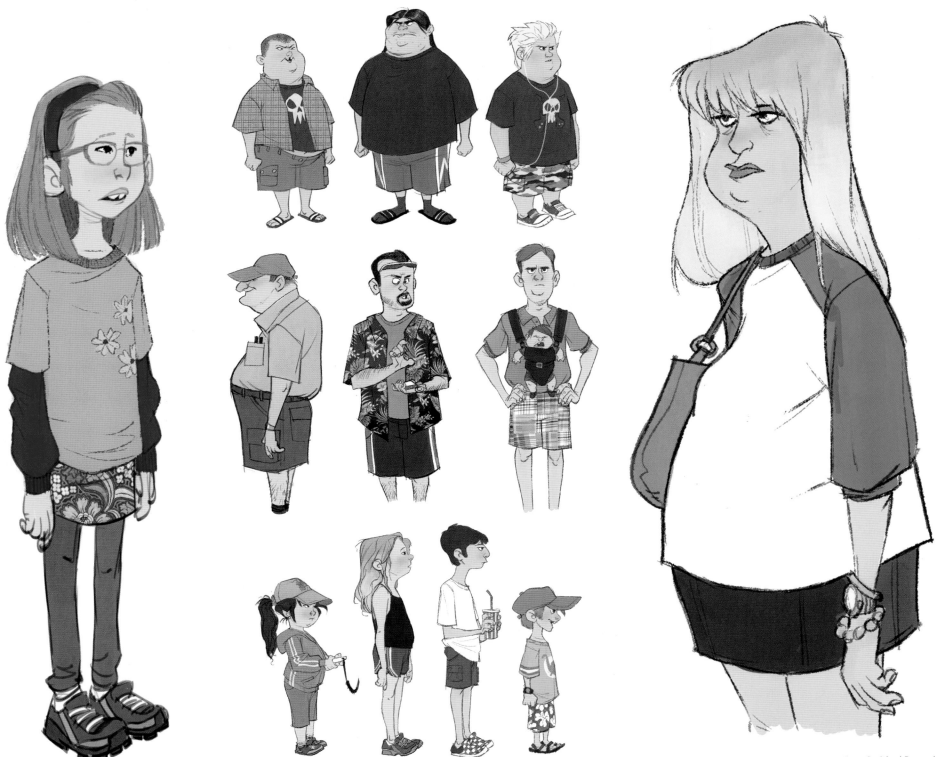

Cory Loftis / Digital

BONUS LEVEL: THE LOST CHARACTERS

A GENERAL IN SICK BAY

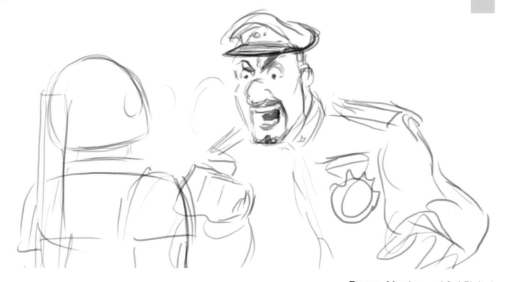

Steve Markowski / Digital

Looking back on all the great characters and story lines that had to be cut from the film, for Hero's Duty, hands down the one everyone grieved the most was General Lockload. Who was he, and where did he go? Screenwriter Phil Johnston explains, "When initially developing the story, it was important to look at the characters and situations as real and not worry too much about the videogame aspect. So we thought in linear terms about what would happen if Ralph actually joined the army. Hero's Duty was much more of a standard-issue military. Ralph got put on KP duty, serving slop in the cafeteria, and then he got thrown in the brig. After that, he was put on demolition duty where he was exploding space waste latrines because all he was good at was breaking things. General Lockload was Calhoun's boss. He also wore the Medal of Heroes around his neck. General Lockload got wounded in battle and ended up unconscious in a full-body cast in sick bay. We had Ralph steal the medal right off of him. As a story it was kind of funny, but it wasn't really on point with Hero's Duty as a game."

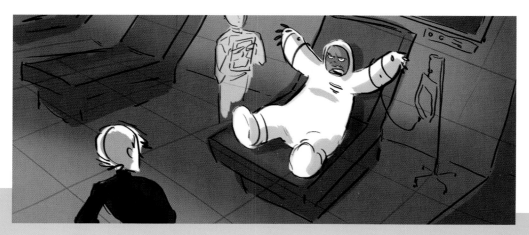

Lissa Treiman / Digital

148

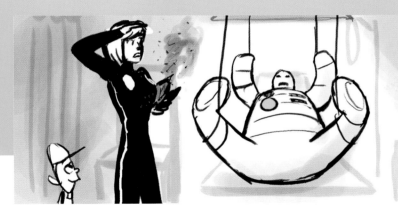

Tom Ellery / Digital

Lissa Treiman / Digital

Minkyu Lee / Digital

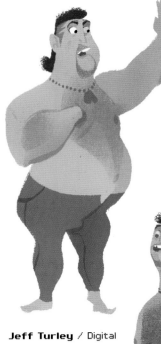

Jeff Turley / Digital

Ryan Lang / Digital

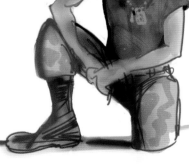

Mike Gabriel / Digital

149

Bill Schwab / Digital

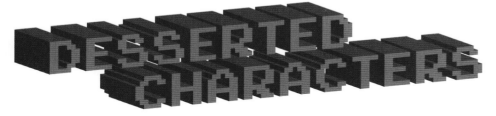

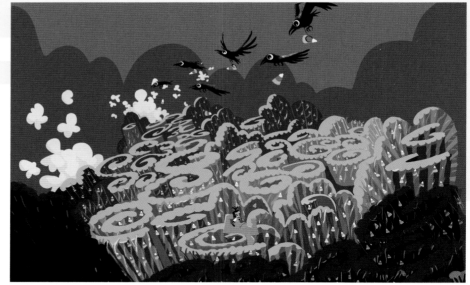

Lorelay Bove / Digital

While Rich and Jim always knew that Sugar Rush was going to be made out of candy, they weren't exactly sure about the gameplay of the world.

For the first few screenings, the gaming goals of Sugar Rush were a mash-up of racing, dancing, and mini-quests. Before it was decided that Ralph and Vanellope had to bake a go-kart, they bonded by having to win its parts. First they had to retrieve the engine from a candy corn maze presided over by Cornelius Cobb, a wacky farmer, and a vicious, fire-breathing uni-candy-corn named Skittles.

Ralph and Vanellope then had to win a dance-off at The Wheelhouse Club, presided over by Lady Go Go, a dancing/singing diva inspired by the likes of Gwen Stefani, Lady Gaga, and Katy Perry. "It was fun because there were these Mad Max ravers," recalls Leo Matsuda, the storyboard artist who developed the sequence. DJ Licious Waferhead provided the house music.

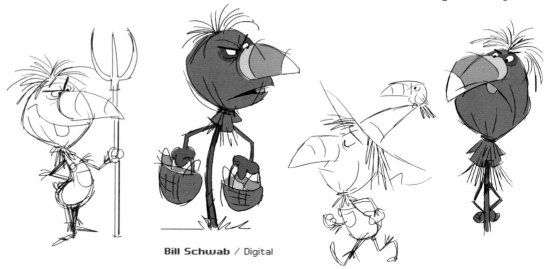

Bill Schwab / Digital

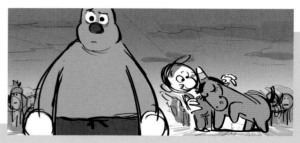

Thomas Ellery, Jeremy Spears / Digital

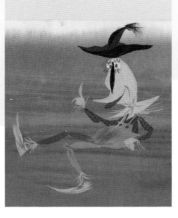
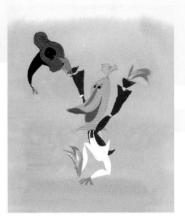

Jeff Turley / Gouache

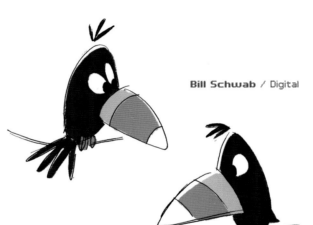

Bill Schwab / Digital

Jeff Turley / Gouache

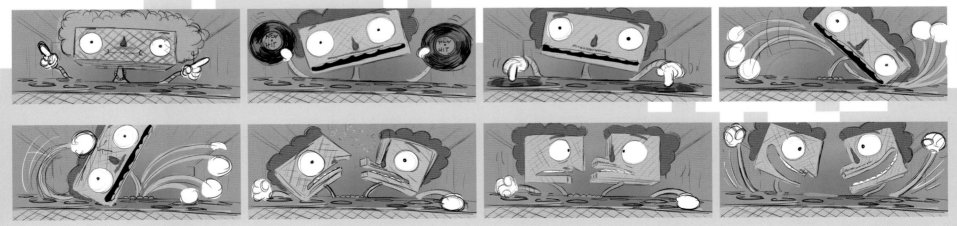

Leo Matsuda / Digital

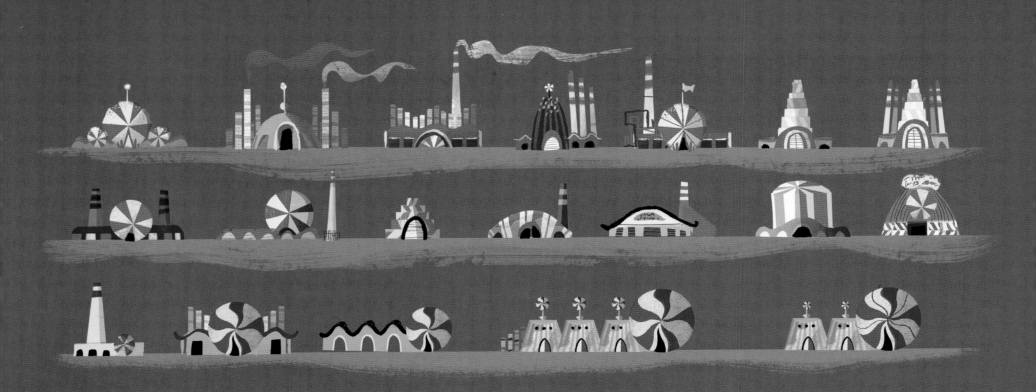

Jeff Turley / Digital

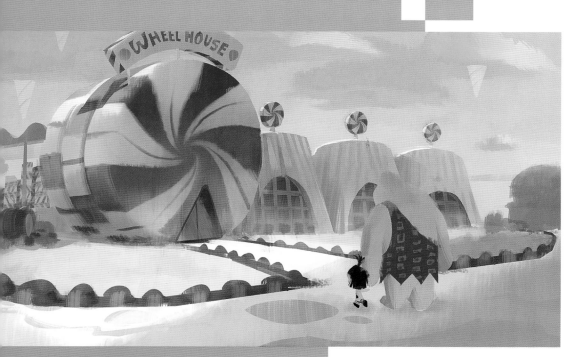

WHEEL HOUSE

Jeff Turley / Digital

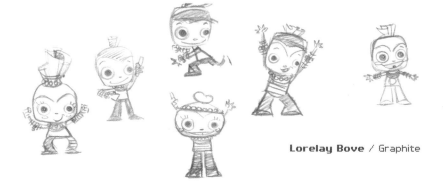

Lorelay Bove / Graphite

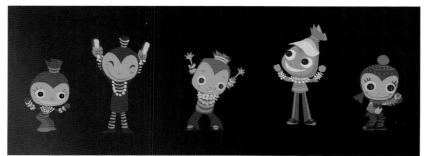

Lorelay Bove / Digital

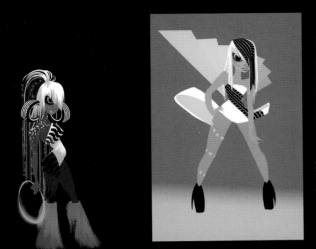
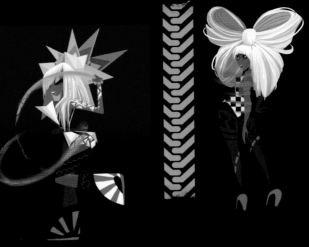

Lorelay Bove / Digital

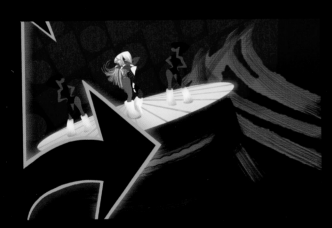
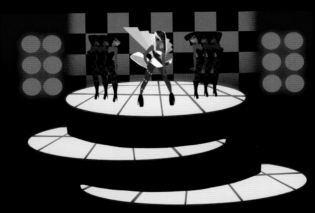

Lorelay Bove / Digital

Lorelay Bove / Digital

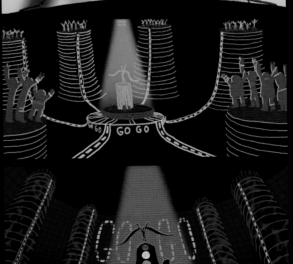

Doug Walker / Digital

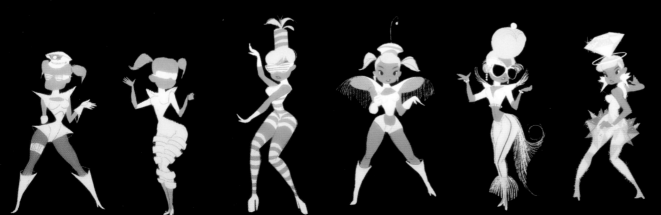

Jeff Turley / Digital

153

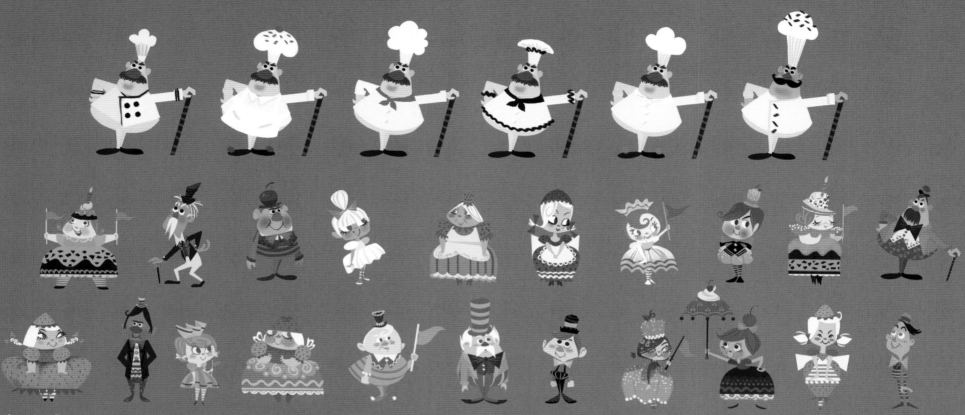

Lorelay Bove / Digital

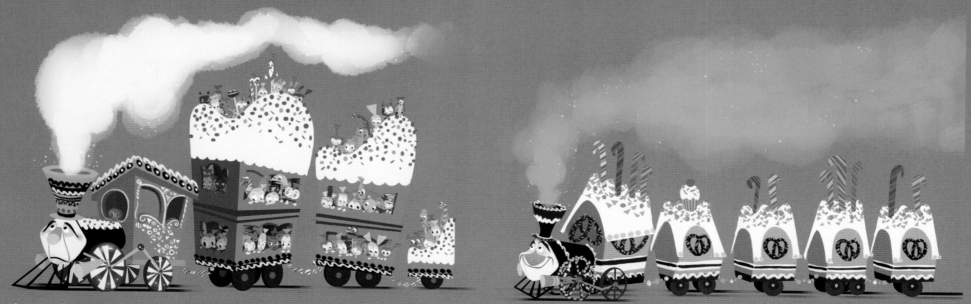

Lorelay Bove / Digital

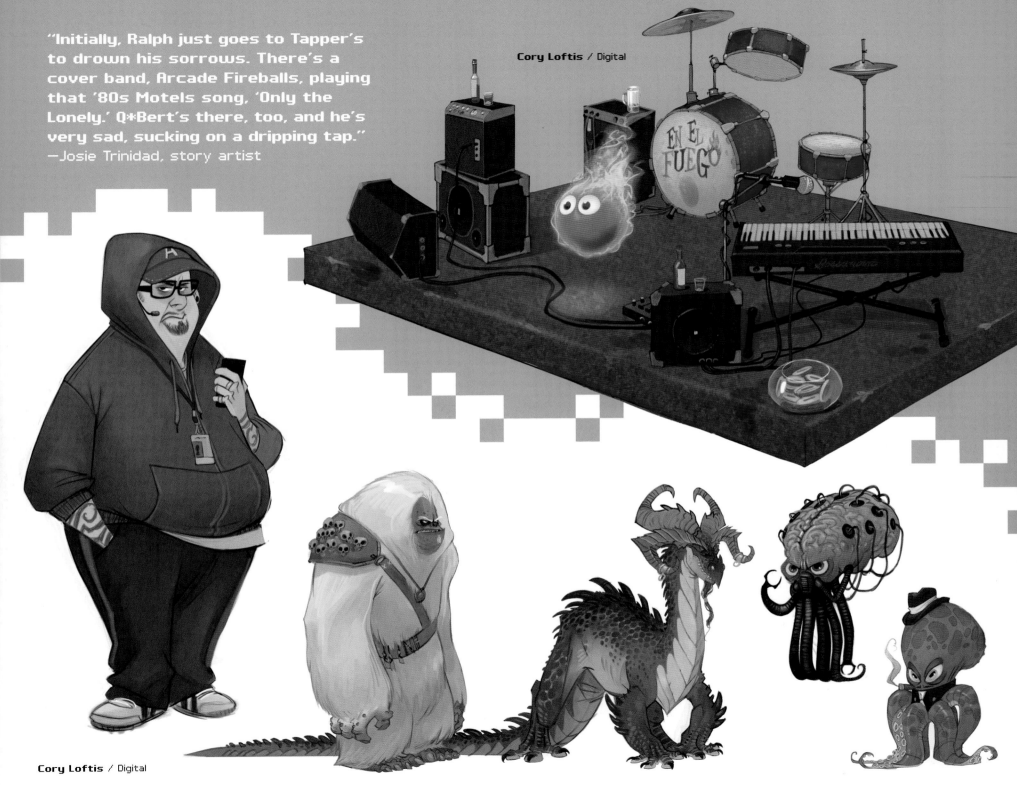

"Initially, Ralph just goes to Tapper's to drown his sorrows. There's a cover band, Arcade Fireballs, playing that '80s Motels song, 'Only the Lonely.' Q*Bert's there, too, and he's very sad, sucking on a dripping tap."
—Josie Trinidad, story artist

Cory Loftis / Digital

Cory Loftis / Digital

EXTREME EZ LIVIN' 2

Few people know that there was going to be another whole world in *Wreck-It Ralph*—that of Extreme EZ Livin' 2.

"Hands down, the easiest thing to pitch about the movie early on was the world of Extreme EZ Livin' 2," ruefully muses Clark. "It was Las Vegas, times ten." A mash-up of outlaw sports games, like Extreme Volleyball, combined with nonlinear sandbox games like The Sims and Grand Theft Auto, Extreme EZ Livin' 2 represented Disney's epitome of a carefree, hedonistic game life.

Ralph originally stopped off in Extreme EZ Livin' 2 when he felt he had failed with Vanellope because, as Rich puts it, "He had given up on his game. He was just trying to go someplace where he fit in. And the tagline for EZ Livin' was, 'There are no good guys or bad guys in our world—just guys.'"

Ian Gooding fondly recalls one development painting by Visual Development Artist James Finch, of a swimming pool with a half-submerged police car sticking out of it. "I thought, 'Wow, that really says it all.'"

Unfortunately, Ralph arrived in Extreme EZ Livin' 2 so late in the story that, according to Mike Gabriel, "It just became one game too many. At a certain point, you've invested enough of your emotions in worlds that have already been established, and it really uproots your connection to the characters if you go someplace new and have to start investing in a whole new batch of characters—even if they are volleyball beach babes in bikinis."

"We had a moment of silence, the day that we cut it from the film," remembers Clark,"but we all knew fundamentally it was the right thing to do."

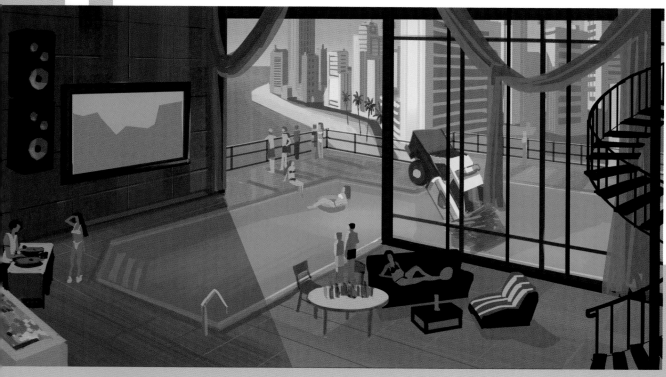

James Finch / Digital

Jeff Turley / Digital

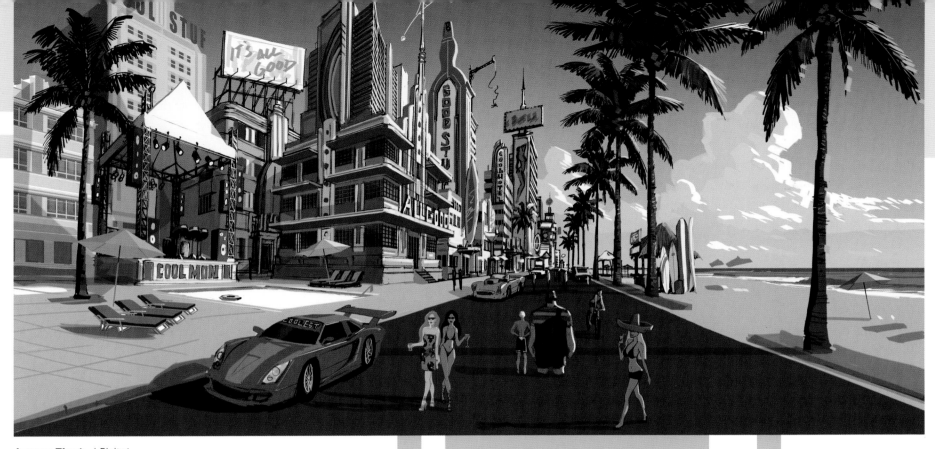

James Finch / Digital

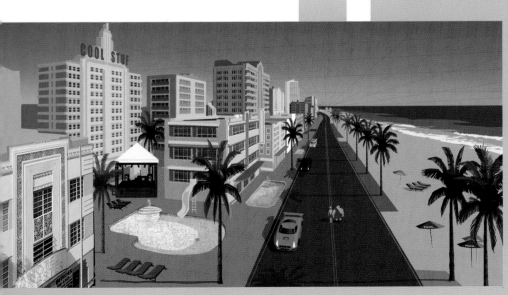

James Finch / Digital

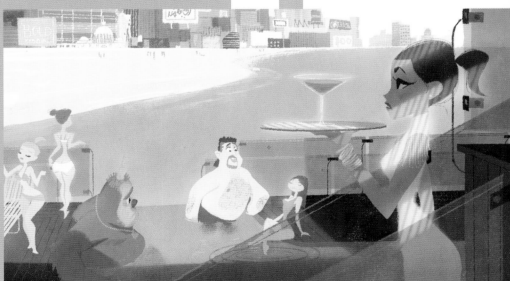

Jeff Turley / Digital

157

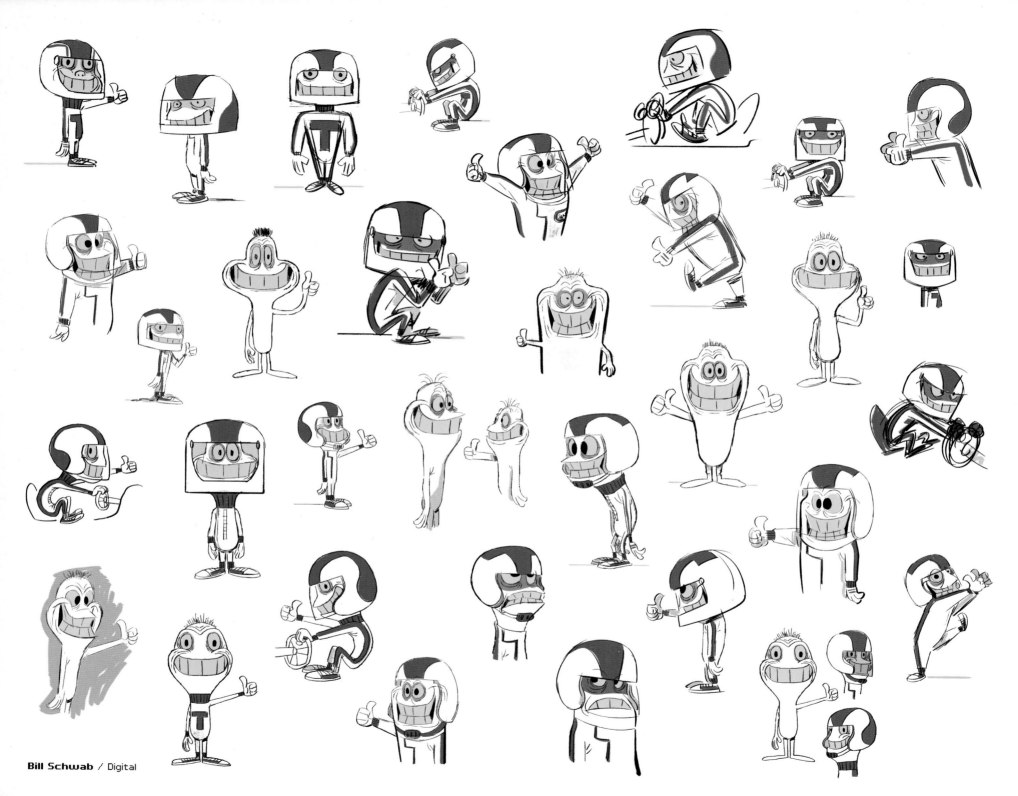

Bill Schwab / Digital

158

Bill Schwab / Digital

ᴀᴄᴋɴᴏᴡʟᴇᴅɢᴍᴇɴᴛꜱ

The authors want to express their sincerest gratitude to Clark Spencer and Rich Moore for suggesting they team up and write this book; Leigh Anna MacFadden at Disney Publishing and Emily Haynes at Chronicle Books for agreeing and for guiding them through the process; to Renato Lattanzi for his optimism and constant support; and to Kyle Gabriel for his superlative transcribing skills.

They also want to thank Mike Gabriel, Ian Gooding, and all of the *Wreck-It Ralph* artists who shared their great stories, and the incomparable production and executive support team of Monica Lago-Kaytis, Jen Vera, Halima Hudson, Eileen Aguirre, and Tanya Oskanian who saw that the interviews got scheduled in the middle of a crazy production process.

On a personal note, Jennifer would like to thank her nine-year-old daughter Agatha, whose exuberance and creative zeal inspires her every day. And Maggie would like to thank her fiance Matt, who supports her through the long hours of all of her creative endeavors.

Bill Schwab / Digital

159

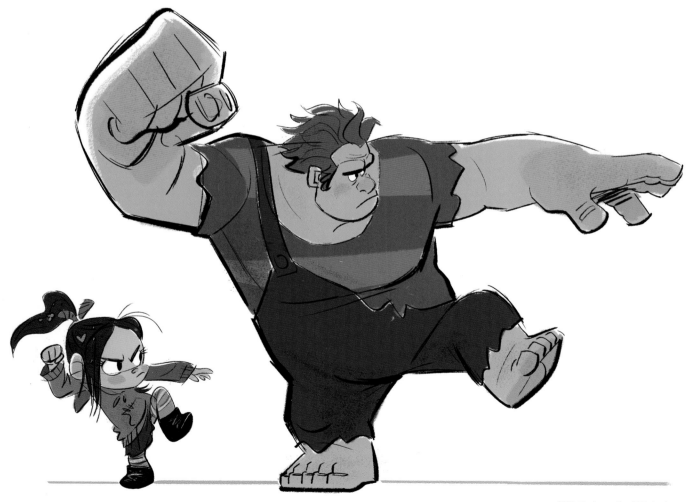

Bill Schwab / Digital